# THE ULTIMATE DRAWING BOOK

# THE ULTIMATE DRAWING BOOK

## BARRINGTON BARBER

ARCTURUS

ARCTURUS

This edition published in 2019 by Arcturus Publishing Limited
26/27 Bickels Yard, 151–153 Bermondsey Street,
London SE1 3HA

ISBN: 978-1-78950-205-3
AD006748UK

Printed in China

# Contents

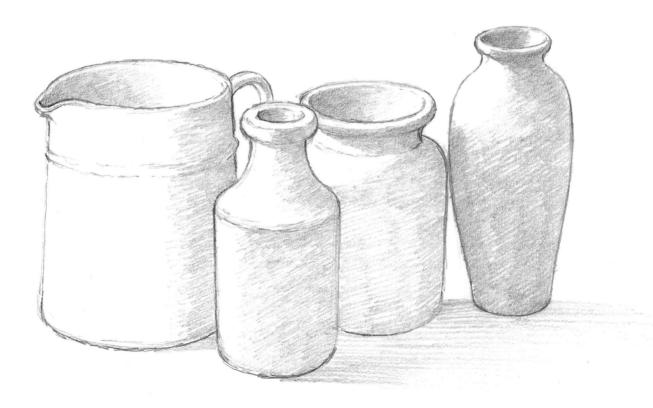

# Introduction

Arguably the oldest art form in the history of civilization, drawing involves representing the three-dimensional world in two dimensions. The earliest examples of drawings are found in cave paintings, in which early humans made visual records of the world around them, including animals, plants, people and events. By 3000BC, Ancient Egyptians were decorating the walls of their temples and tombs with drawings depicting their daily life, and then the Ancient Greeks began making elaborate drawings on their pottery vases.

Paper as we know it was invented around 1300, and by the 15th century a dramatic shift occurred in European history with the onset of the Renaissance. This cultural movement brought with it a renewed interest in science, art, music and religion, and art became a respected and highly skilled profession. Draftsmen – or 'masters of drawing' – such as Leonardo da Vinci and Michelangelo emerged, and produced masterpieces depicting the human form.

By the 16th century, along with the rise of the academies, sets of strict rules were introduced into the discipline of drawing. Trainee artists learned their trade by copying other artists' works, and rules governing facial expressions and body positions were strongly enforced. There was a reaction against these rules in the 18th century, and the Romantic artists became much softer and freer in their artworks. Drawing styles continued to diversify, with some artists favouring a rigorous, classical approach and others a more realistic look through working directly from nature.

Today, drawing can follow any style and is often used to convey personal expression and emotion. The materials used to create pictures are wide and varied, as are the sizes and shapes of the paper you can use. But there is one thing that has never changed: the all-important need to observe and practise.

This book is a complete practical guide to the art of drawing, taking the reader from the very first steps – such as choosing a pencil – through to completing a full-scale, finished drawing. The first chapter sets out all the tools and materials you will need. There is information about pencils, conté crayons, graphite, pens, pastels, chalk, charcoal, brushes, stumps, paper, erasers and sharpeners, as well as practical exercises for getting to grips with the basic techniques of drawing: pencil shading, cross-hatching, using pen and ink, shading with chalk, using brush and wash, trying your hand at scraperboard, and creating objects that appear to be three-dimensional.

Having worked through the basics, the book then covers the three most popular types of drawing: still life, landscapes, and figures and faces. Within each chapter, the author provides examples of illustrations showing the key features to focus on, with different viewpoints of the same subjects, pitfalls to avoid and step-by-step exercises to hone your skills.

From a rural Italian vista following the style of Leonardo, a charming portrait of three dancing girls following Rubens, or a few random apples and bottles from the author's own kitchen, a wide variety of examples and exercises are given, and can be referred to again and again to help you become a better artist. By practising and repeating the exercises within these pages, you'll soon discover that your drawings start coming to life.

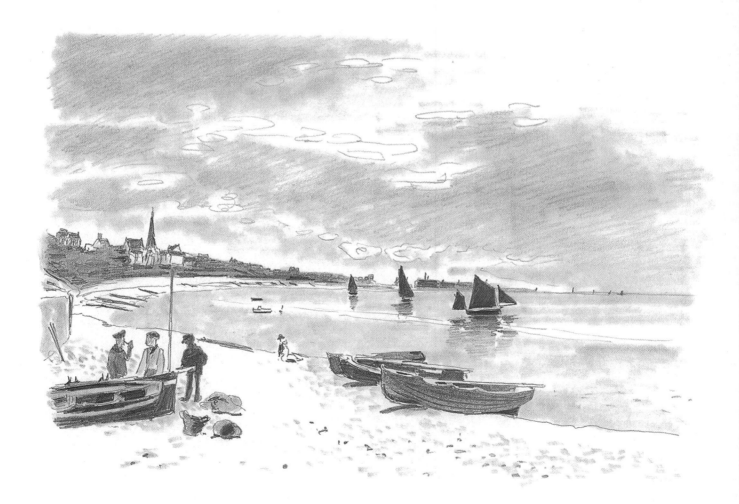

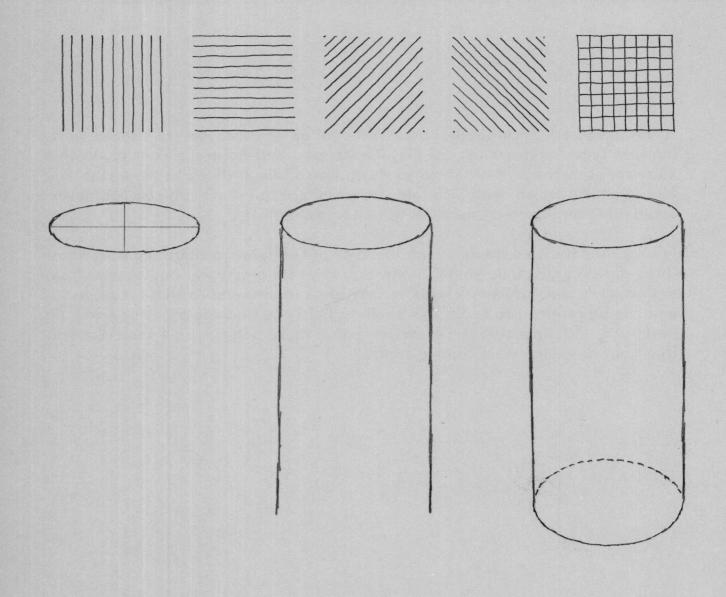

# Basics

When beginning your journey as an artist, you first need to think about your tools and materials, and how to use them. This chapter explores the main items every artist needs in their toolkit, including pencils, conté crayons, graphite, pens, pastels, chalk, charcoal, brushes, stumps, paper, erasers and sharpeners. For each item, there are hints and tips about sizes, thicknesses, colour qualities

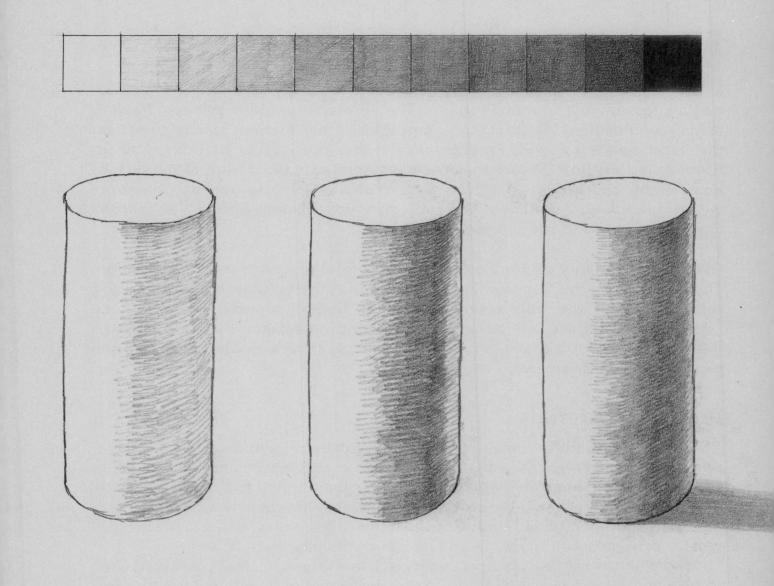

and the best ones to try. Next, there are sets of exercises that will help you practise your drawing techniques, from making simple lines with pen and ink through to three-dimensional shading to produce realistic images. Whether you're a complete beginner or an experienced artist, you should come back to these exercises again and again to refine your skills.

# First Steps

In this first chapter of the book you will find a range of different exercises, beginning with the extremely basic. The aim is to prepare you for drawing actual compositions. Before the composing of any picture can be effective, the artist needs to work hard to ensure that the quality of their drawing has reached the point where they can concentrate on the design of the picture and not be concerned about the details of drawing the objects or people within it. Looking carefully at the subject of your picture before you start to draw is a very good routine to adopt.

Give yourself plenty of practice in making careful drawings from observation. This involves correcting mistakes, leaving out parts that don't work and redrawing until the object on your paper begins to resemble what you actually see. The process outlined is slow and painstaking. If adopted, it is the foundation for a really impressive drawing procedure which should soon produce an improvement in technique.

## Drawing materials

Any medium is valid for drawing still lifes, landscapes, figures and faces. That said, some media are more valid than others in particular circumstances, and in the main their suitability depends on what you are trying to achieve. Try to equip yourself with the best materials you can afford; quality does make a difference. You don't need to buy all the items listed below, and it is probably wise to experiment gradually as you gain in confidence.

Start with the range of pencils suggested, and when you feel you would like to try something different, then do so. Be aware that each material has its own identity, and you have to become acquainted with its individual facets before you can get the best out of it or discover whether it is the right material for your purposes.

### Pencil

The normal type of wooden-cased drawing pencil is, of course, the most versatile instrument at your disposal. You will find the soft black pencils are best. Mostly I use B, 2B, 4B and 6B. Very soft pencils (7B–9B) can be useful sometimes, and harder ones (H) very occasionally. Propelling or clutch pencils are very popular, although if you choose this type you will need to buy a selection of soft, black leads with which to replenish them.

### Conté

Similar to compressed charcoal, conté crayon comes in different colours, different forms (stick or encased in wood like a pencil) and in grades from soft to hard. Like charcoal, it smudges easily but is much stronger in its effect and more difficult to remove.

### Carbon pencil

This can give a very attractive, slightly unusual result, especially the dark brown or sepia, and the terracotta or sanguine versions. The black version is almost the same in appearance as charcoal, but doesn't offer the same rubbing-out facility. If you are using this type, start off very lightly because you will not easily be able to erase your strokes.

## Graphite

Graphite pencils are thicker than ordinary pencils and come in an ordinary wooden casing or as solid graphite sticks with a thin plastic covering. The graphite in the plastic coating is thicker, more solid and lasts longer, but the wooden casing probably feels better. The solid stick is very versatile because of the breadth of the drawing edge, enabling you to draw a line 6 mm (¼ in) thick, or even thicker, and also very fine lines. Graphite also comes in various grades, from hard to very soft and black.

## Pens

Push-pens or dip-pens come with a fine pointed nib, either stiff or flexible, depending on what you wish to achieve. Modern fine-pointed graphic pens are easier to use and less messy but not as versatile, producing a line of unvarying thickness. Try both types.

The ink for dip-pens is black Indian ink or drawing ink; this can be permanent or water-soluble. The latter allows greater subtlety of tone.

## Pastel/chalk

If you want to introduce colour into your drawings, either of these can be used. Dark colours give better tonal variation. Avoid bright, light colours. Your choice of paper is essential to a good outcome with these materials. Don't use a paper that is too smooth, otherwise the deposit of pastel or chalk will not adhere to the paper properly. A tinted paper can be ideal, because it enables you to use light and dark tones to bring an extra dimension to your drawing.

## Charcoal

In stick form this medium is very useful for large drawings, because the long edge can be used as well as the point. Charcoal pencils (available in black, grey and white) are not as messy to use as the sticks but are less versatile. If charcoal drawings are to be kept in good condition the charcoal must be fixed with a spray-on fixative to stop it smudging.

## Brush

Drawing with a brush will give a greater variety of tonal possibilities to your drawing. A fine tip is not easy to use initially, and you will need to practise if you are to get a good result with it.

Use a soluble ink, which will give you a range of attractive tones.

A number 0 or number 2 nylon brush is satisfactory for drawing. For applying washes of tone, a number 6 or number 10 brush in sablette, sable or any other material capable of producing a good point is recommended.

## Stump

A stump is a tightly concentrated roll of absorbent paper formed into a fat pencil-like shape. Artists use it to smudge pencil, pastel or charcoal and thus smooth out shading they have applied, and graduate it more finely.

## Paper

You will find a good-quality cartridge paper most useful, but choose one that is not too smooth; 160 gsm weight is about right. (If you are unsure, ask in your local art shop, where they will stock all the materials you require.)

Drawing in ink can be done on smoother paper, but even here a textured paper can give a livelier result in the drawing. For drawing with a brush, you will need a paper that will not buckle when wet, such as watercolour paper. Also see under Pastel/chalk.

## Eraser

The best all-purpose eraser for the artist is a putty eraser. Kneadable, it can be formed into a point or edge to rub out all forms of pencil. Unlike the conventional eraser it does not leave small deposits on the paper. However, a standard soft eraser is quite useful as well, because you can work over marks with it more vigorously than you can with a putty eraser.

Most artists try to use an eraser as little as possible, and in fact it only really comes into its own when you are drawing for publication, which requires that you get rid of superfluous lines. Normally you can safely ignore erasers in the knowledge that inaccurate lines will be drawn over and thus passed over by the eye which will see and follow the corrected lines.

## Sharpener

A craft knife is more flexible than an all-purpose sharpener and will be able to cope with any medium. It goes without saying that you should use such an implement with care and not leave the blade exposed where it may cause harm or damage.

# Exercises in technique

The following technical practices should help you to ease your way into drawing in a range of different styles. There are, of course, many more than the ones we show, but these will serve very well as a basis. You will discover all sorts of other methods through your own investigations and adapt them to serve your purpose.

## Pencil shading test

When you are using pencil to add tone to your drawings, it soon shows if you are not very expert. The only way you can develop this facility is to practise shading in various ways in order to get used to seeing the different tones achievable. This exercise is quite difficult but good fun and can be repeated many times over a period of weeks, just to help you get your hand and eye in. You will find the control it gives you over the pencil very valuable.

You will need a very dark pencil (4B), a slightly less dark pencil (2B) and a lighter pencil (such as a B). If you wish, you can always use a harder lighter pencil, such as an H or 2H.

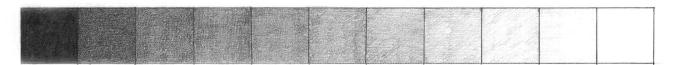

Draw out a long line of squares measuring about 1 in (2.5 cm) square. Shade each one, starting with a totally black square. Allow the next square of shading to be slightly lighter, and so on, gradually shading each square as uniformly as possible with a lighter and lighter touch, until you arrive at white paper.

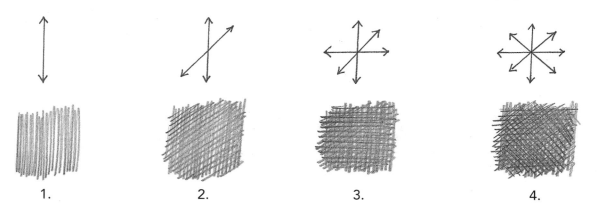

1.          2.          3.          4.

5.

## Building up tones by cross-hatching:

1. Vertical strokes first, close together.

2. Oblique strokes from top right to bottom left over the strokes shown in 1.

3. Horizontal strokes over the strokes shown in 1 and 2.

4. Then make oblique strokes from top left to bottom right over the strokes shown in 1–3.

5. Smooth and finely graduated tones can be achieved by working over your marks with a stub.

# Pencil and graphite

A pencil is the easiest and most obvious implement with which to start an exploration of technique. Try the following series of simple warming-up exercises, which can be practised every day that you put aside time to draw. This is very useful for improving your technique.

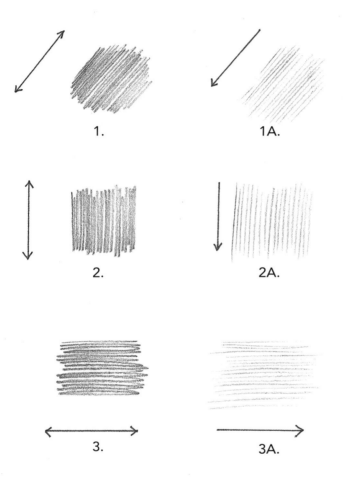

1. | 1A. | 2. | 2A. | 3. | 3A.

1. A backward and forward motion of the hand, always in an oblique direction, produces an even tone quickly.

2. The same motion vertically.

3. The same motion horizontally.

1A. 2A. and 3A.
Now try a slightly more careful method where the hand draws the lines in one direction only.

Try using a graphite stick for the next two exercises; they can also be done with a well-sharpened soft pencil.

1. Lay the side edge of the point of the graphite or pencil onto the paper and make smooth, smudged marks.

2. Using the point in random directions also works well.

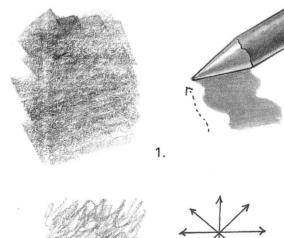

1.

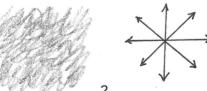

2.

# Pen and ink

There is a whole range of exercises for pen work, but of course this implement has to be used rather more lightly and carefully than the pencil so that its point doesn't catch in the paper.

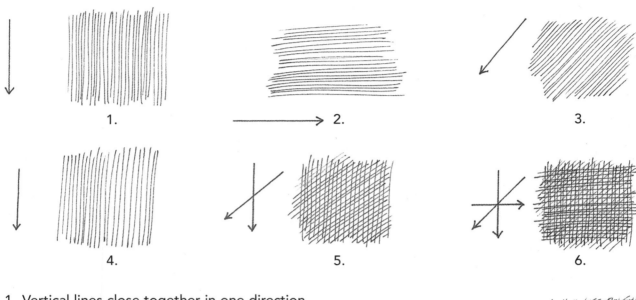

1. Vertical lines close together in one direction.

2. Horizontal lines close together in one direction.

3. Oblique lines close together in one direction.

   Repeat as above but this time building up the strokes:

4. Draw vertical lines.

5. Draw oblique lines on top of the verticals.

6. Draw horizontal lines on top of the oblique and vertical lines.

7. Draw oblique lines at 90 degrees to the last oblique lines on top of the three previous exercises to build up the tone.

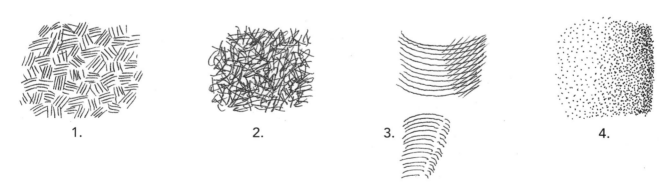

1. Make patches of short strokes in different directions, each time packing them closer together.

2. Draw small overlapping lines in all directions.

3. Draw lines that follow the contours of a shape, placing them close together. For an additional variation, draw oblique lines across these contour lines.

4. Build up myriad dots to describe tonal areas.

# Shading with chalk

This next series of exercises is similar to the one you have just done but requires extra care not to smudge your marks as you put them down. The key in this respect is not to use a smooth paper. Choose one with a texture that will provide a surface to which the chalk can adhere.

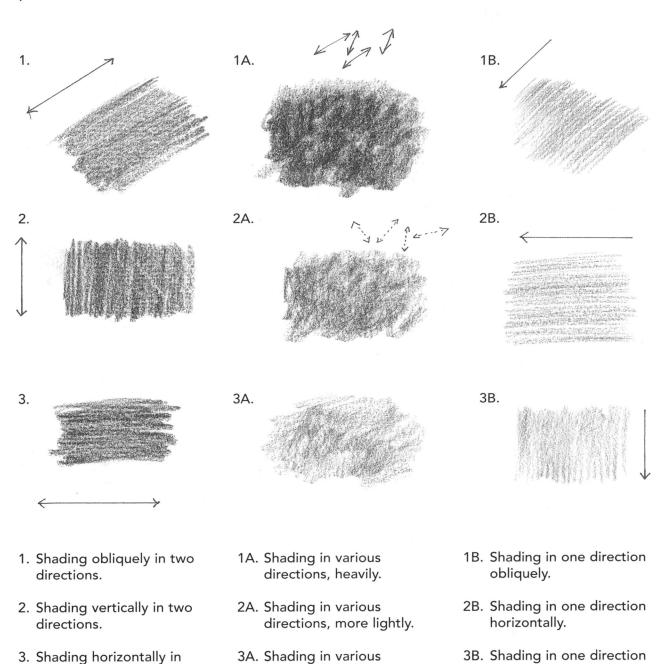

1. Shading obliquely in two directions.

2. Shading vertically in two directions.

3. Shading horizontally in two directions.

1A. Shading in various directions, heavily.

2A. Shading in various directions, more lightly.

3A. Shading in various directions, very lightly.

1B. Shading in one direction obliquely.

2B. Shading in one direction horizontally.

3B. Shading in one direction vertically.

In a series of squares, practise shading of various strengths, progressing from the heaviest to the lightest.

# Brush and wash

The best way to start with brush and wash is to try these simple exercises. Your brush should be fairly full of water and colour, so mix a generous amount on a palette or saucer first, and use paper that won't buckle.

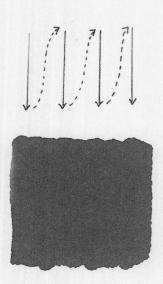

1. With a brush full of ink or watercolour diluted in water, lay a straightforward wash as evenly as possible on watercolour paper.

2. Repeat, but this time brushing the wash in all directions.

3. Load a lot of colour onto your brush and then gradually add water so that the tone gets weaker as you work. Keep working with the brush until it finally dries and you wipe out the last bit of colour.

4. Practise drawing soft lines with a brush and wash.

# Scraperboard

Take a fine-pointed and a curved-edge scraper and try your hand at scraperboard. The curved-edge tool produces broader, thicker lines than the pointed tool, as can be seen from the examples shown below.

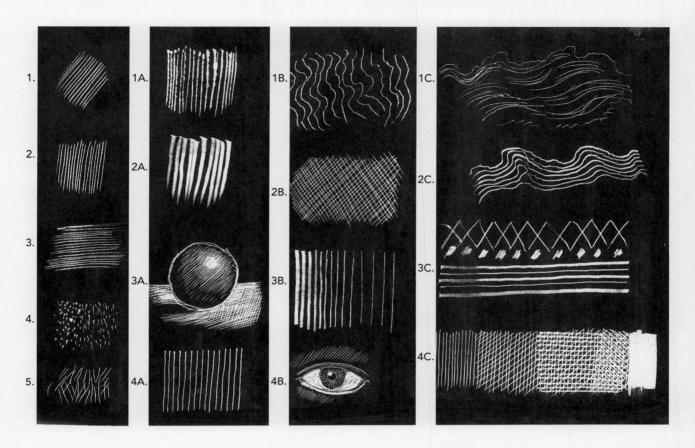

1. Oblique fine line.

2. Vertical fine line.

3. Horizontal fine line.

4. Short pecks.

5. Short pecks and strokes.

1A. Thicker vertical lines.

2A. Thicker oblique lines.

3A. Draw a ball, then scrape away to reveal light side.

4A. Thicker, measured vertical strokes.

1B. Scraped wavy lines.

2B. Cross-hatching with fine lines.

3B. Gradually reducing from thick to fine lines.

4B. Draw an eye shape and then scrape out light areas.

1C. Lightly scraped wavy lines.

2C. Thickly scraped wavy lines.

3C. Criss-cross pattern.

4C. Multiple cross-hatching increasing in complexity from left to right.

Pointed tool

Curved-edge tool

# Lines into shapes

Before you begin any kind of drawing, it is necessary to practise the basics. This is essential for the complete beginner, and even for the experienced artist it is very useful. If you are to draw well you must be in control of the connection between eye and hand. There are many exercises to help you achieve this. The following are the simplest and most helpful I know.

Complete them all as carefully as you can, drawing freehand, at the sizes shown. The more you repeat them, the more competent and confident you will become – and this will show in your drawing.

## Lines

As you draw, try to keep your attention exactly on the point where the pencil touches the paper. This will help to keep mind and hand synchronized, and in time make drawing easier.

1. Begin with vertical lines, keeping them straight and the same length.

2. Produce a square with a series of evenly spaced horizontal lines.

3. Now try diagonal lines, from top right to bottom left, varying the lengths while keeping the spacing consistent.

4. Next, draw diagonals from top left to bottom right. You may find the change of angle strange at first.

5. To complete the sequence, try a square made up of horizontals and verticals crossing each other.

## Circles

At first it is difficult to draw a circle accurately. For this exercise I want you to draw a series of them next to each other, all the same size. Persist until the circles on the paper in front of you look like the perfect ones you can see in your mind's eye. When you achieve this, you will know that your eye and mind are coordinating.

## Variations

Paul Klee described drawing as 'taking a line for a walk'. Try drawing a few different geometric figures:

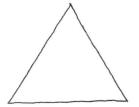 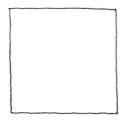 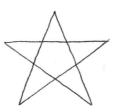 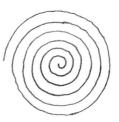 

1. Triangle – three sides of the same length.

2. Square – four sides of the same length.

3. Star – one continuous line.

4. Spiral – a series of decreasing circles ending in the centre.

5. Asterisk – 16 arms of the same length radiating from a small black point.

Finish by practising a few S-shaped figures, which are formed by making two joined but opposing arcs. You will constantly come across shapes like these in your drawings.

# Three dimensions

Every object you draw will have to appear to be three-dimensional if it is to convince the viewer. The next series of practice exercises has been designed to show you how this is done. We begin with cubes and spheres.

1. Draw a square.

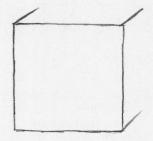

2. Draw lines that are parallel from each of the top corners and the bottom right corner.

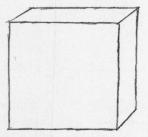

3. Join these lines to complete the cube.

This alternative method produces a cube shape that looks as though it is being viewed from one corner.

1. Draw a diamond shape or parallelogram elongated across the horizontal axis.

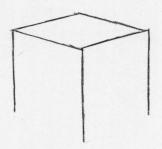

2. Now draw three vertical lines from the three angles shown; make sure they are parallel.

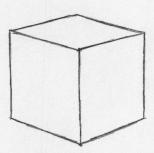

3. Join these vertical lines.

# Shading

Once you have formed the cube, you are halfway towards producing a realistic three-dimensional image. The addition of tone, or shading, will complete the trick.

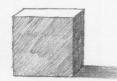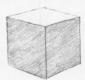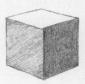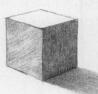

There is only one way of drawing a sphere. What makes each one individual is how you apply tone. In this example we are trying to capture the effect of light shining on the sphere from top left.

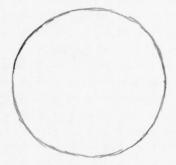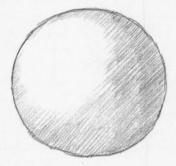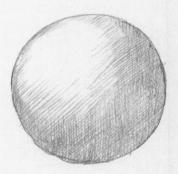

1. Draw a circle as accurately as possible.

2. Shade in a layer of tone around the lower and right-hand side in an almost crescent shape, leaving the rest of the surface untouched.

3. Subtly increase the depth of the tone in much of the area already covered, without making it uniform all over.

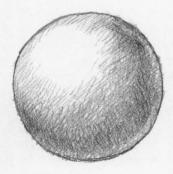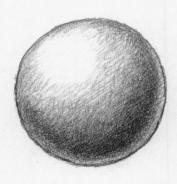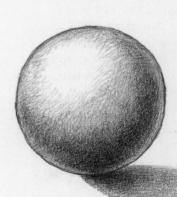

4. Add a new crescent of darkish tone, slightly away from the lower and right-hand edges; ensure this is not too broad.

5. Increase the depth of tone in the darkest area.

6. Draw in a shadow to extend from the lower edge on the right side.

# Ellipses

One shape you need to learn to draw if you are to show a circular object seen from an oblique view is an ellipse. This is a curved figure with a uniform circumference and a horizontal axis longer than the perpendicular axis.

An ellipse changes as our view of it shifts. Look at the next series of drawings and you will see how the perspective of the glass changes as its position alters in relation to your eye level.

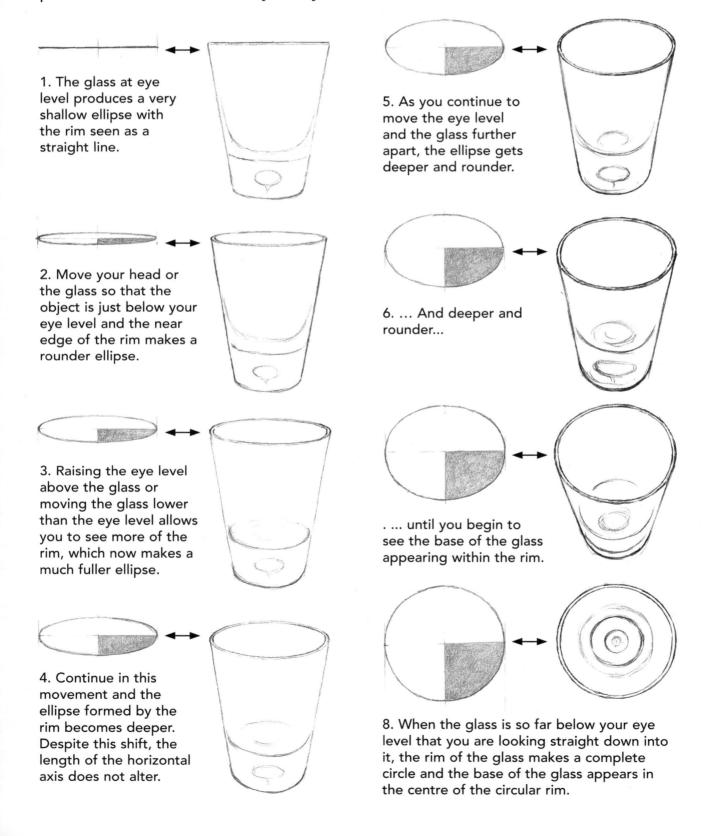

1. The glass at eye level produces a very shallow ellipse with the rim seen as a straight line.

2. Move your head or the glass so that the object is just below your eye level and the near edge of the rim makes a rounder ellipse.

3. Raising the eye level above the glass or moving the glass lower than the eye level allows you to see more of the rim, which now makes a much fuller ellipse.

4. Continue in this movement and the ellipse formed by the rim becomes deeper. Despite this shift, the length of the horizontal axis does not alter.

5. As you continue to move the eye level and the glass further apart, the ellipse gets deeper and rounder.

6. … And deeper and rounder…

. … until you begin to see the base of the glass appearing within the rim.

8. When the glass is so far below your eye level that you are looking straight down into it, the rim of the glass makes a complete circle and the base of the glass appears in the centre of the circular rim.

# Ellipses practice: cylinders

Ellipses come into their own when we have to draw cylindrical objects. As with our previous examples of making shapes appear three-dimensional, the addition of tone completes the transformation.

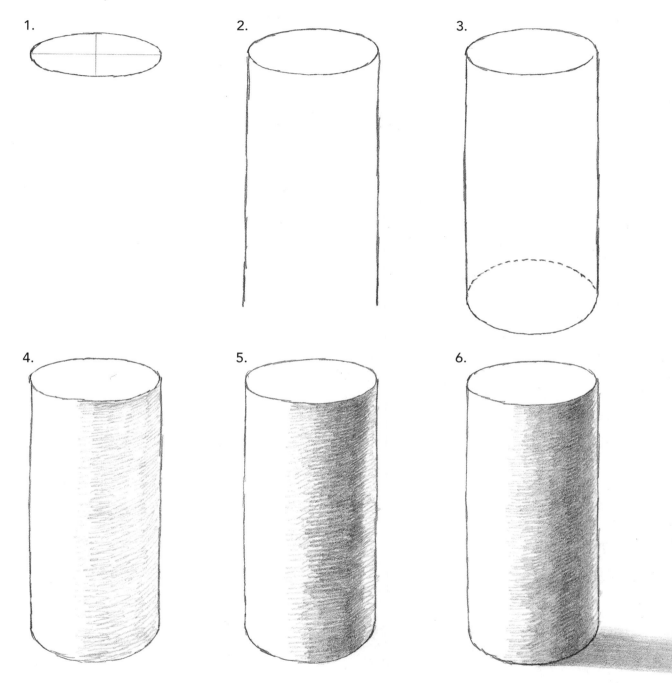

1. Draw an ellipse.

2. Draw two vertical straight lines from the two outer edges of the horizontal axis.

3. Put in half an ellipse to represent the bottom edge of the cylinder. Or, draw a complete ellipse lightly, then erase the half that would only be seen if the cylinder were transparent.

4. To give the effect of light shining from the left, shade very lightly down the right half of the cylinder.

5. Add more shading, this time to a smaller vertical strip that fades off towards the centre.

6. Add a shadow to the right, at ground level. Strengthen the line of the lower ellipse.

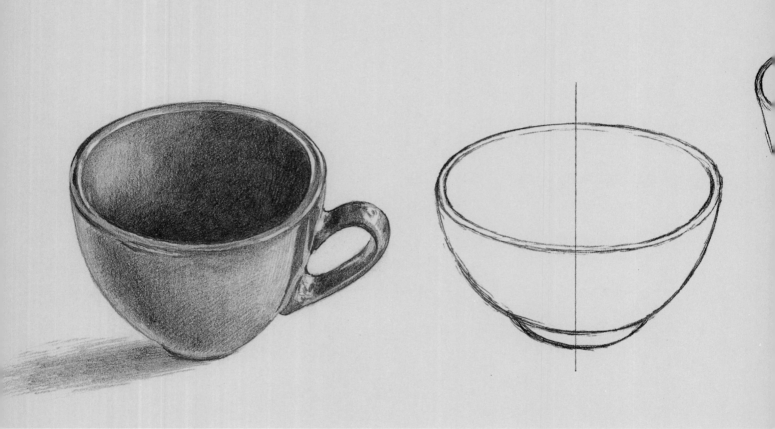

# Still Life

Having mastered the basics, this chapter looks at still-life drawing, revealing all the steps involved from the very first thoughts to the finished picture. We begin by examining the shapes of simple objects such as elliptical glasses, rectangular chairs and spherical oranges, and then show how to achieve realistic textures when depicting fabric, glass, metal, flowers and food. Once

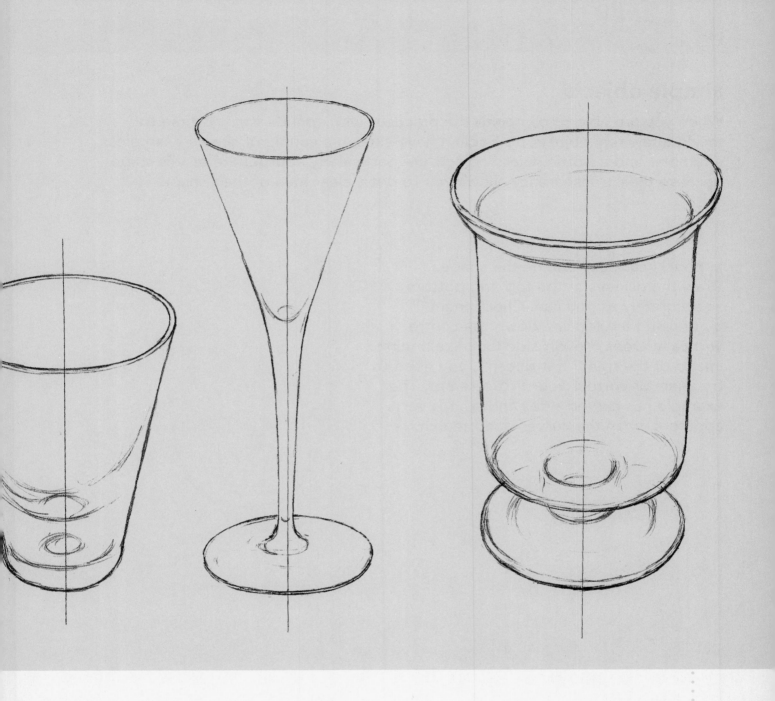

you've decided what you want to draw, we explain how to combine objects in pleasing arrangements, how to light them, block in the shadows and complete the picture. Examples by some of the masters of still-life compositions are included to illustrate well-balanced arrangements, and then I show how to draw a still life using everyday items from my own kitchen.

# Simple objects

When you are able to complete the practices with confidence, it is time to tackle a few real objects. To begin, I have chosen a couple of simple examples: a tumbler and a bottle. Glass objects are particularly appropriate at this stage because their transparency allows you to get a clear idea of their shape.

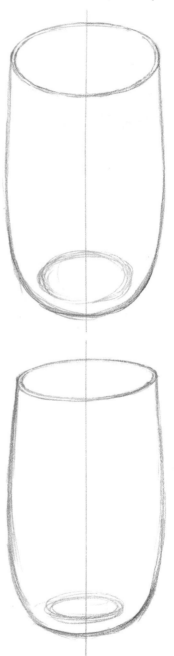

In pencil, carefully outline the shape. Draw the ellipses at the top and bottom as accurately as you can. Check them by drawing a ruled line down the centre vertically. Does the left side look like a mirror image of the right? If it doesn't, you need to try again or correct your first attempt. The example has curved sides and so it is very apparent when the curves don't match.

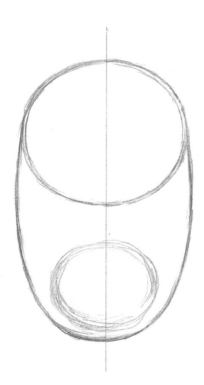

Now shift your position in relation to the glass so that you are looking at it from higher up. Draw the ellipses at the top and bottom, then check them by drawing a line down the centre. You'll notice this time that the ellipses are almost circular.

Shift your position once more, this time so that your eye level is lower. Seen from this angle the ellipses will be shallower. Draw them and then check your accuracy by drawing a line down the centre. If the left and right sides of your ellipses are mirror images, your drawing is correct.

You have to use the same discipline when drawing other circular-based objects. Here we have two different types of bottle: a wine bottle and a beer bottle. With these I want you to start considering the proportions in the height and width of the objects. An awareness of relative proportions within the shape of an object is very important if your drawings are to be accurate.

After outlining their shapes, measure them carefully. First, draw a line down the centre of each bottle. Next mark the height of the body of the bottle and the neck, then the width of the body and the width of the neck. Note the proportional difference between the width and the length.

The more practice at measuring you allow yourself, the more adept you will become at drawing the proportions of objects accurately. In time you will be able to assess proportions by eye, without the need for measuring. To provide you with a bit more practice, try to draw the following objects, all of which are based on a circular shape, although with slight variations and differing in depth.

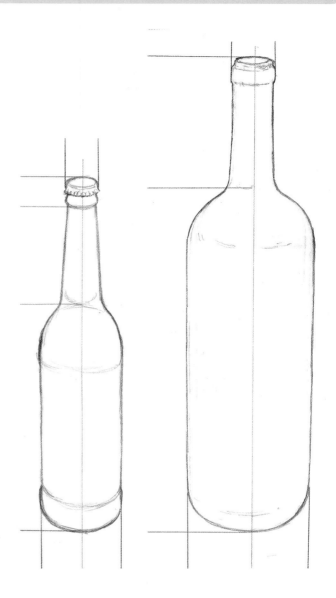

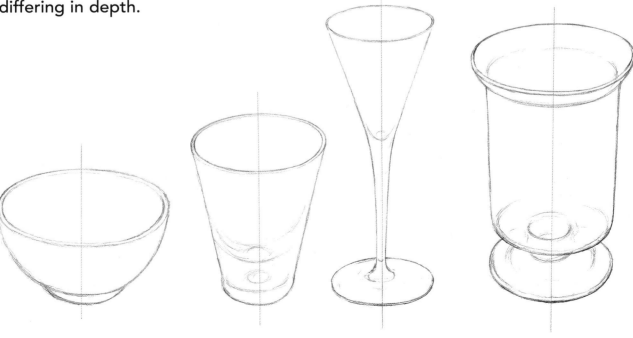

# Surface texture

Solid objects present a different challenge and can seem impossibly daunting after you have got used to drawing objects you can see through. When I encourage them to put pencil to paper, novice pupils often initially complain, 'But I can't see anything!' Not true. Solid objects have one important characteristic that could have been especially designed to help the artist out: surface texture. In the beginning you might find these practices a bit tricky, but if you persevere you will find them immensely rewarding.

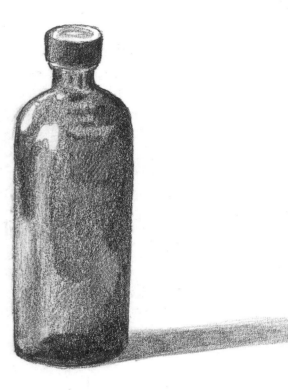

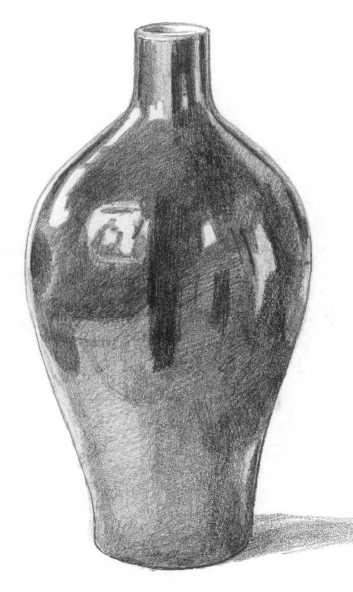

The two darkly glazed objects presented here appear almost black with bright highlights and reflections. Begin by putting in the outlines correctly, then try to put in the tones and reflections on the surface as carefully as you can. You will have to simplify at first to get the right look, but as you gain in confidence you will have a lot of fun putting in detailed depictions of the reflections.

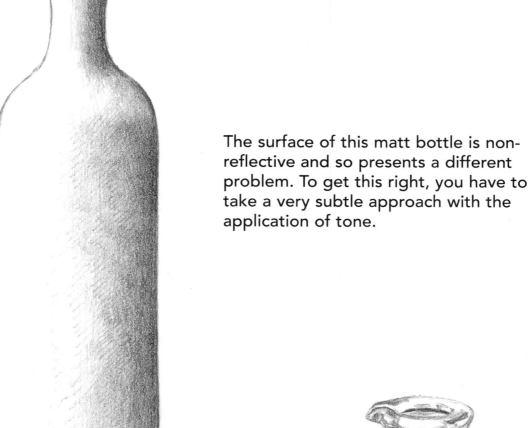

The surface of this matt bottle is non-reflective and so presents a different problem. To get this right, you have to take a very subtle approach with the application of tone.

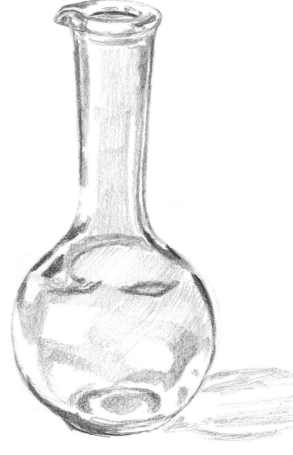

The problem with clear glass is how to make it look like glass. In this example the bright highlights help us in this respect, so put them in. Other indicators of the object's materiality are the dark tones, which give an effect of the thickness of the glass.

# Rectangular objects

Unlike some other types of drawing, you don't need to know a great deal about perspective to be able to produce competent still lifes. You will, however, find it useful to have a basic grasp of the fundamentals when you come to tackle rectangular objects.

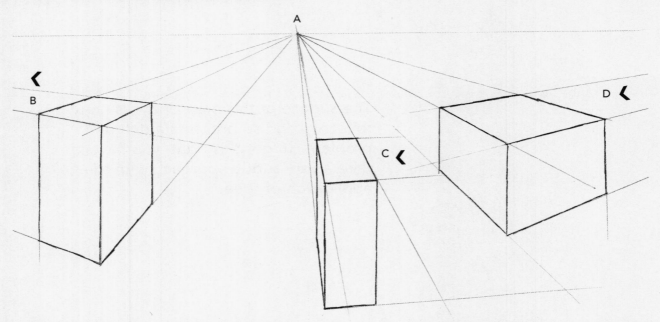

Perspective can be constructed very simply by using a couple of reference points: eye level (the horizontal line across the background) and (A) one-point perspective lines (where all the lines converge at the same point).

The perspective lines relating to the other sides of the object (B, C, D) would converge at a different point on the eye level. For the sake of simplicity at this stage, they are shown as relatively horizontal.

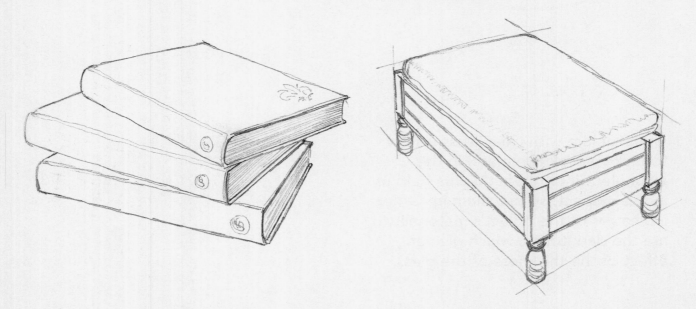

After studying the diagram, try to practise the basic principles of perspective by drawing a range of rectilinear objects. Don't be too ambitious. Begin with small pieces, such as books, cartons and small items of furniture.

You will find that different objects share perspectival similarities – in my selection, compare the footstool with the pile of books, and the chair with the carton.

The wicker basket and plastic toy box offer slightly more complicated rectangles than the blanket box. With these examples, when you have got the perspective right, don't forget to complete your drawing by capturing the effect of the different materials. Part of the fun with drawing box-like shapes comes in working out the relative evenness of the tones needed to help convince the viewer of the solidity of the forms. In these three examples, use tone to differentiate the lightest side from the darkest, and don't forget to draw in the cast shadow.

# Spherical objects

You shouldn't find it difficult to practise drawing spherical objects. Start by looking in your fruit bowl, and then scanning your home generally for likely candidates. I did this and came up with an interesting assortment. You will notice that the term 'spherical' covers a range of rounded shapes. Although broadly similar, none of the examples is identical. You will also find variations on the theme of surface texture. Spend time on these practices, concentrating on getting the shapes and the various textural characteristics right.

For our first practice, I chose an apple, an orange and a plum. Begin by carefully drawing in the basic shape of each fruit, then mark out the main areas of tone.

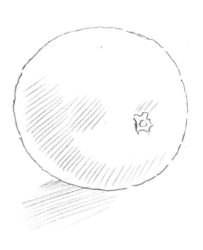

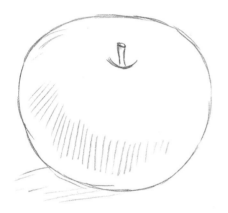

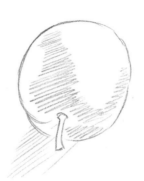

The orange requires a stippled or dotted effect to imitate the crinkly nature of the peel; see the basic patches of tone on page 14 for an example.

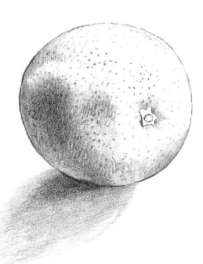

Take the lines of tone vertically round the shape of the apple, curving from top to bottom and radiating around the circumference. Gradually build up the tone in these areas. In all these examples, don't forget to draw the cast shadows.

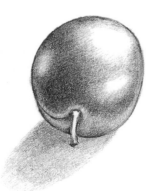

To capture the silky-smooth skin of a plum, you need an even application of tone and obvious highlights to denote the reflective quality of the surface.

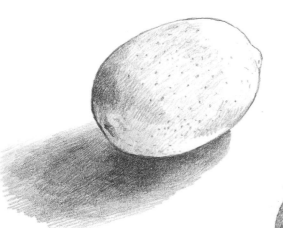

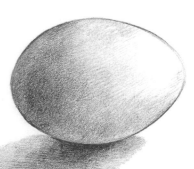

The surface of an egg, smooth but not shiny, presents a real test of expertise in even tonal shading.

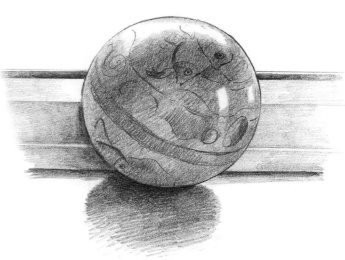

The texture of a lemon is similar to that of the orange. Its shape is longer, though.

The shading required for this round stone was similar to that used for the egg but with more pronounced pitting.

The perfect rounded form of this child's ball is sufficiently shiny to reflect the light from the window. Because the light is coming from behind, most of the surface of the object is in shadow; the highlights are evident across the top edge and to one side, where light is reflected in a couple of smaller areas. The spherical shape of the ball is accentuated by the pattern curving round the form.

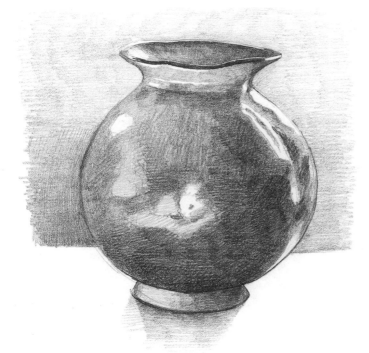

The texture of this hand-thrown pot is not uniform, and so the strongly contrasting dark and bright tones are not immediately recognizable as reflections of the surrounding area. The reflections on the surface have a slightly wobbly look.

# Introducing different media

Taking an object and drawing it in different types of media is a very useful practice when you are developing your skills in still life. The materials we use have a direct bearing on the impression we convey through our drawing. They also demand that we vary our technique to accommodate their special characteristics. For the first exercise, I have chosen a cup with a normal china glaze but in a dark colour.

Drawn in pencil, each tonal variation and the exact edges of the shape can be shown quite easily – once you are proficient, that is.

Attempt the same object with chalk (below), and you will find that you cannot capture the precise tonal variations quite so easily as you can with pencil. The coarser tone leaves us with the impression of a cup while showing more obviously the dimension or roundness of the shape. A quicker medium than pencil, chalk allows you to show the solidity of an object but not its finer details.

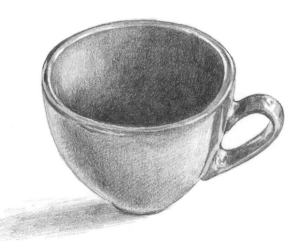

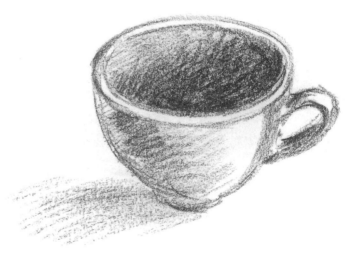

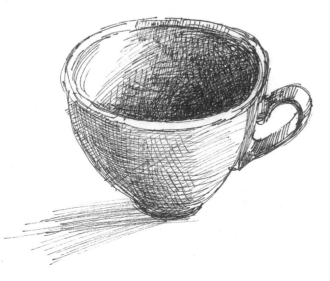

Although ink (left) allows you to be very precise, this is a handicap when you are trying to depict the texture of an object. The best approach is to opt for rather wobbly or imprecise sets of lines to describe both the shape and texture. Ink is more time-consuming than either pencil or chalk, but has the potential for giving a more dramatic result.

If you want to make what you are drawing unmistakable to the casual viewer, you will have to ensure that you select the right medium or media. Unfortunately for the beginner, in this respect the best result is sometimes achieved by using the most difficult method. This is certainly the case with our next trio, where wash and brush succeed in producing the sharp, contrasting tones we associate with glass.

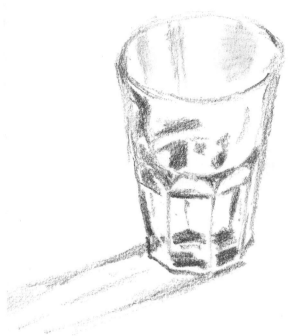

Although this example in chalk is effective in arresting our attention, it gives us just an impression of a glass tumbler.

The quality of the material is most strikingly caught with wash and brush, which produces hard, bright surfaces and the illusion of light coming from behind the object.

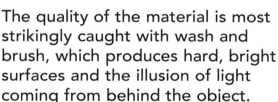

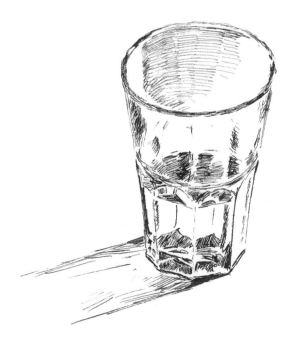

Pen and ink is a very definite medium to work in. Here it allows the crispness of the glass edges to show clearly, especially in the lower half of the drawing.

# Exploring Textures

Once you have begun the process of mastering the drawing of the shapes of various objects, you have to turn your attention to showing the different qualities of the materials that they are made of.

The ability to differentiate between textures in one picture and to give a sense of the feel of the objects you draw is a skill that you must develop if you want to produce good work in the still-life genre. In this section you will find practice exercises to help your development, starting with simple textures and gradually introducing more complex examples.

Don't forget that what you are doing is in fact making marks on the paper with pencil, pen or brush. Given that fact, the whole solution to producing the effects of the texture of the material of the objects' surface is in the manipulation of the marks you are going to make. You are not drawing cloth, fur or glass; you are drawing lines or dots or patches of tone which, if placed together in an artistic way, will convince the eye that the object drawn is indeed made of that substance. What you need to consider is only the arrangement of the marks you make and their intensity or tone.

## Textiles

The best way to understand the qualities of different textures is to look at a range of them. We'll begin by examining different kinds of textiles: silk, wool and cotton. The key with each example is the way the folds of cloth drape and wrinkle. You will need to look carefully too at the way the light and shade fall and reflect across the folds of the material, because these will tell you about the more subtle qualities of the surface texture.

A silk handkerchief which, apart from a couple of ironed creases in it, shows several smooth folds and small undulations. The tonal qualities show contrasts between light and dark, and the bright areas ripple with small patches of tone to indicate the smaller undulations. We get a sense of the material's flimsiness from the hem and the pattern of stitched lines.

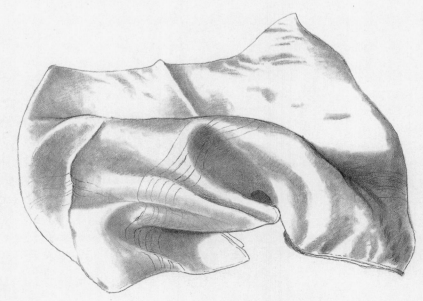

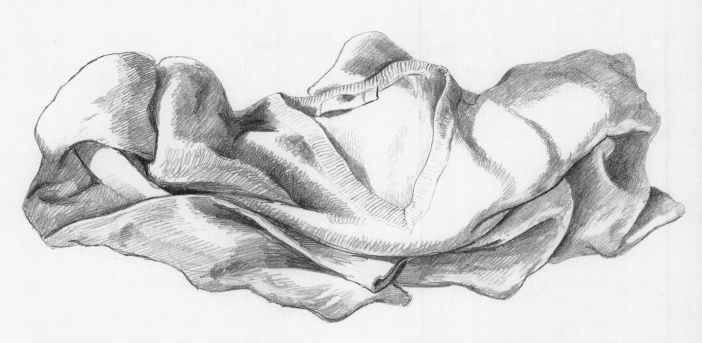

The folds in this woolly jumper are soft and large. There are no sharp creases to speak of. Where the previous example was smooth and light, the texture here is coarser and heavier. The showing of the neckline with its ribbed pattern helps to convince the eye of the kind of texture we are looking at.

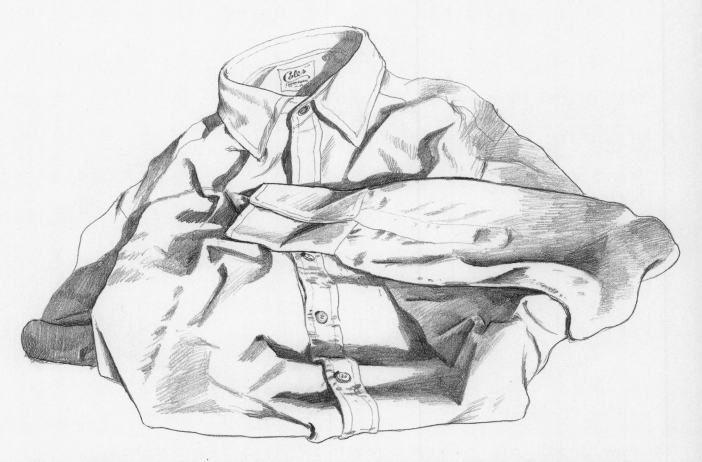

This well-tailored cotton shirt is cut to create a certain shape. The construction of the fabric produces a series of overlapping folds. The collar and the buttoned fly-front give some structure to the otherwise softly folded material.

A deck shoe in soft leather, with soft edges and creases across the toe area, has none of the high shine of formal shoes. The contrast between the dark inside of the shoe and the lighter tones of the outside help to define the overall texture.

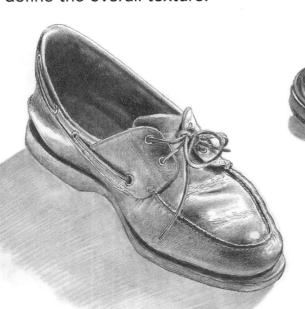

The shiny black surface of patent leather reflects a lot of light and gives off a rather watery effect.

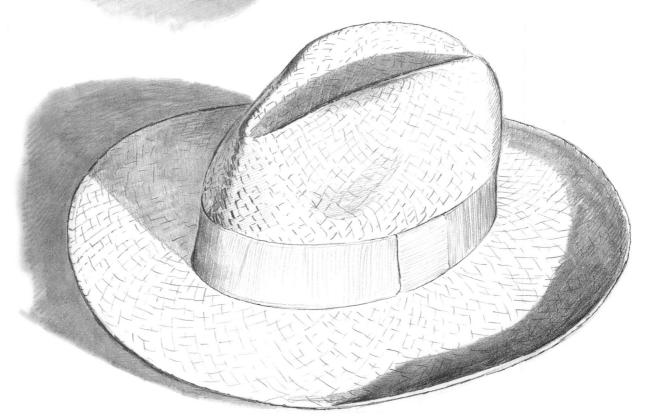

A straw hat produces a clear-cut form with definite shadows that show the shape of the object clearly. The texture of the straw, woven across the structure, is very distinctive. Well-worn hats of this kind tend to disintegrate in a very characteristic way, with broken bits of straw disrupting the smooth line.

# Exercise with paper

Now we have a look at something completely different. In the days when still-life painting was taught in art schools, the tutor would screw up a sheet of paper, throw it onto a table lit by a single source of light, and say, 'Draw that.' Confused by the challenge, many students were inclined to reject it. In fact, it is not as difficult as it looks. Part of the solution to the problem posed by this exercise is to think about what you are looking at. Soon you will realize that although you have to try to follow all the creases and facets, it really doesn't matter if you do not draw the shape precisely or miss out one or two creases. The point is to make your drawing look like crumpled paper, not necessarily achieve an exact copy.

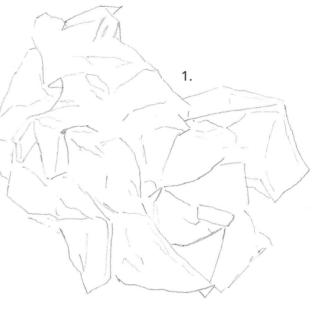

1. Draw the lines or folds in the paper, paying attention to getting the sharp edges of the creases.

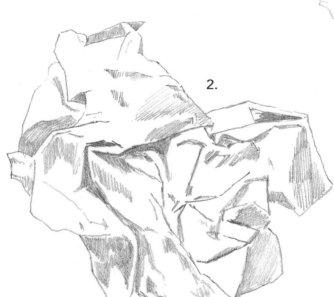

2. Put in the main areas of tone.

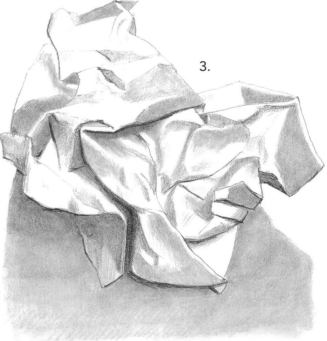

3. Once you have covered each tonal area, put in any deeper shadows, capturing the contrasts between these areas.

# Glass

Glass is a great favourite with still-life artists because at first glance it looks almost impossible to draw. All the beginner needs to remember is to draw what it is that can be seen behind or through the object. The object is to differentiate between the parts that you can see through the object and the reflections that stop you seeing straight through it. You will find that some areas are very dark and others very bright and often close up against each other. The highlights reflect the brightest light, and whatever is behind the glass is a sort of basis for all the brighter reflections.

Make sure that you get the outside shape correct. When you come to put in the reflections, you can always simplify them a bit. This approach is often more effective than over-elaborating.

1.

1. Draw the outline of this glass as carefully as you can. The delicacy of this kind of object demands increased precision in this respect.

2.

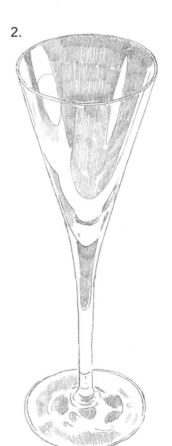

2. When you are satisfied you have the right shape, put in the main shapes of the tonal areas, in one tone only, leaving the lighter areas clear.

3.

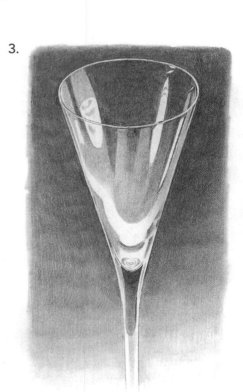

3. Finally, put in the darkest tones quite strongly. Each of these three drawings should inform anyone seeing them very precisely about the object and its materiality.

# Metal

Now we look at metal objects. First we have a silver candlestick, which gives some idea of the problems of drawing metallic surfaces. There is a lot of reflection in this particular object because it is highly polished, so the contrast between dark and light tends to be at the maximum. With less polished metalware, the contrast won't be so strong.

A silver candlestick does not have a large area of surface to reflect from. Nevertheless, the rich contrast of dark and light tones gives a very clear idea of how metal appears. Silver produces a softer gleam than harder metals. Note how within the darker tones there are many in-between tones and how these help to create the bright, gleaming surface of our example.

Take your time with this sort of object. It requires quite a bit of dedication to draw all the tonal shapes correctly, but the result is worth it. Your aim must be for viewers to have no doubt about the object's materiality when you have completed the drawing.

This battered old watering can is made of galvanized metal and has a hammered texture and many large dents. The large areas of dark and light tone are especially important in giving a sense of the rugged texture of this workaday object. No area should shine too brightly, otherwise the surface will appear too smooth.

## Contrasting textures

If we succeed in capturing an object's surface, it is very likely we will also manage to convey its presence. Our two manufactured objects – a glazed vase and a teddy bear – offer different types of solidity, while the range of plants shown on the facing page test our ability to describe visually the fragility of living matter. The artist should always aim to alter their approach to suit the materiality of the object they are drawing.

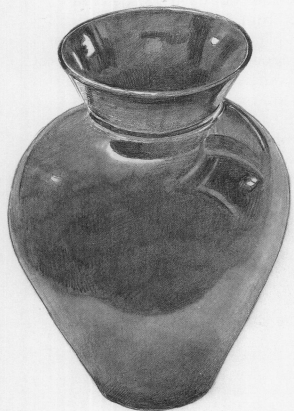

The effects produced by the brilliant glaze on this rather beautiful vase are not so difficult to draw. The reflections are strong and full of contrast, giving us glimpses of the light coming through surrounding windows. They do not, however – as is the case with metallic objects – break the surface into many strips of dark and light; check this difference for yourself by looking at the objects shown on page 41.

Teddy bears are very attractive to young children, and Paddington Bear is particularly so because of the many stories told about him. This particular soft toy incorporates various textures and qualities: the cuddly softness of the character himself, the shiny softness of the plastic boots, the hardness of the wooden toggles and the rather starchy material of the floppy hat and duffle coat.

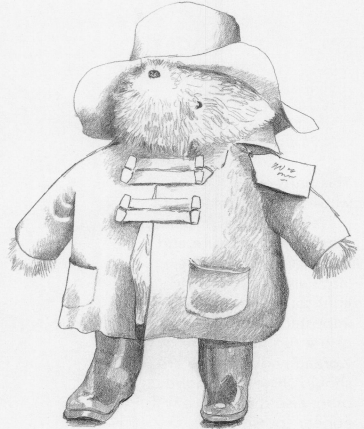

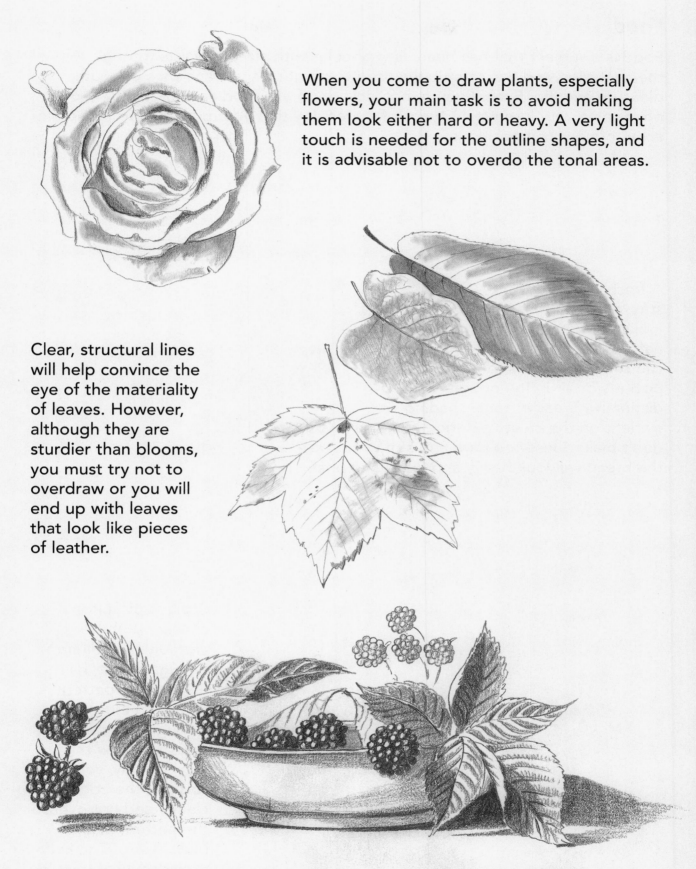

When you come to draw plants, especially flowers, your main task is to avoid making them look either hard or heavy. A very light touch is needed for the outline shapes, and it is advisable not to overdo the tonal areas.

Clear, structural lines will help convince the eye of the materiality of leaves. However, although they are sturdier than blooms, you must try not to overdraw or you will end up with leaves that look like pieces of leather.

The shiny, dark globes of the blackberries and the strong, structural veins of the pointed leaves make a nice contrast. The berries are just dark and bright, whereas the leaves have some mid-tones that accentuate the ribbed texture and jagged edges.

# Food

Food is a subject that has been very popular with still-life artists through the centuries, and has often been used to point up the transience of youth, pleasure and life. Even if you're not inclined to use food as a metaphor, it does offer some very interesting types of materiality that you might like to include in some of your compositions.

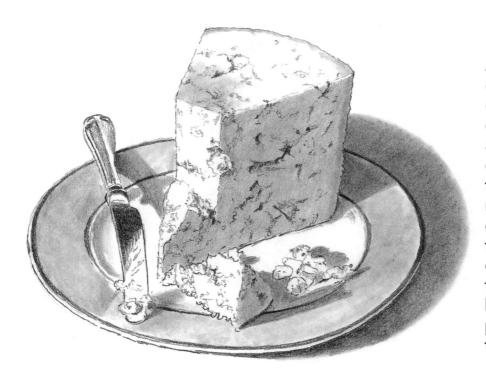

A freshly baked stick of bread that looks good enough to eat. Where it is broken, you can see the hollows formed by pockets of air in the dough. Other distinctive areas of tonal shading are evident on the crusty exterior. Make sure you don't make these too dark and stiff, otherwise the bread will look heavy and lose its appeal.

A piece of Stilton cheese, slightly crumbly but still firm enough to cut, has an amazing pattern of veined blue areas through the creamy mass. To draw this convincingly, you need to show the edge clearly and not overdo the pattern of the bluish veins. The knife provides a contrast in texture to the cheese.

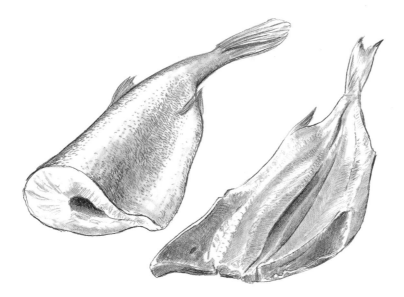

Two views of fish with contrasting textures: scaly outer skin with bright reflections, and glistening interior flesh. Both shapes are characteristic, but it is the textures that convey the feel of the subject to the viewer.

This large cut of meat shows firm, whitish fat and warm-looking lean meat in the centre. Although the contrast between these two areas is almost enough to give the full effect, it is worth putting in the small fissures and lines of sinew that sometimes pattern and divide pieces of meat.

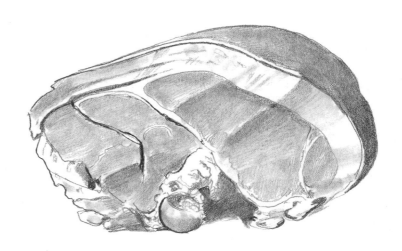

A marked contrast in textures, with a plump chicken appearing soft against the grained surface of a wooden chopping board. Careful dabbing with a pointed bit of kneadable eraser has given a realistic goose-bump look to darker areas of the chicken's skin and where there are shadows.

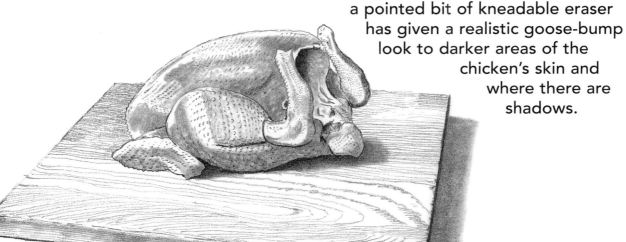

# Combining Objects

When you have worked hard at getting the individual objects accurately drawn and giving some idea of their texture, you are ready to start the process of setting up a complete still-life group. There are no rules for this, just myriad approaches. One of the best methods of learning is to look at the works of other artists and to understand approaches that might work for you.

Begin by drawing fairly simple arrangements. Don't spread your objects out too much. Concentrate on seeing how a series of overlapping shapes can build a different overall shape. Try out contrasting materials to see how they alter the look of your picture. It is great fun to try different combinations of shapes or to experiment with harmonizing shapes where all the objects are similar. Take your time, avoiding the temptation to get too complicated too early. If you do become overambitious, you will only end up frustrating yourself and becoming disillusioned. Take things slowly, and enjoy the process.

With experience will come the ability to see arrangements that have come about by chance. Like most artists, you will have to be satisfied with making arrangements. But do notice the accidental ones because these will inform your own arrangements, and have a good time playing with these.

## Approaches

Once you reach this stage in your learning process, the actual drawing of individual objects becomes secondary to the business of arranging their multifarious shapes into interesting groups. Many approaches can be used, but if you are doing this for the first time it is advisable to start with the most simple and obvious.

Put together three or four objects of the same type and roughly similar size. Place them close together. The effect, especially if you place them against a neutral background, is a harmonious arrangement of closely related shapes.

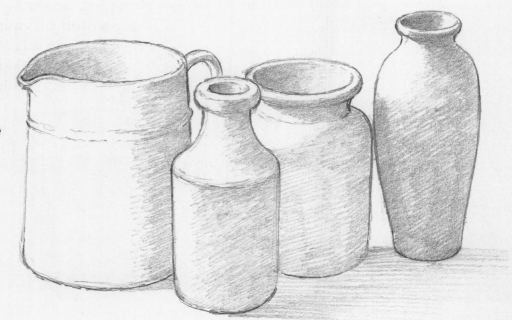

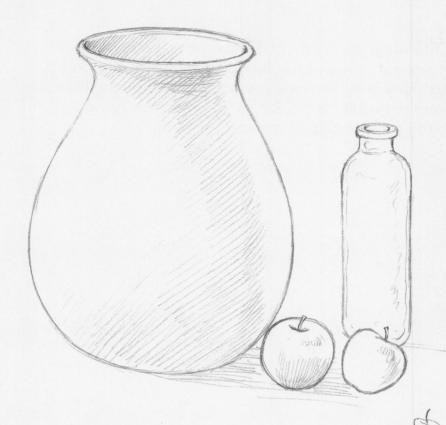

Now try the opposite. Find several objects that contrast radically in size and shape: something large and bulky, something small and neat, and something tall and slim.

Contrast is the point of this combination, so when considering the background, go for a contrast in tone.

Another version of this approach is combining a tall, spindly object with a solid, flat object. The candlestick and book shown in our example are obvious contrasts. Neither object by itself would work well as a composition.

# Multiple objects

Here, we are going to play the numbers game and show how the number of objects included in an arrangement changes the feel or dynamic of the group. The aim of this exercise is to show how you can slowly build up your still-life composition if you try drawing them bit by bit. By adding more as you go along, you will begin to see the possibilities of the composition.

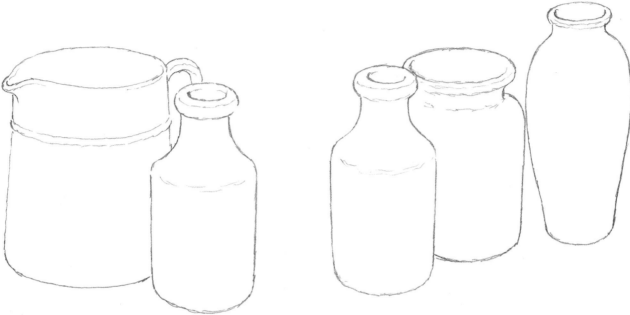

Two's company ...

Three's not quite a crowd ...

Now try four, choosing variety over conformity and varying sizes and shapes: mix curves and straight lines, large and bulky, small and slim.

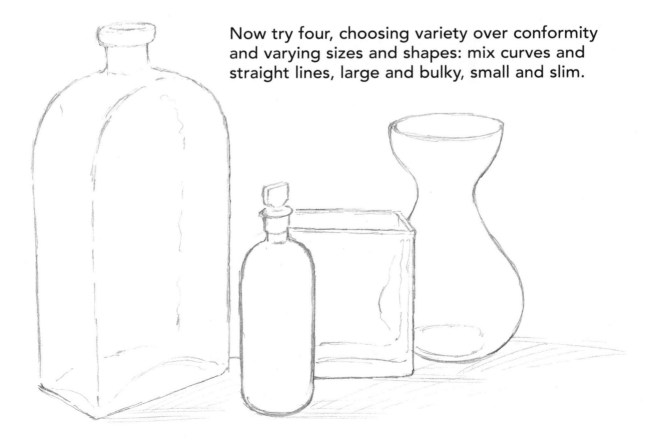

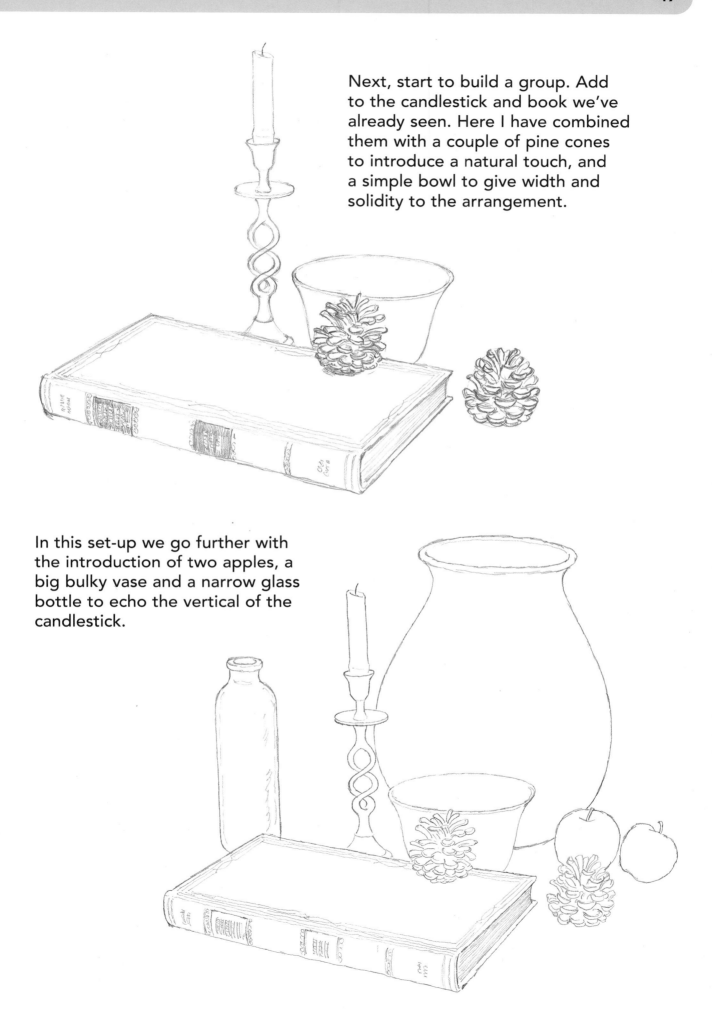

Next, start to build a group. Add to the candlestick and book we've already seen. Here I have combined them with a couple of pine cones to introduce a natural touch, and a simple bowl to give width and solidity to the arrangement.

In this set-up we go further with the introduction of two apples, a big bulky vase and a narrow glass bottle to echo the vertical of the candlestick.

# Measuring up

One of your first concerns when you are combining objects for composition will be to note the width, height and depth of your arrangement, since these will define the format and therefore the character of the picture that you draw. The outlines shown below – all of which are after works by masters of still-life composition – provide typical examples of arrangements where different decisions have been made.

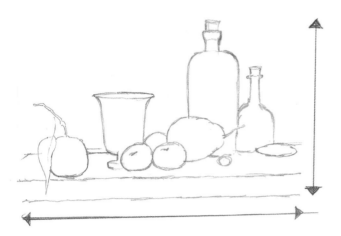

In our first example (after Chardin), the width is greater than the height, and there is not much depth.

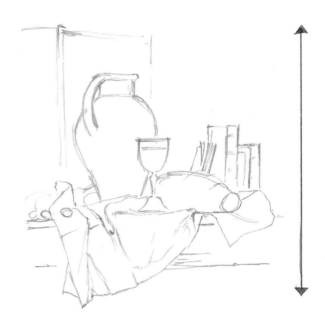

The height is the dominant factor in our second example (also after Chardin). The lack of depth gives the design a pronounced vertical thrust.

In his original, Francisco Zurburán put the emphasis solely on width. The objects, which divide neatly into three sub-groups, align themselves across our view horizontally, allowing us to take in one sub-group at a time, or all three simultaneously.

Now for something entirely different, this time after Samuel van Hoogstraten. This sort of still life was a great favourite in the 17th and 18th centuries, when it provided both a showcase for an artist's brilliance and a topic of conversation for the possessor's guests.

Almost all the depth in the picture has been sacrificed to achieve what is known as a 'trompe l'oeil' effect, meaning 'deception of the eye'. The idea was to fix quite flat objects to a pin-board, draw them as precisely as possible and hope to fool people into believing them to be real.

Depth is required to make this kind of arrangement work (after Osias Beert). Our eye is taken into the picture by the effect of the receding table-top, the setting of one plate behind another, and the way some of the objects gleam out of the background.

# Framing

Every arrangement includes an area that surrounds the group of objects you are drawing. How much is included of what lies beyond the principal elements is up to the individual artist and the effect that they are trying to achieve. Here, we consider three different 'framings', where varying amounts of space are allowed around the objects.

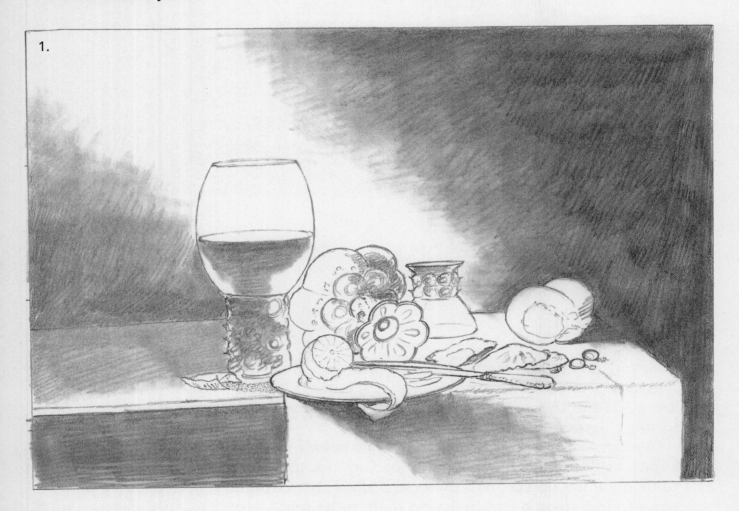

1.

1. A large area of space above the main area, with some to the side and also below the level of the table. This treatment seems to put distance between the viewer and the subject matter.

2. The composition is made to look crowded by cropping into the edges of the arrangement.

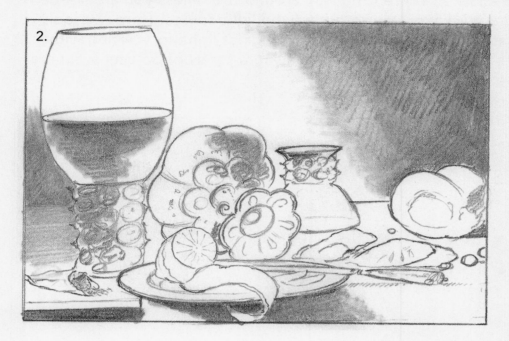

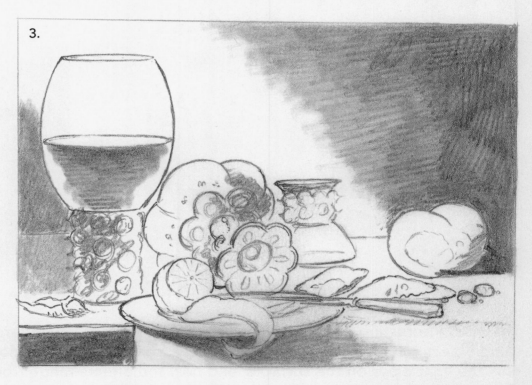

3. This is the framing actually chosen by the artist Willem Claesz. The space allowed above and to the sides of the arrangement is just enough to give an uncluttered view and yet not so much that it gives a sense of the objects being left alienated in the middle of an empty space.

# Lighting

The quality and nature of the light with which you work will have a large bearing on your finished drawing. A drawing can easily be ruined if you start it in one light and finish it in another. There is no way around this unless you are adept enough to work very quickly or you set up a fixed light source. Here, we look at the visual implications of adopting different kinds of lighting, starting with the range of effects that you can obtain by placing a series of objects around a single source of even light.

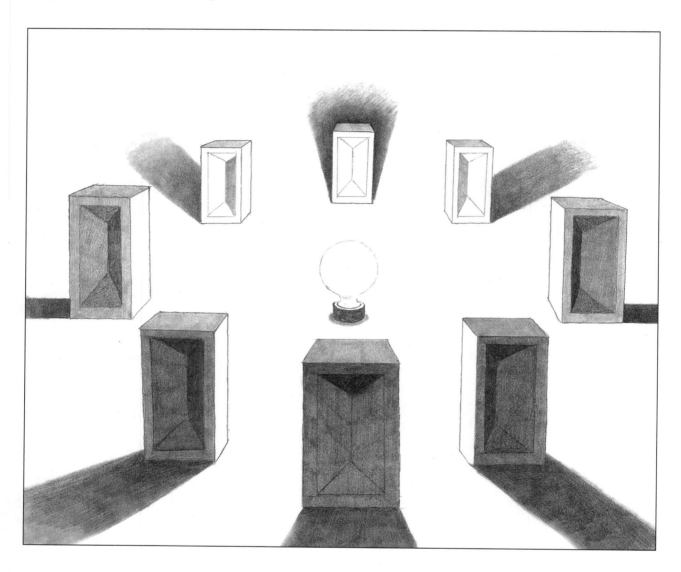

The most interesting point to take from this exercise is how different the same object can look when light shines on it from different positions. Note how the light plays on the surfaces, and how the effects range from a total absence of shadow to complete shadow, depending on the position of each object in relation to the light. In each case, the cast shadow appears to anchor the brick to the surface it is resting on, an effect that is often usefully employed by artists to give atmosphere to their drawings.

Here we show the same three objects arranged in the same way in different lighting versions. Each one also shows the nature of the lighting, in this case an anglepoise lamp with a strong light which shows the direction that the light is coming from.

1. These three pots are lit entirely from the front – the light is coming from in front of the artist. The shadows are behind the pots and the impression is of flatter shapes.

2. Here the light is right behind the objects. Therefore the pots look dark with slivers of light around the edges. Except for the circle of the lamp, the background is dark.

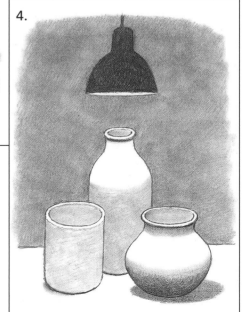

3. Lighting from one side gives the best impression of the three-dimensional quality of the pots. The cast shadows and the areas of shadow on the pots both help to define their roundness.

4. Lighting from above is similar to side lighting but the cast shadows are smaller and the shadow on the pots is, on the whole, less obvious.

# Themes and Composition

When still life becomes more practical, it is time to start considering what sort of picture you want to draw. Some of the most suitable objects in terms of contrast of shape and texture are the everyday items connected with eating, such as utensils, crockery and cutlery. These can be turned into a theme, taking the idea of the preparation of a meal or a table laid. Any such day-to-day activity can become your theme. Getting dressed, for example, could be shown by an array of clothes half-folded and half-strewn across a bed, or hanging on doors or chairbacks.

All the normal activities of everyday existence tend to have objects that relate to them and can therefore represent them. Grouping these objects together reminds people of the activity, and so there will be an immediate emotional response in the onlooker as a result of the association of ideas.

Start with things you know most about, as you will be familiar with the forms of the objects and will invest them with your own emotional response. Then, once you have completed two or three of these types of still-life compositions, have a go at ones that you are less familiar with. It all adds specific interest to your pictures, both for you and the person who views them.

## Food and drink

We start with a popular form of still-life drawing – food and drink. The traditional pictures of this subject often show food ready for the preparation of a meal, rather than the completed dish. This has the effect of creating a more dynamic picture.

This classic 17th-century still life by the Italian artist Carlo Magini shows the basic preparation of a dish. Note the balance achieved between the man-made objects and the food. The hardware is towards the back of the kitchen table and the food is at the front.

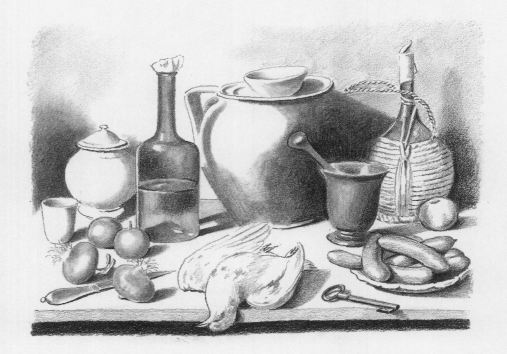

This still life by Italian artist Filippo de Pisis (1896–1956) is simpler and is drawn in a looser, more impressionistic way. Here, the intention of a 20th-century artist is to create a feeling of light glancing off the ingredients of an arrangement of apples and a melon slice.

This is an accidental still life come upon by chance in my own kitchen, where a few apples put down on a marble slab were backed by a bottle of water, a bottle of wine and a roll of kitchen towel. The formality of the composition caught my eye and I drew it quickly before it became disarranged.

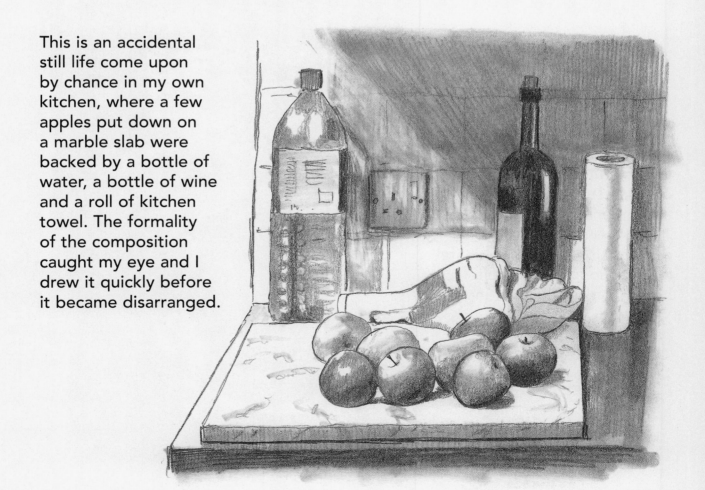

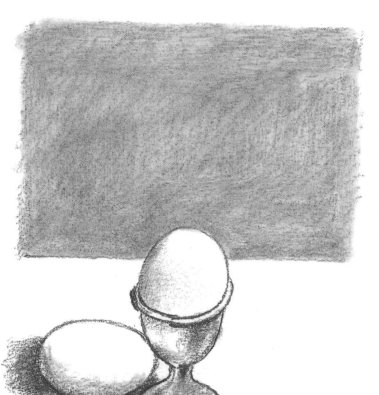

This very simple example by the Italian artist Renato Guttuso (1912–87) shows just two eggs and an egg cup. The arrangement of the eggs on a surface with the curve of the egg in the egg cup jutting up into the background tone of the far wall makes a very abstract and tightly perfect design.

This second piece by Guttuso shows a tin can, a packet of cigarettes and an egg in a fragment of pottery dish. The rather unorganized composition has an accidental look, although it might in fact have been carefully arranged.

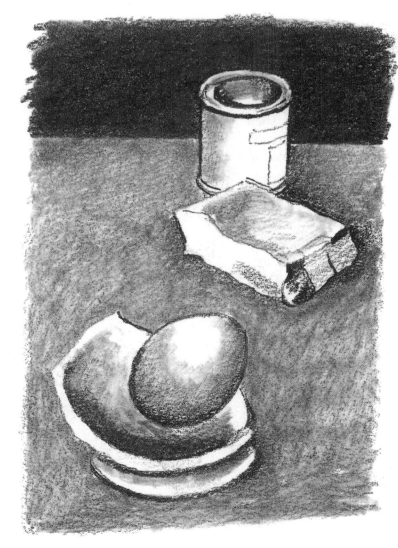

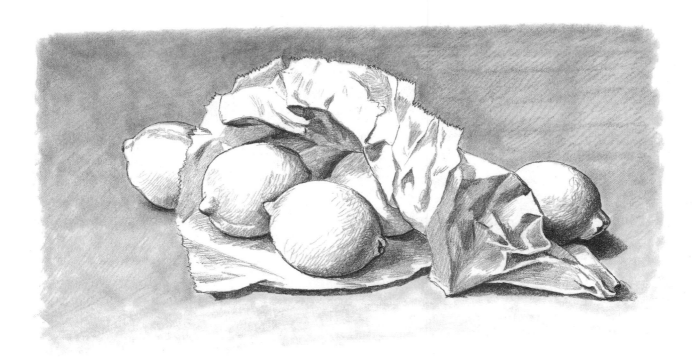

This picture of a few lemons spilled out of a crumpled paper bag has a simplicity and elegance that the British artist Eliot Hodgkin (1905–87) has caught well. Again, it looks quite a random arrangement but may well have been carefully placed to get the right effect. Whichever the case may be, it is a very satisfying, simple composition.

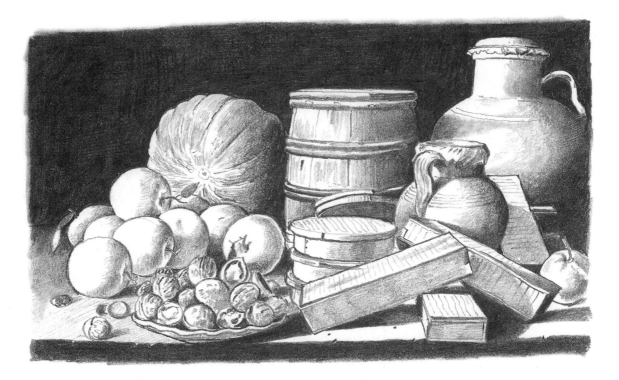

Conversely, this beautiful piece by the famous Spanish artist Luis Meléndez (1716–80) is a full and even crowded arrangement, but because of its simple workaday subject matter, it gives a very solid and complete-looking group of objects. The pots, packets and loose fruits and nuts both contrast and harmonize with each other at the same time.

# Bringing It All Together

Now we come to the last stage of this chapter, which is to practise doing a complete still life from the very first thoughts to the finished picture.

The first challenge is always to choose the objects, and this can be done in different ways. You might want to create a theme, or you might want to use objects which to you represent some form of beauty – either of shape or texture – and which would produce a satisfying effect when placed together.

There are plenty of approaches to try, but in this particular exercise we shall use a much simpler method and choose only objects that can be easily found around the home. This means that you may put quite different things together, but they will all be accessible. When you have got some idea about what is available, you can begin to consider the final picture. Do you want something sprawling, or something tightly composed? Do you require a large space around your arrangement, or will you set it to one side of the picture? What about the depth of the picture? Do you like to see everything grouped closely together, or would more contrast between further and nearer objects be more to your taste? Finally, you will have to consider how the picture is lit. With all those decisions made, you will be ready to start.

## Find your objects

First, make a selection of some objects that both appeal to your eye and are sufficiently varied to give you the possibility of creating interesting arrangements. Look around for things that you will not need to use in your day-to-day life during the period that you are drawing them. It is awkward if you are drawing your still life and suddenly the saucepan right in the middle of your picture has to be used to cook lunch, for example.

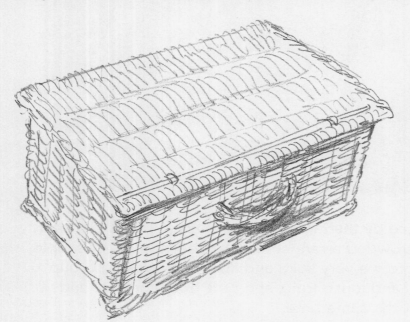

I began by deciding that I wanted some large objects as well as smaller ones, and the first thing I liked the look of was a wicker hamper that my wife uses for storage.

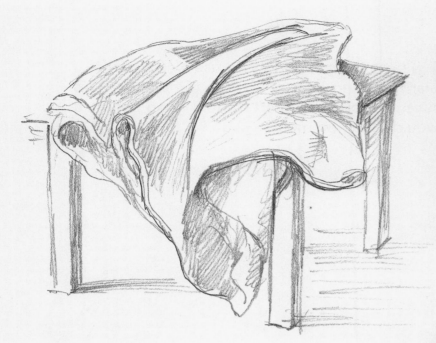

I then thought that a piece of cloth could be useful for adding interesting texture to the arrangement and could also act as a joining element between one item and another, so I found a long tablecloth. It is drawn here on a small side table that might also be used in the picture.

Next, I went for a large curved pot which would give some height to the composition.

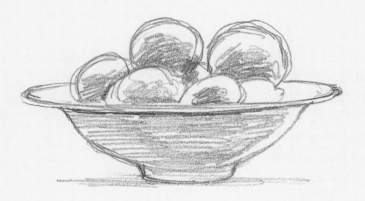

I decided that it would be nice to have something perishable in the picture, so I chose a bowl of oranges and lemons that was on the sideboard.

Everything that I selected so far was quite solid in substance, so I found a rounded glass jug which would add a certain brilliance and transparency to any arrangement.

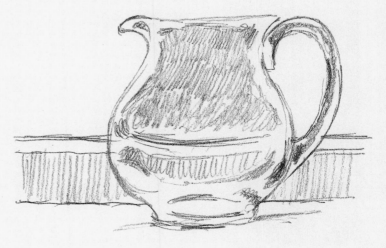

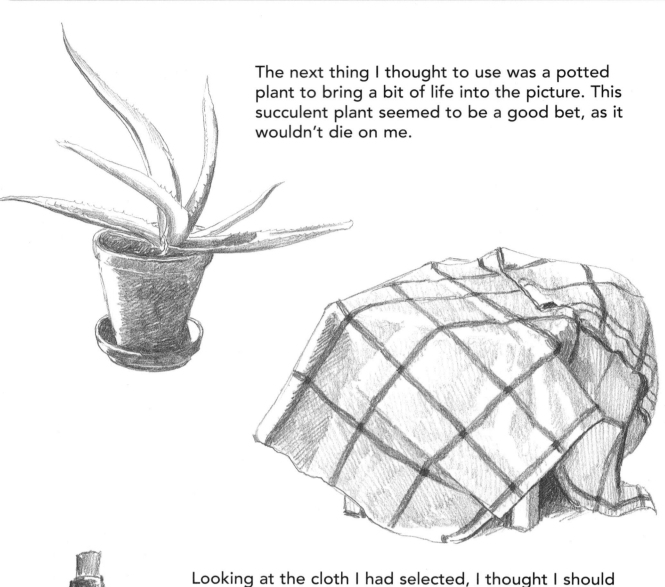

The next thing I thought to use was a potted plant to bring a bit of life into the picture. This succulent plant seemed to be a good bet, as it wouldn't die on me.

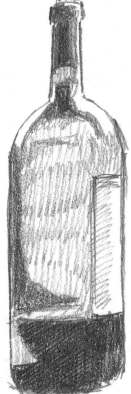

Looking at the cloth I had selected, I thought I should have an alternative, so I found a large check tablecloth that would give me another effective prop. A half-finished bottle of red wine and a large, oddly shaped empty glass bottle were the next objects that I considered for the composition.

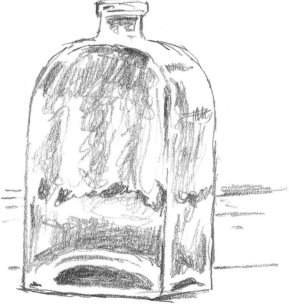

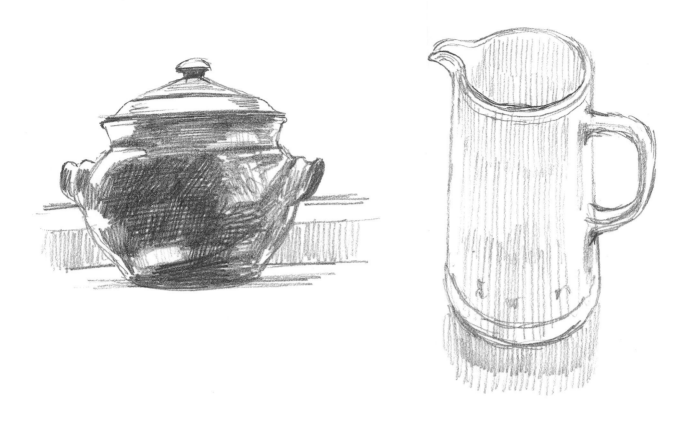

I then spotted a heavy casserole with a lid, a tall white jug, a large pottery jug and a glass bowl, all of which looked interesting in their shapes and texture. By now I had collected together a good selection of objects, which I would later have to go through in order to whittle them down to the final ones for the finished composition.

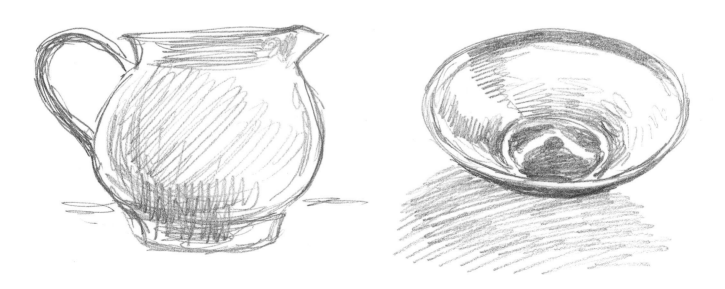

# How to light your objects

Whatever your still-life arrangement is, there will always be the problem of how the objects within it are lit. There are many ways of doing this, using artificial and natural light. Here we look at just two solutions, but many more variations are possible.

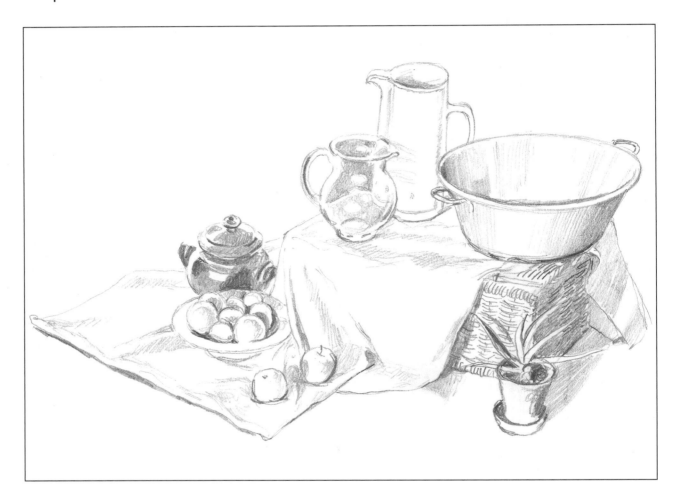

Now is the time to consider lighting. How would I like my arrangement to look? I placed a few of the objects around and on the hamper in such a position that the light from the windows lit up the arrangement very brightly. The rather flat front lighting gives a very clear view of the various shapes of the objects.

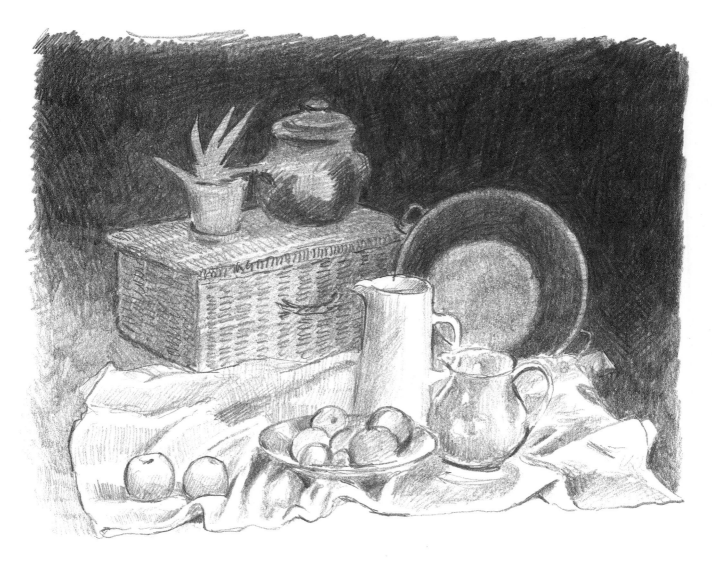

Then I rearranged them against a darker background and put several of the objects well back into the gloom of the space. Only the objects to the front of the composition were well lit, which gave a lot more drama to the picture.

# Try different viewpoints

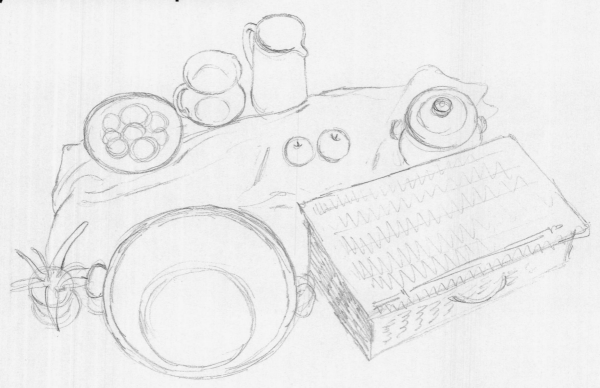

Next, I laid out the objects in a loose arrangement on the floor to see what they would look like seen from a higher eye level. Looking down on the objects, it was almost possible to draw them like a map. So did I want this high-level view?

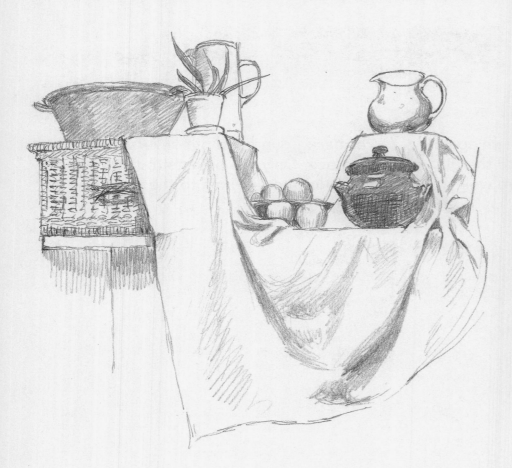

I then had to try the alternative – a low-level view where I would have to look up at all the objects to draw them. So I put them all on a table and sat down on the floor to see the effect. From this position, the composition took on a monumental quality.

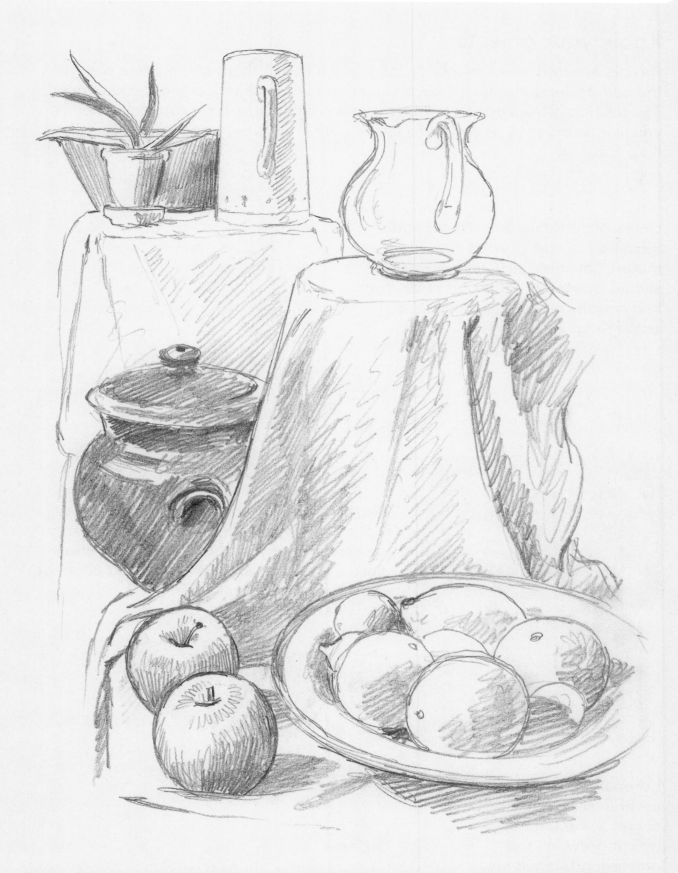

Next, I rearranged the objects and walked round them until from one side I got this view of them partly at my eye level and partly below it, which gives an interesting effect and also draws the eye into the picture more easily.

# Know your objects

Having selected your objects, found a place to put them and made a plan for the composition, the next step is to understand each object more thoroughly. The best possible way to do this is to draw them separately as many times as you like, in order to really get to know them. This is very good practice for the final drawing.

Drape a cloth over something and observe the sort of folds that the material makes. Each kind of material should be studied; this particular cloth had soft, heavy folds with creases showing up in it.

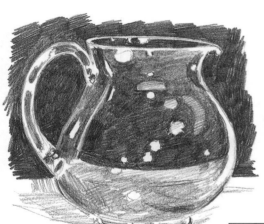

The glass jug had a quality of transparency and was highly reflective. It was not as easy to draw as the cloth, but trying it out soon gave a good idea of how this object could be effective in the final still life.

I drew the plant from several views in order to get some idea of how it grew. As the only living thing in my composition, it was probably the most subtle object.

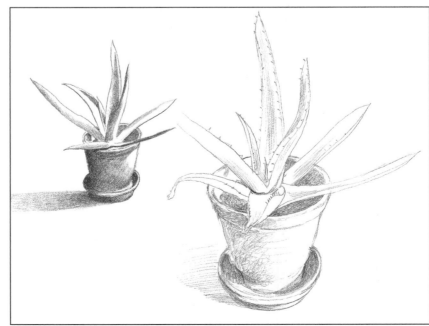

The main thing about drawing the heavy pot was to get the effect of its roundness and bulk. This required a bit of practice so that I could get the shape drawn in swift movements of my pencil without pausing.

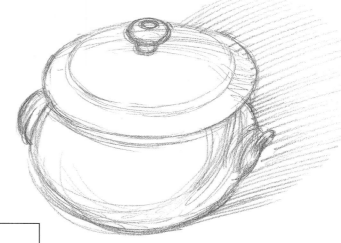

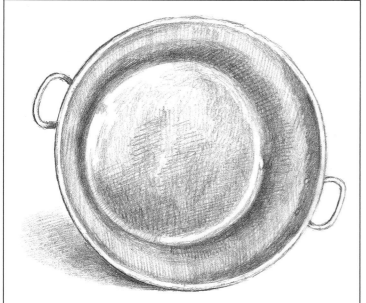

The copper pan had both reflectiveness and solidity, and I decided that I would like to look inside it, so it required support from behind with a stool or box in order to display the shinier interior. The round shape also was a good, large form to place behind other things.

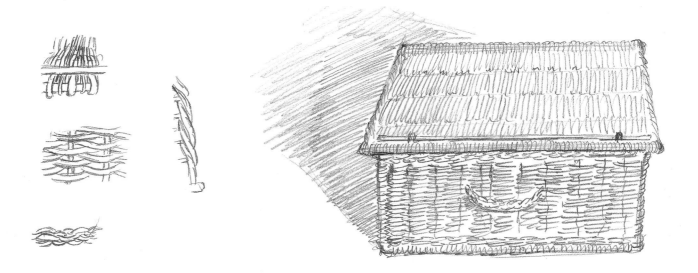

The wickerwork hamper was a nice straightforward shape, but its texture was harder to draw. I made some studies of the way that the pieces of wickerwork were interwoven, especially round the edges and the handle.

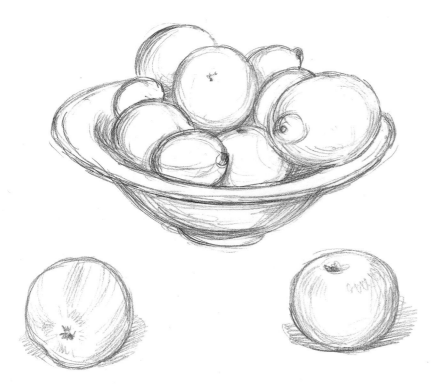

The bowl of oranges and lemons and the apples basically called for the same treatment. I drew them rapidly with unbroken lines until I had got the feel of their shapes and how they lay against each other.

I drew the tall white jug with its edge pattern from different angles until I had decided which angle suited my composition best.

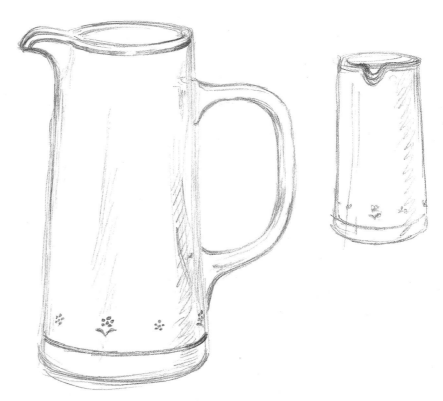

# A rough composition

With everything else resolved, I had to put together my final idea for the composition of my picture. Here I have drawn a very rough composition of the arrangement of all these different objects that I decided I liked best of all. I settled upon the angle of the light and what sort of background the composition should have.

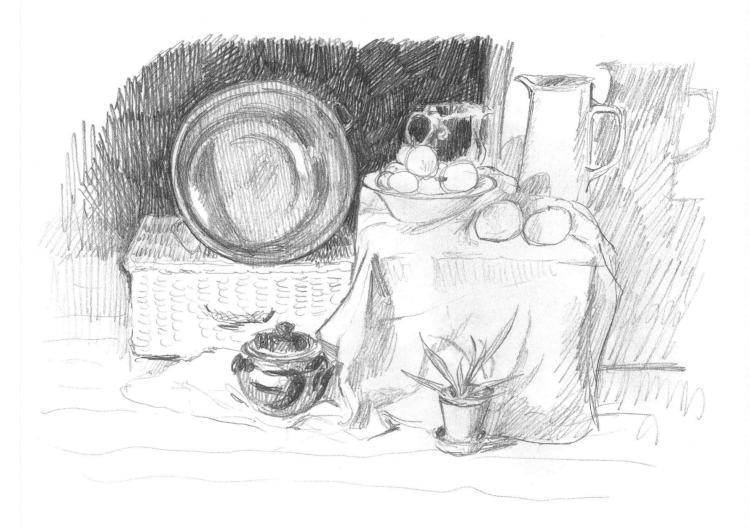

Here I have the light coming from the left, fairly low and casting a shadow on some of the objects on the side wall. Behind the main part of the composition is the darkness of the room behind, so the arrangement is well lit but against a dark space. I covered the side table with the cloth but allowed the jug and bowl of fruit to rumple it up a little. The heavy dark pot and the spiky plant are at the base of the foreground. The hamper and the large copper pan act like a backdrop on the left-hand side.

# Outline drawing

Having decided on my arrangement and made a fairly quick sketch of it, I now knew what I was going to do. The first thing I needed to establish was the relative positions and shapes of all the articles in the picture, so I made a very careful line drawing of the whole arrangement, with much correcting and erasing to get the accuracy I wished to convey in the final picture. You could of course use a looser kind of drawing, but for this exercise I was being very precise in getting all the shapes right and their dispositions carefully related. This is your key drawing upon which everything depends, so take your time to get it right. Each time you correct your mistakes, you are learning a valuable lesson about drawing.

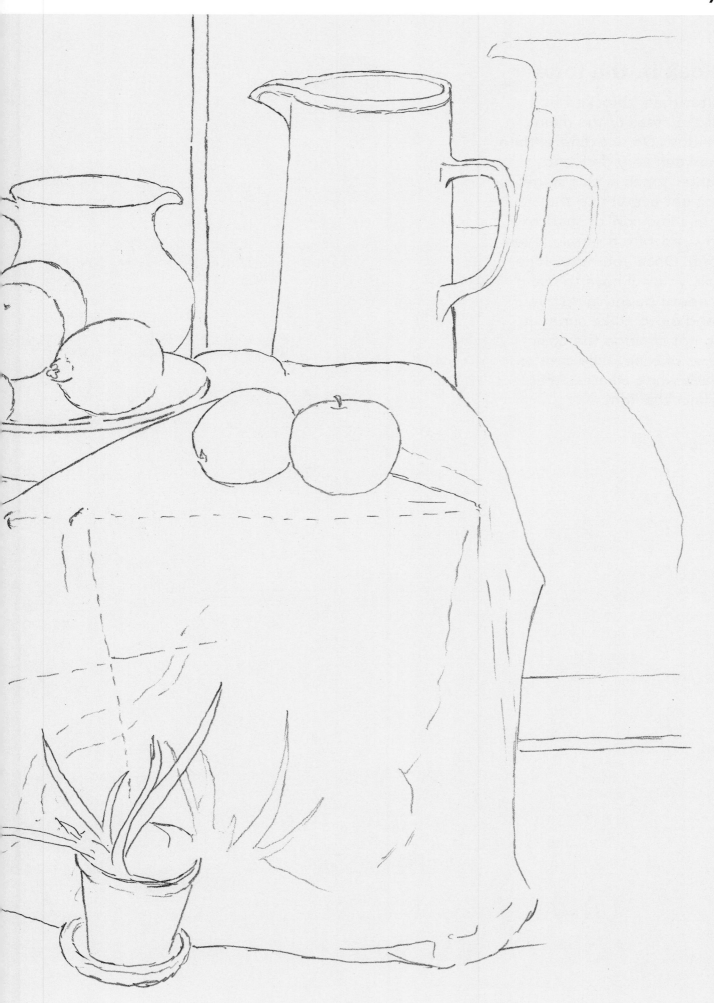

## Block in the tone

After that, I blocked in all the areas of the main shadow. Do not differentiate between very dark and lighter tones at this stage; just get everything that is in some sort of shadow covered with a simple, even tone. Once you have done this, you will have to use a sheet of paper to rest your hand on to make sure you do not smudge the basic layer of tone. Take care to leave white all areas that reflect the light.

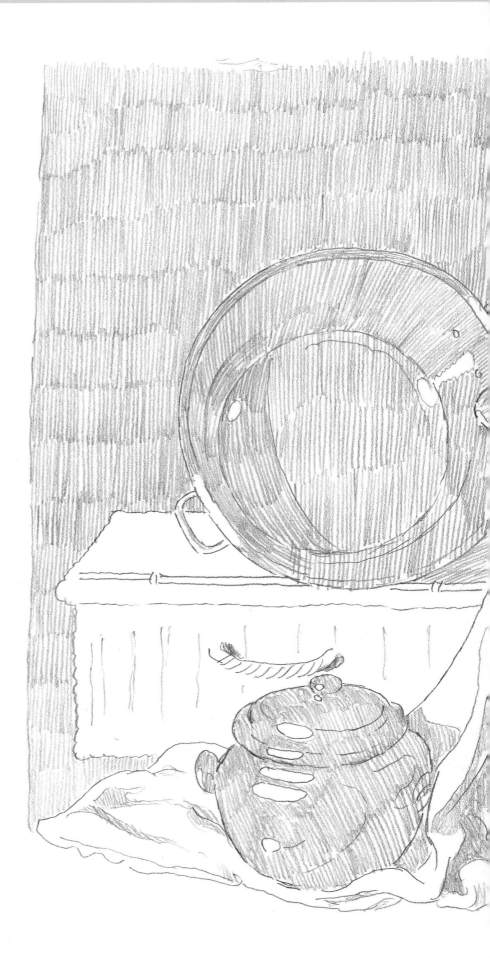

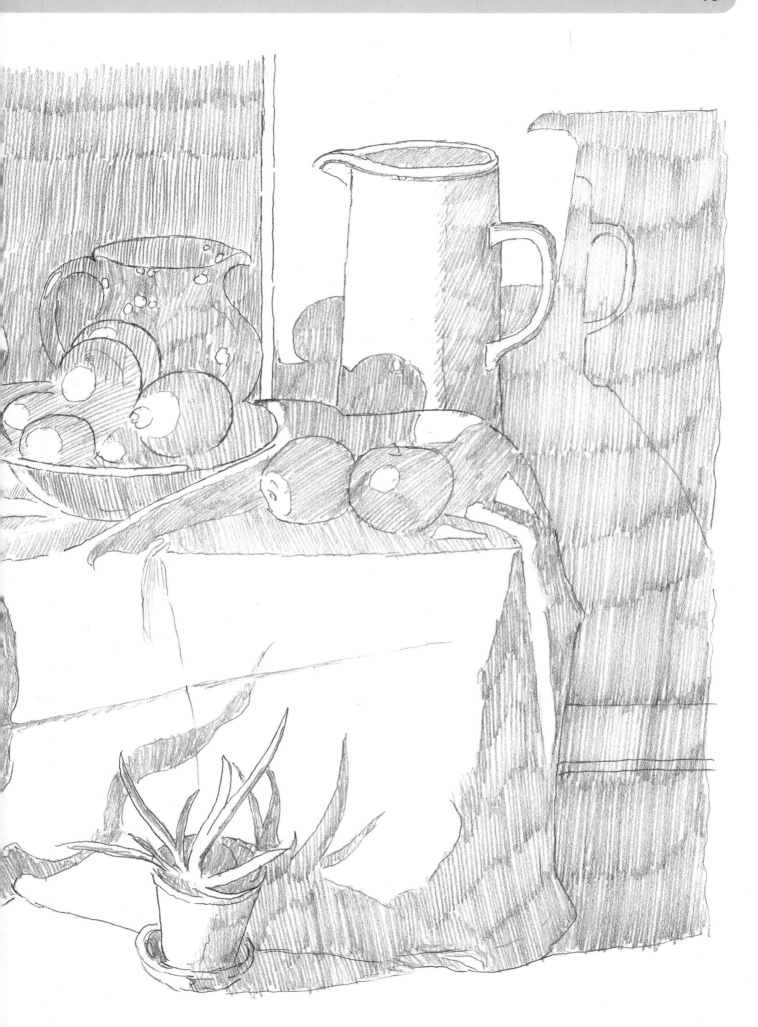

## The completed picture

Finally, I did the careful working up of all the areas of tone so that they began to show all the gradations of light and shade. I made sure that the dark, spacious background was the darkest area, with the large pan, the glass jug and the fruit looming up in front of it. The cast shadows of the plant and where the cloth drapes were put in crisply, and the cast shadow of the jug on the side wall required some subtle drawing.

Before I considered my drawing finished, I made sure that all the lights and darks in the picture balanced out naturally so that the three-dimensional aspects of the objects were clearly shown. This produced a satisfying, well-structured arrangement of shapes with the highlights bouncing brightly off the surfaces.

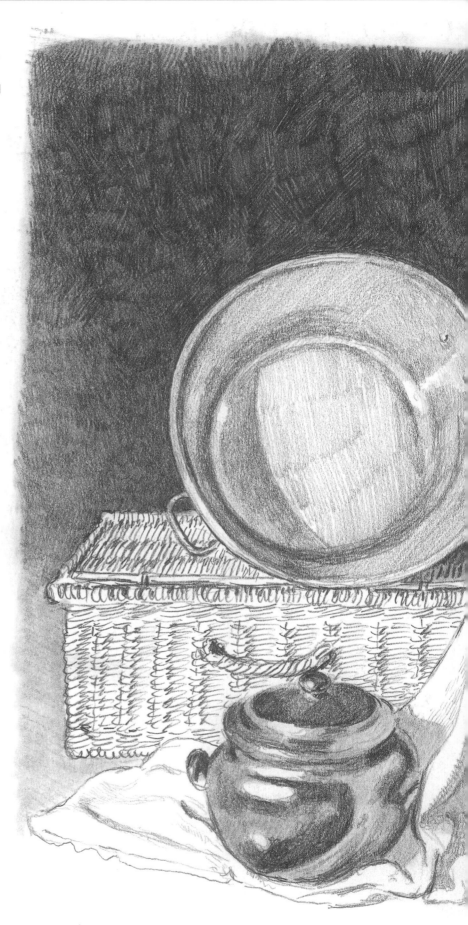

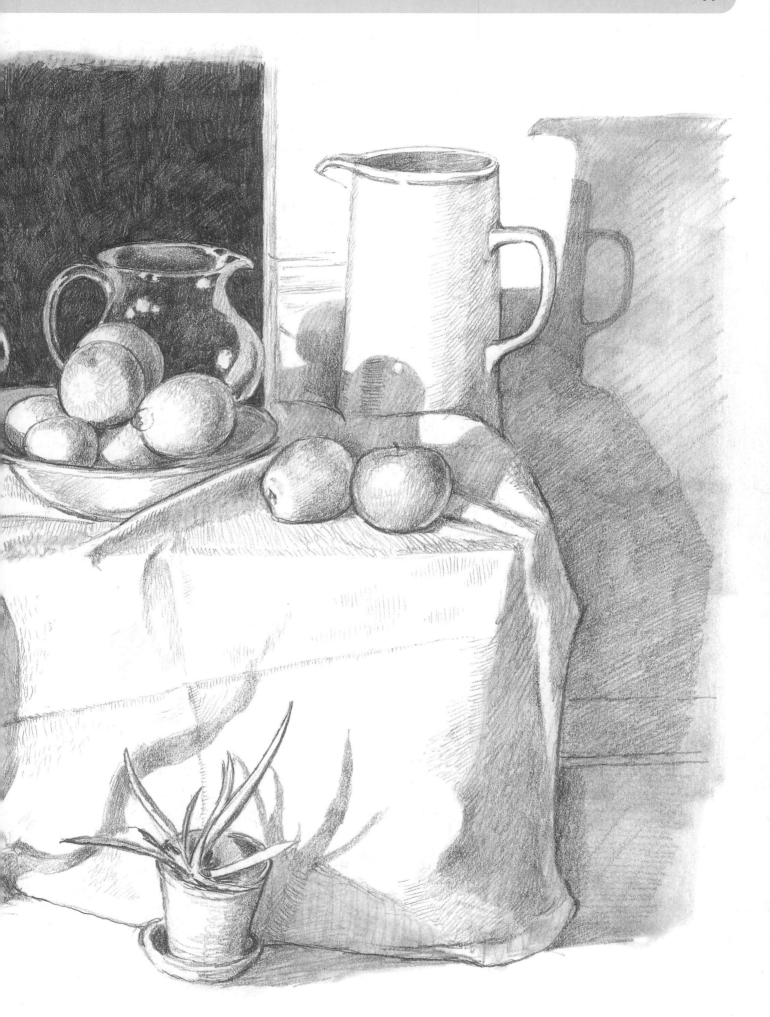

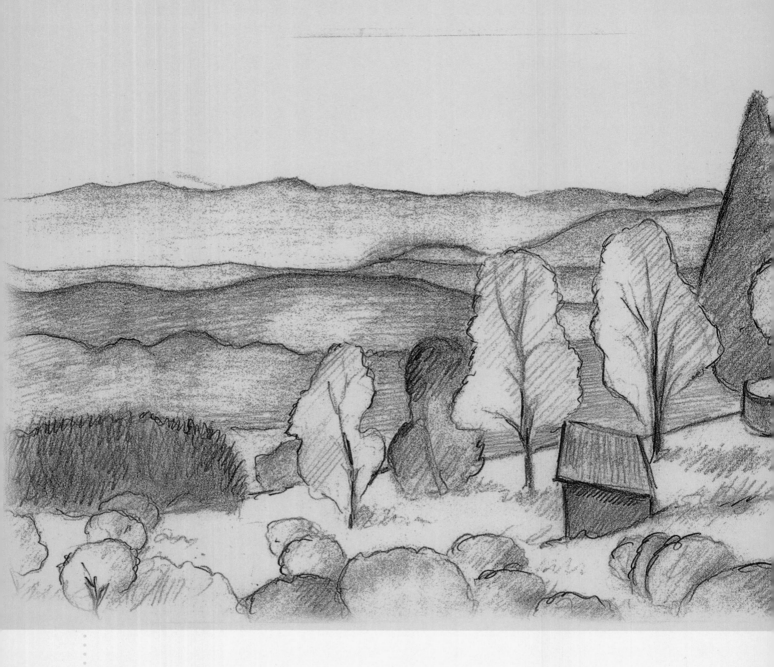

# Landscapes

All artists who appreciate nature and enjoy working outdoors will want to learn how to draw landscapes. The first step is to choose a view that you'd like to depict, from the humble view outside your kitchen window to a magnificent panorama that you discover during a long walk in the countryside. This chapter explains the basics of finding, framing and editing your

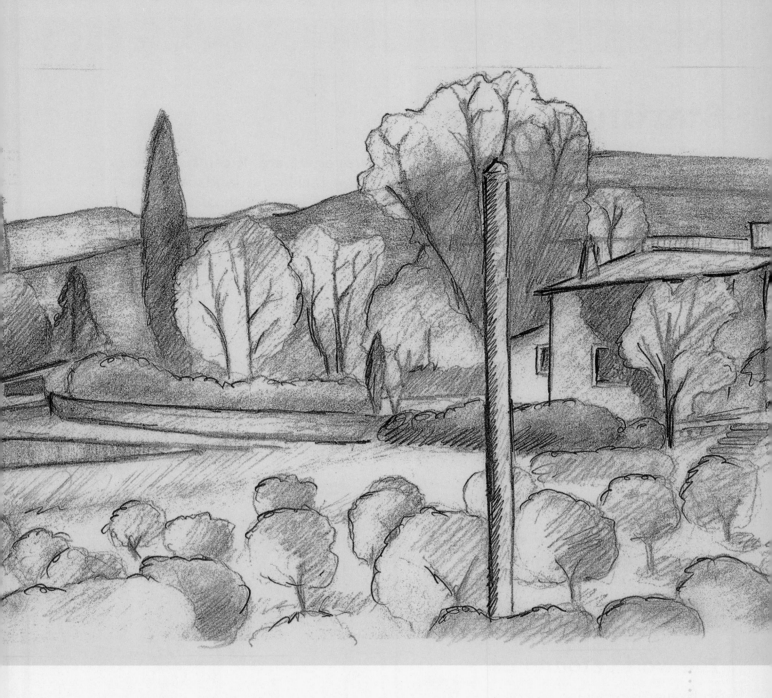

viewpoint, and covers the main features of landscapes that you'll need to practise, including skies, hills, water, rocks, grass, trees, beaches and buildings. Exercises show how to draw waterfalls by leaving empty areas in your artworks, how to indicate distance by placing carefully drawn flowers in the foreground, and how to plan and create an entire landscape over several days.

# Starting Points

Landscape is what we see all around us, wherever we are. It can be a view of an open area of countryside or town. When tackling a landscape, the artist's first task is to select a view, then decide on how much of that view to show, and from which angle. Complementary with this selection process is analysis of the proportion and organization of the shapes evident within your landscape, and how these may be clarified or emphasized. In the next few pages, you will find examples of selection and analysis which you can use as building blocks and take with you into the sections that follow.

Producing landscapes, in any medium, is an excellent pursuit. Apart from getting you out into the world and helping you to appreciate its beauties and structure, it calms the mind. As you draw and observe, a certain detached acceptance of what is there in front of you takes over. It is also fascinating to discover ways of translating impressions of an outside scene into a two-dimensional set of marks on the paper. Whether or not you share some of the experience of your observation with others, it is a truly beneficial activity.

## The world around us

To begin to draw landscapes, you need a view. Look out of your windows. Whether you live in the countryside or in the town, you will find plenty to interest you. Next, go into your garden and look around you. Finally, step beyond your personal territory, perhaps into your street. Once we appreciate that almost any view can make an attractive landscape, we look at what lies before us with fresh eyes. The two views shown here are on either side of my house.

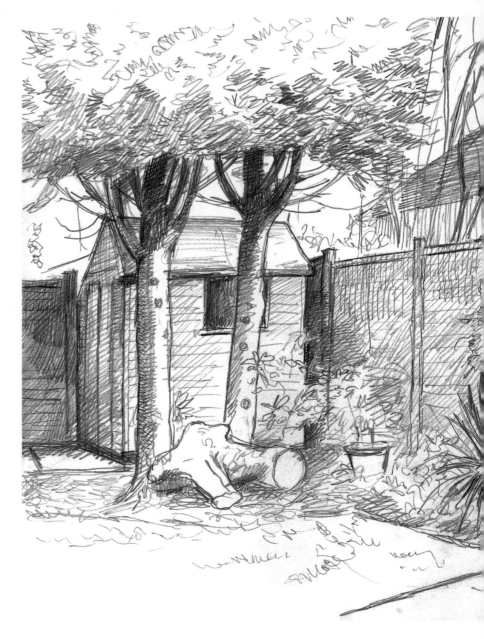

In this outside view of the garden, behind the fence can be seen the roof of a neighbour's house and some trees growing up in the next-door garden. In the corner of my own garden there is a small shed with two fir trees growing in front of it, with a large log at their foot. The flowerbed to the right is full of plants, including a large potted shrub, with ivy growing over the fence. Closer in is the edge of the decking with flowerpots and a bundle of cane supports leaning against the fence. A small corner of the lawn is also visible. The main features in this view are a fence, two trees and a garden hut.

The drawing below is of the view from my front gate. All the houses in my road have front gardens, and there is a substantial area of trees, shrubs and grass before you reach the road proper. We see over-hanging trees on one side, and walls, fences and small trees and shrubs on the other, creating the effect of a tunnel of vegetation. The general effect of the dwindling perspective of the path and bushes either side of the road gives depth to the drawing. The sun has come out, throwing sharp shadows across the path interspersed with bright sunlit splashes. The overall effect is of a deep perspective landscape in a limited terrain.

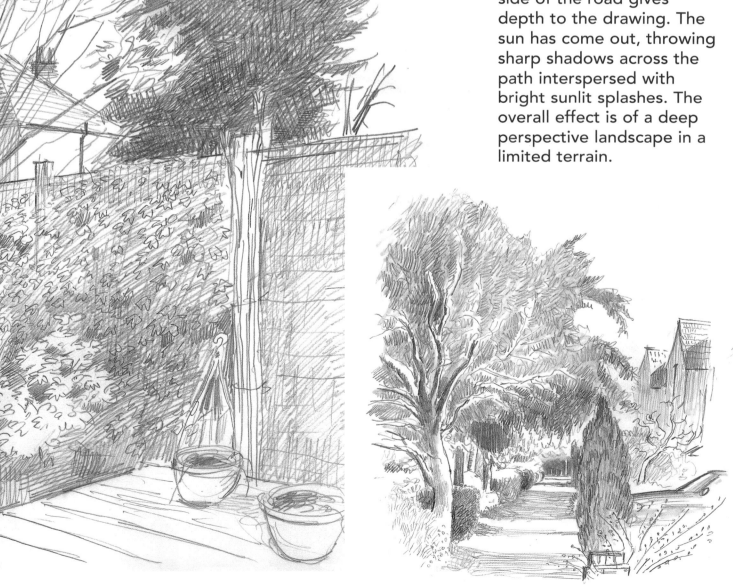

# Framing a view

One way to get a better idea of what you are going to draw when you attempt a landscape is to use a frame. Most artists use a frame at some time as a means of limiting the borders of their vision and helping them to decide upon a view, especially with large landscapes.

In the first example below, a very attractive Lakeland view has been reduced to a simple scene by isolating one part of it. With landscape drawing, it is important to start with a view you feel you can manage. As you become more confident, you can include more. You will notice how the main shapes are made more obvious by the framing method.

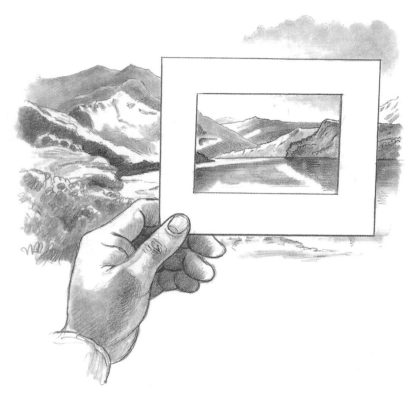

By cutting out a rectangle of card not much larger than 4 inches by 5 inches (10 x 13 cm) and holding it up against your chosen landscape, you can begin to control exactly what you are going to draw. Move it closer to your eyes and you see more; move it further away and you see less of a panorama. In this way, you can isolate the areas that you think will make a good composition and gradually refine your choice of image.

This rather more sophisticated frame, consisting of two right-angled pieces of card, enables you to vary the proportion of your aperture and allows greater scope for variation.

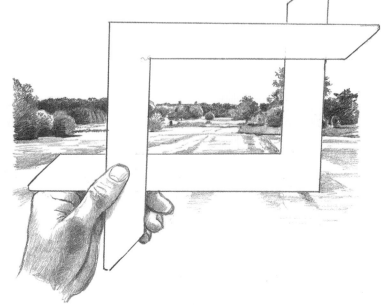

# Choosing a size

At some point you will have to decide how large your picture is going to be. In the beginning, you may only have a small pad at your disposal, and this will dictate your decision. Starting small and gradually increasing the size of your picture is advisable for the inexperienced, but you will quickly get beyond this stage and want to be more adventurous.

Ideally you should have a range of sketchbooks to choose from: small (A5), medium (A4) and large (A3). If this seems excessive, choose one between A5 and A4, and also invest in a larger A3. A5 is a very convenient size for carrying around but isn't adequate if you want to produce detailed drawings, so a hybrid between A5 and A4 is a good compromise. The cover of your sketchbook should be sufficiently stiff to allow it to be held in one hand without bending while you draw.

The grade of paper you use is also important. Try a 160 gsm cartridge, which is pleasant to draw on and not too smooth.

When it comes to tools, soft pencils give the best and quickest result. Don't use a grade harder than B; 2B, 4B and 6B offer a good combination of qualities and should meet most of your requirements. See pages 10–11 for additional information about drawing materials.

It is not too difficult to draw a landscape on an A5 pad, but it does limit the detail you can show.

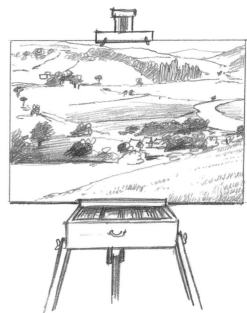

When you are more confident, try a larger landscape on an A2 size sheet of paper. This can be placed on a board mounted on an easel, or just leant against a convenient surface.

When you are really confident, it is time to look at different types of proportion and size. One very interesting landscape shape is the panorama, where there is not much height but an extensive breadth of view. This format is very good for distant views seen from a high vantage point.

# Viewpoints

Finding a landscape to draw can be very time-consuming. Some days I have spent more time searching than drawing. Never regard search time as wasted. If you always just draw the first scene you come to and can't be bothered to look around that next corner, you will miss some stunning opportunities. Reconnaissance is always worthwhile. Let's look at some different kinds of viewpoint and the opportunities they offer the artist.

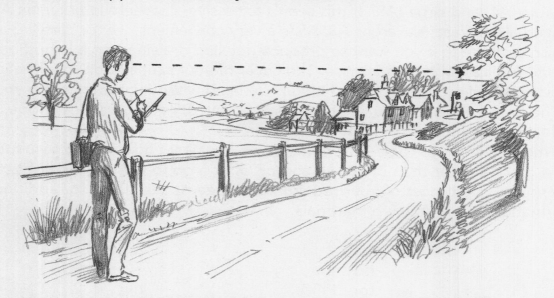

A view along a diminishing perspective, such as a road, river, hedge or avenue, or even along a ditch, almost always allows an effective result. The change of size gives depth and makes such landscapes very attractive. Well-drawn examples of this type suggest that we, the onlookers, can somehow walk into them.

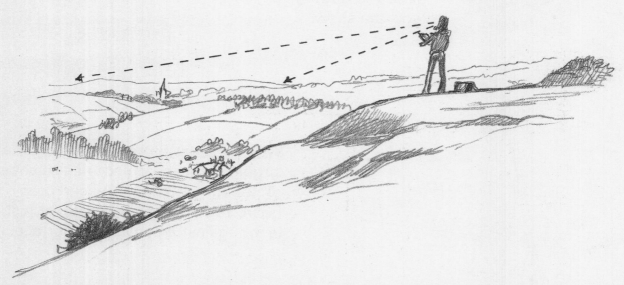

A landscape seen from a high point is usually eye-catching, although not always easy to draw. Look for a high point that offers views across a valley to other high points in the distance. From such a perspective the landscape is somehow revealed to the viewer. If you try this approach, you will have to carefully judge the sizes of buildings, trees and hillsides to ensure the effect of distance is recognized in your picture.

# Editing your viewpoint

A good artist has to know what to leave out of their picture. You don't have to rigorously draw everything that is in the scene in front of you. It is up to you to decide what you want to draw. Sometimes you will want to include everything, but often some part of your chosen view will jar with the picture you are trying to create. Typical examples are objects that obscure a spacious view or look too temporary, or ugly, for the sort of timeless landscape you wish to draw. If you cannot shift your viewpoint to eliminate the offending object, just leave it out. The next two drawings show a scene before and after 'editing'.

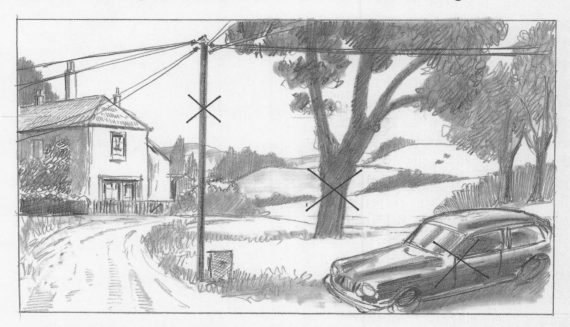

In this view, a telegraph pole and its criss-crossing wires, a large tree and a car parked by the road are complicating what is an attractive landscape.

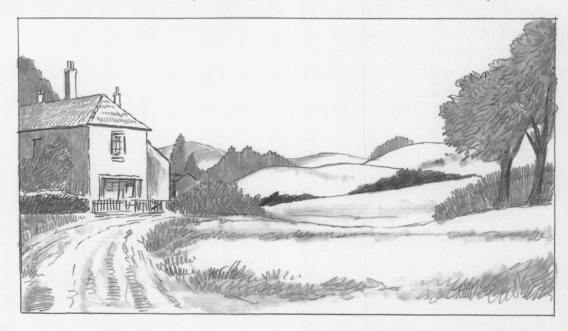

Eliminate those offending objects and you are left with a good sweep of landscape held nicely between the country cottage and unmade road, and the coppice of trees over to the right.

# Types of landscape

Put very simply, there are four possible types of landscape to be considered in terms of the size and shape of the picture you are going to tackle. Your landscape could be large and open, small and compact, tall and narrow or very wide with not much height.

## Small and compact

The emphasis here is on the close-up details and textures in the foreground, a good structural element in the middleground and a well-defined background. The direction of the light helps the composition, showing up the three-dimensional effects of the row of small cottages with the empty road between them and the hedges and walls in the foreground. Look at the way the pencil marks indicate the different textures of these various features.

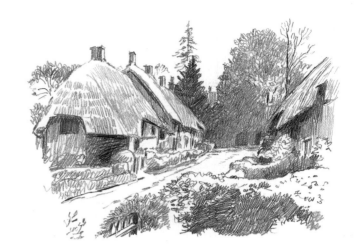

## Open and spreading

The most impressive aspect of this example is the sculptural, highly structured view of the landscape. This has been achieved by keeping the drawing very simple. Note that the textures are fairly homogenous and lacking in individual detail. The result is a landscape drawing that satisfies our need for a feeling of size and scope.

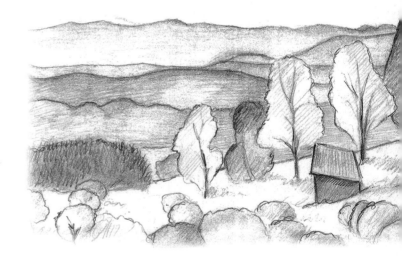

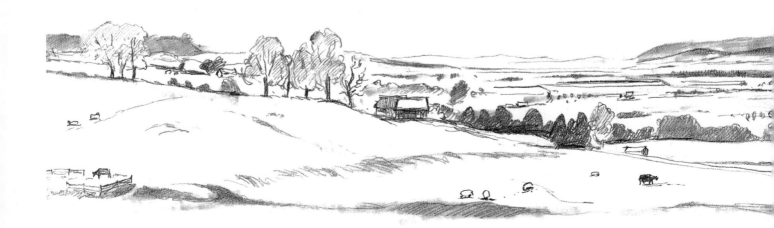

## Tall

Because most landscapes are horizontally extended, generally speaking, the vertical format is not appropriate. However, where you are presented with more height than horizontal extension, the vertical format may come into its own, as here. The features are shown in layers: a road winding up a hill where a few cypresses stand along the edge of the slope, sharply defined; behind it another hill slanting off in the opposite direction; and above that the sky with sun showing through mist.

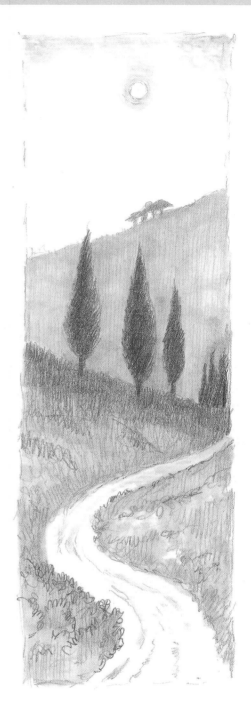

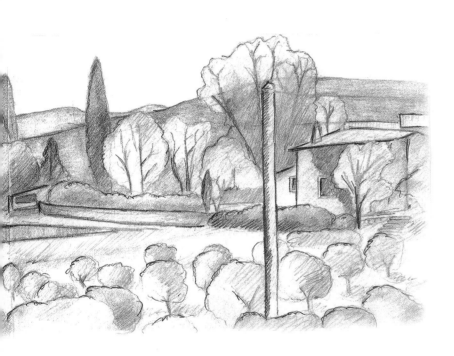

## Panoramic

The basis of landscape is the view you get when you rotate your head around 90 degrees and cover a very wide angle of vision. However, this type is not easy to draw because you have to keep changing your point of view and adjusting your drawing as you go. Remember: the vertical measurement of a panoramic drawing is always much less than the horizontal measurement.

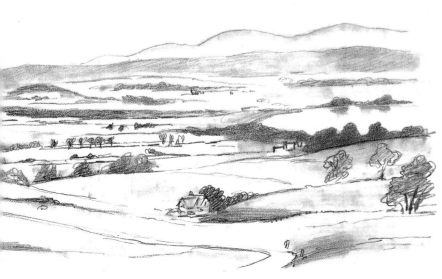

# Viewing the ground

All landscapes have, at most, three layers of depth or vertical development: background, middleground and foreground.

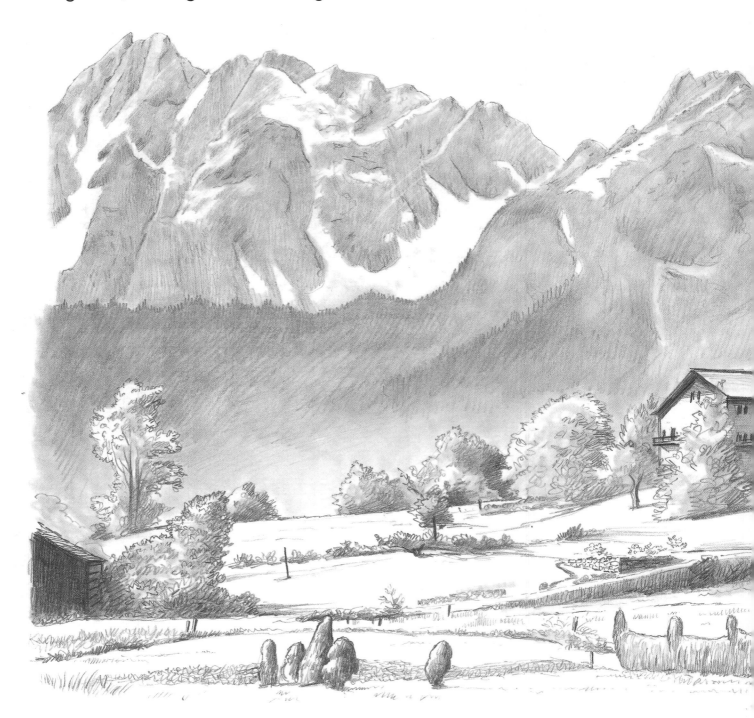

## Foreground

The foreground is important to the overall effect of a composition, its details serving to lead the eye into a picture, and also to the observation of the more substantial statement made by features in the middleground. Intentionally, there is usually not much to hold the viewer's attention. The few features are often drawn precisely with thought given to the textures but not so much as to allow them to dominate the picture.

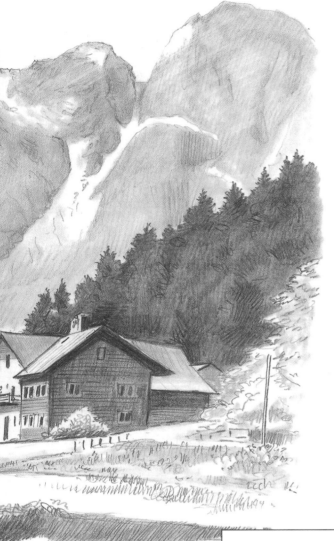

## Background

The background is the most distant part and is usually less defined, less textured and softer in effect than the other areas.

## Middleground

The middleground forms the main part of most landscapes, and gives them their particular identity. The structure of this layer is important because the larger shapes produce most of the interest. However, any details can vary in clarity.

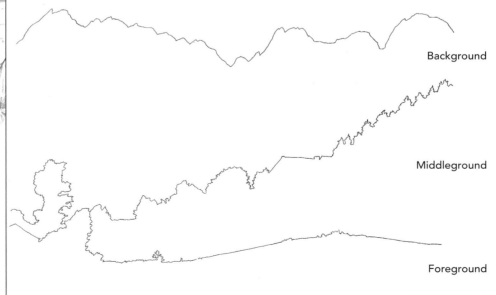

Background

Middleground

Foreground

# Skies and hills

Any landscape will be made up of one or more of the features shown on the following pages. These are sky, hills, water, rocks, vegetation (such as grass and trees), beach and buildings. Obviously each grouping offers enormous scope for variation. For the moment, I want you to look at each set of comparative examples and note how the features are used.

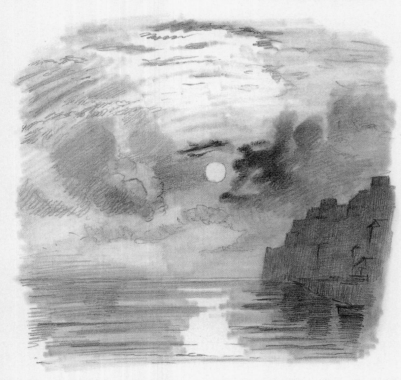

A very simple landscape/ seascape is brought to dramatic life by the contrast of dark and light tones. The moon shines through clouds that show up as dark smudges around the source of light. The lower part of the picture features calm water reflecting the light, and the dark silhouette of a rocky shore.

A halcyon sky (below) takes up almost three-quarters of this scene and dominates the composition, from the small cumulus clouds with shadows on their bases to the sunlight flooding the flat, open landscape beneath.

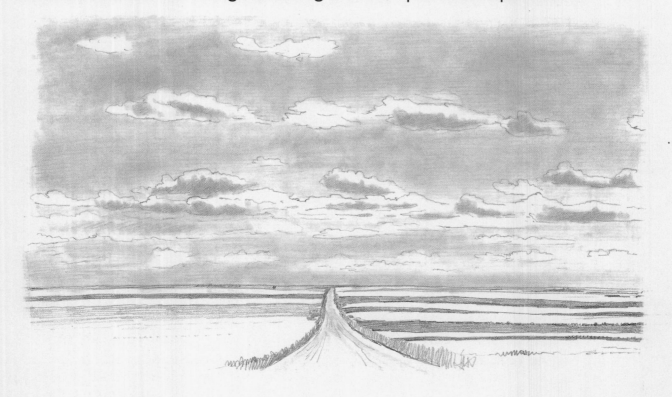

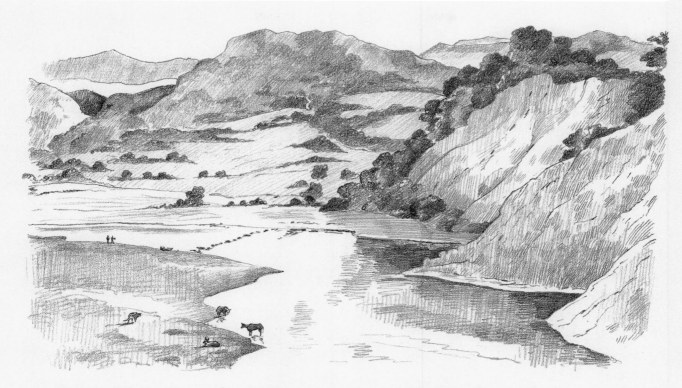

In this example, the high viewpoint allows us to look across a wide river valley to rows of hills receding into the depth of the picture. The tiny figures of people and cattle standing along the banks of the river give scale to the wooded hills. Notice how the drawing of the closer hills is more detailed and more textured. Their treatment contrasts with that used for the hills further away, which seem to recede into the distance as a result.

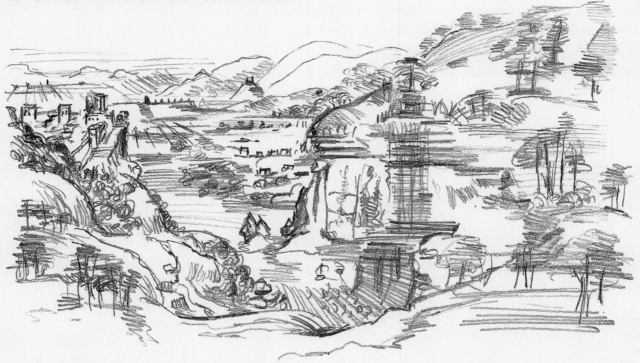

The myriad layers of features make this type of landscape very attractive to artists. This example is after Leonardo. Notice the way details are placed close to the viewer, and how the distance is gradually opened up as the valleys recede into the picture. Buildings appear to diminish as they are seen beyond the hills, and the distant mountains appear in serried ranks behind.

# Water and rocks

The reflective qualities of water make it a very useful addition to a landscape. Water can also introduce movement to contrast with stiller elements on view. Below, we look at three of the possibilities given by the addition of water. On the facing page, we consider the raw power that the inclusion of rocks can bring to a picture.

The impact of this wintry scene (after Monet) is made by the contrasts in darks and lights. These are noticeable between the principal features and especially within the river. Contrast the dark of the trees on either bank of the river with the white of the snow-covered

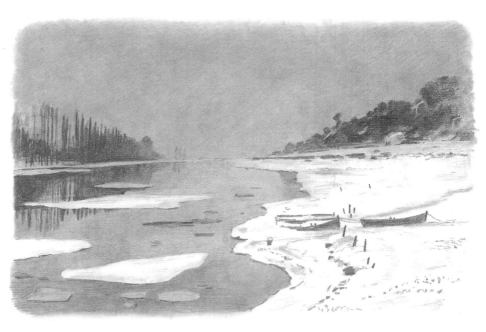

banks; the inky blackness where the tall poplars on the far bank reflect in the water; the grey of the wintry sky reflecting in other areas of the river; and the brilliance of the white ice floes. On the bank, a few smudgy marks help to define the substance of the snowy landscape.

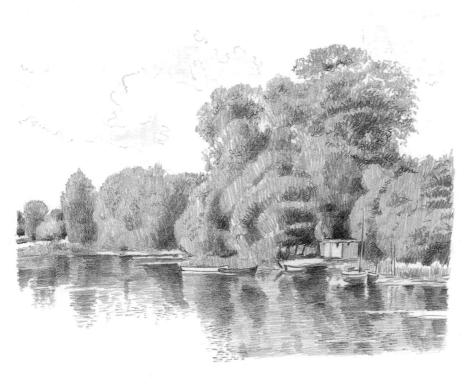

The River Oise in summer (after Perrier) looks more inviting than Monet's depiction of the Seine. The leafy trees are presented as a solid mass, bulking up above the ripples of the river, where the shadowed areas of the foliage are strongly reflected. The many horizontal strokes used to draw these reflections help to define the rippling surface of the calmly flowing river.

The turbulence of the water and its interaction with the static rocks is the point of this small-scale study. Note how the contrast between the dark and light parts of the water intensifies nearer to the shore. As the water recedes towards the horizon, the shapes of the waves are less obvious and the tonal contrast between the dark and light areas lessens.

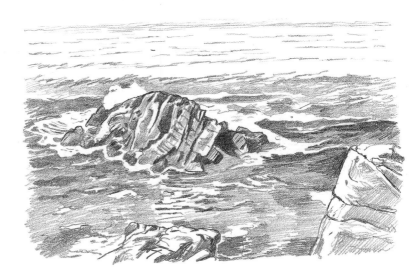

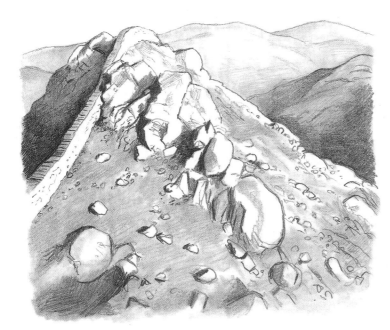

This close-up of a rocky promontory shows starkly against a background of mountaintops drawn quite simply across the horizon. The rock wall effectively shadows the left-hand side of the hill, creating a strong, definite shape. In the middleground, large boulders appear embedded in the slope. Smaller rocks are strewn all around. Note how the shapes of the rocks and the outline of the hill are defined by intelligent use of tone.

The main feature in this landscape is the stretch of rocky shoreline, its contrasting shapes pounded smooth by heavy seas. Pools of water reflect the sky, giving lighter tonal areas to contrast with the darker shapes of the rock. This sort of view provides a good example of an important first principle when drawing landscapes: include more detail close to the viewer, and less detail further away.

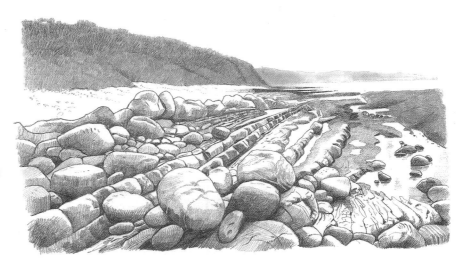

# Grass and trees

Grass and trees are two of the most fundamental elements in landscape. As with the other subjects, there are many variations in type and in how they might be used as features.

Tufts and hummocks of grass mingle with flowers in this close-up of a hillside. The foreground detail helps to add interest to the otherwise fairly uniform

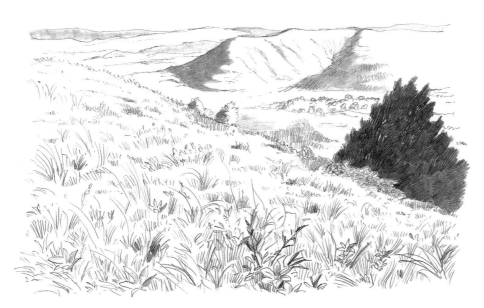

texture. The smoothness of the distant hills suggests that they too are grassy. The dark area of trees just beyond the edge of the nearest hill contrasts nicely with the fairly empty background.

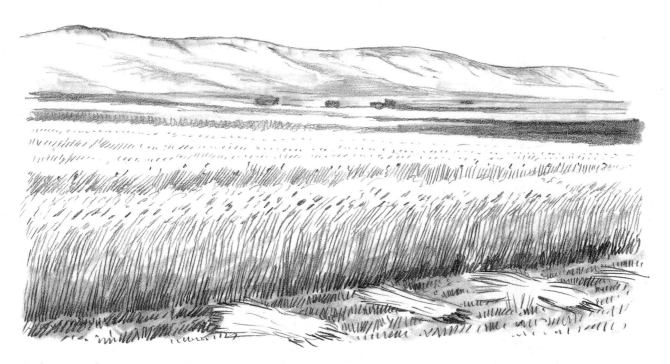

Cultivated crops produce a much smoother top surface as they recede more into the distance than do wild grasses. The most important task for an artist drawing this kind of scene is to define the height of the crop – here it is wheat – by showing the point where the ears of corn weigh down the tall stalks. The texture can be simplified and generalized after a couple of rows.

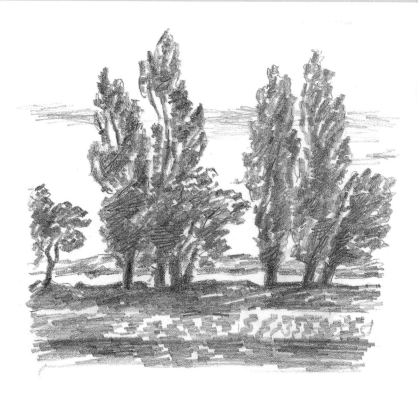

When you tackle trees, don't try to draw every leaf. Use broad pencil strokes to define areas of leaf rather than individual sprigs. Concentrate on getting the main shape of the tree correct, and the way the leaves clump together in dark masses. In this copy of a Constable, the trees are standing almost in silhouette against a bright sky with dark, shadowy ground beneath them.

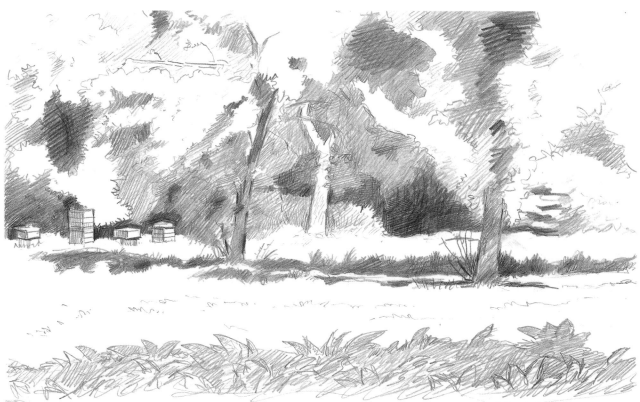

The trees in this old orchard were heavy with foliage when I drew them on a brilliant, sunny day. Nowhere is there a suggestion of individual leaves, just broad, soft shapes indicating the bulk of the trees. They presented themselves as textured patches of dark and light, with a few branches and their trunks outlined against this slightly fuzzy backdrop. An area of shadow under the nearest trees helps define their position on the ground. On the left, some old beehives show up against the shadow. In the immediate foreground, the texture of leafy plants in the grass helps to give a sense of space in front of the trees.

# Beaches

Beaches and coastline are a rather specialized example of landscape because of the sense of space that you find when the sea takes up half of your picture.

Our first view (below) is of Chesil Bank in Dorset, which is seen from a low clifftop looking across the bay. Our second view (right) is of a beach seen from a higher viewpoint from one end, receding in perspective until a small headland of cliffs is visible just across the background.

This view looks very simple: a great bank of sand and pebbles sweeping around and across the near foreground, with a lagoon in front and right in the foreground, and hilly pastureland behind the beach on the left. Across the horizon are the cliffs of the far side of the bay, and beyond them the open sea. Notice the smooth tones sweeping horizontally across the picture to help show the calm sea and the worn-down headland, and the contrast of dark tones bordered with light areas where the edge of sand or shingle shows white.

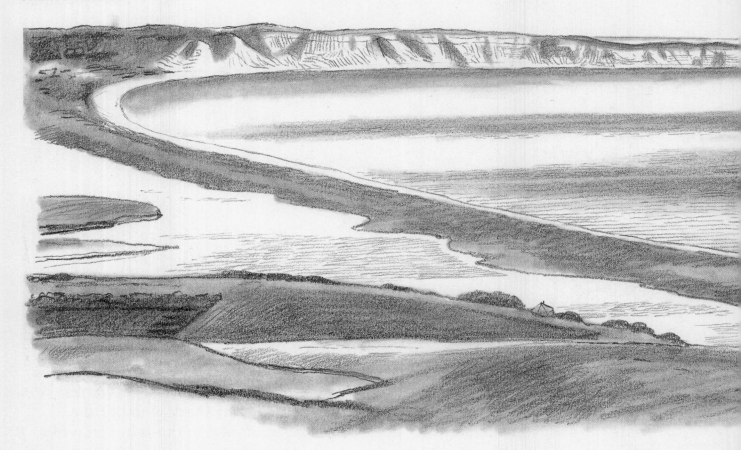

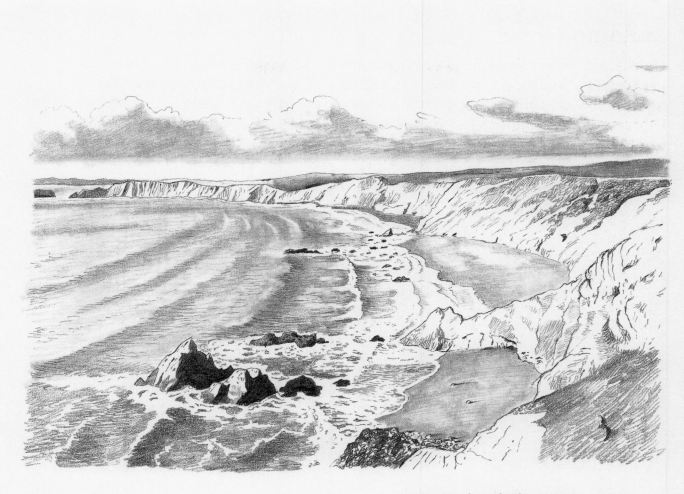

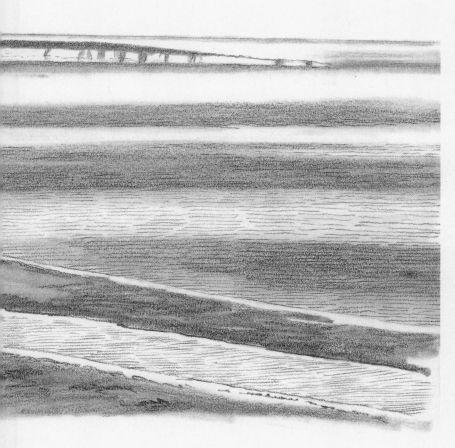

Here, the dark, grassy tops of the cliffs contrast with the lighter rocky texture of the sides as they sweep down to the beach. The beach itself is a tone darker than the cliff, but without the texture. The hardest part of this type of landscape is where the waves break on the shore. You must leave enough white space to indicate surf, but at the same time intersperse this with enough contrasting areas of dark tone to show the waves. The tone of the rocks in the surf can be drawn very dark to stand out and make the surf look whiter. The nearest cliff face should have more texture and be more clearly drawn than the further cliff face.

# Buildings

Unless you are drawing in the wilderness, buildings will often feature in your landscapes, and may offer interest because of their arbitrary appearance against the sky and/or vegetation. Where they form the main subject of a landscape, they will tend to dominate and appear as a mass of verticals and horizontals against geometric hard shapes.

In this copy of John Piper's view of Fotheringay Church at night, the building is etched sharply against a very dark sky, with the architectural outlines of the main shapes put in very strongly. The texture of the crumbling surface of the old church is well judged, as is the decorative effect provided by the mouldings around the doors and windows. The depth and contrast in the shadows ensures that the effect of bright moonlight comes across well.

In this copy of a Pissarro study of a street in Rouen, the emphasis is on the vertical character of the Gothic church and old houses. Only the narrow space of the street is allowed to project into these verticals, which are also etched sharply against the sky. Notice how the contrasting textures created by the house fronts pull the vertical shapes closer together as they recede down the street.

It is easy to become confused with the details of texture in a scene such as this – of the Grand Canal in Venice (after Canaletto). It exemplifies one of landscape's golden rules: always put the main shapes of buildings in first. The repetition of architectural details must be kept as uniform as possible, otherwise the buildings will look as though they are collapsing. Never try to draw every detail; pick out only the most definite and most characteristic, such as the arches of the nearer windows and doors, and the shapes of the gondolas in the foreground. The reflections of the buildings in the water are suggested, with the darkest shadows depicted by horizontal lines under the buildings. Multiple cross-hatching has been put in to denote the darker side of the canal. On the lit side, white space has been left and the sky above lightly shaded to enhance the definition and provide greater contrast.

# Structure and Anatomy of Landscape

The structure of landscape is the way we see the basic shapes of the various features found in the landscape in relation to the underlying shape of the earth supporting them. If we use the analogy of the human form and its anatomy, we can envisage the rock formation as the basic skeleton and then everything laying over this or growing out of it as the flesh and organs.

In terms of drawing, the main consideration for the artist is how to use the information taken in by the eye and organize it in such ways that it makes sense to the observer. One of the artist's principal aids in this regard is perspective. Another is the ability to simplify the layers of the landforms into a series of geometric shapes such as triangles, rectangles, circles, ellipses and angles. This helps us to construct the shape of the landscape in a drawing so that it captures the effect of the shape received by the eye.

Never forget that the world is three-dimensional and that your eyes perceive it as such. When we commit a view of the world onto a flat surface such as paper, we have to employ techniques to give the illusion of depth, distance and spaciousness. In this section of the book you will learn about these techniques. You will see how a few simple construction lines can give an impression of depth and space, and how constructing a sort of scaffolding of geometric shapes can help you to organize what you see into a flat picture.

The multiplicity of shapes that appear before the eye in any landscape can be daunting, especially for the beginner. However, don't panic! What you can see, you can also analyze. By taking the main forms and ignoring the details to start with, you will be able to tackle the problem. Most drawing problems can be solved through the use of quite straightforward measures. You need to know how to control and manipulate these multiple shapes in order for your drawing to be satisfying to look at. Set about the process as outlined in this section. Study it carefully, taking it one step at a time, and don't hurry. Absorb its lessons and you should find your task simpler.

## Understanding perspective

The science of perspective is something with which you will have to become acquainted in order to produce convincing depth of field. This is especially important if you want to draw urban landscapes. The following diagrams are designed to help you understand how perspective works and enable you to incorporate its basic principles into your work.

Like any science, perspective comes with its own language and terms. This diagram offers a visual explanation of the basic terms, as well as giving you an idea of the depth of space. The centre line of vision is the direction in which you are looking. The horizon line or your eye level produces the effect of the distant horizon of the land or sea. The picture plane is effectively the area of your vision where the landscape is seen. The other terms are self-explanatory.

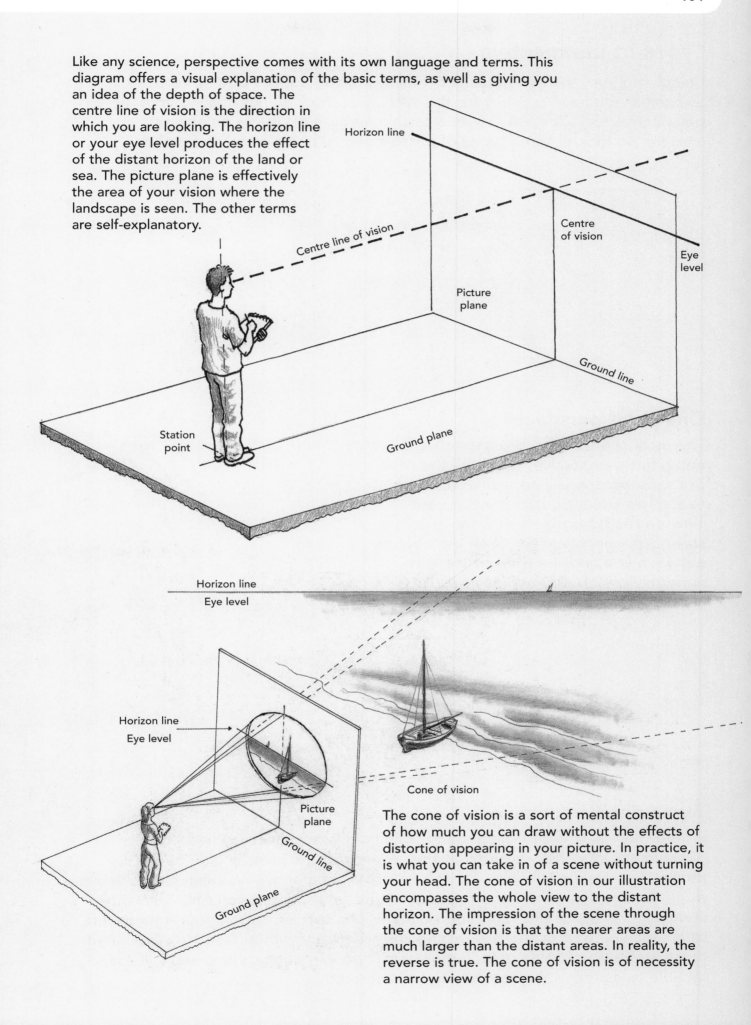

Horizon line

Centre line of vision

Centre of vision

Eye level

Picture plane

Ground line

Station point

Ground plane

Horizon line

Eye level

Horizon line

Eye level

Picture plane

Ground line

Cone of vision

Ground plane

The cone of vision is a sort of mental construct of how much you can draw without the effects of distortion appearing in your picture. In practice, it is what you can take in of a scene without turning your head. The cone of vision in our illustration encompasses the whole view to the distant horizon. The impression of the scene through the cone of vision is that the nearer areas are much larger than the distant areas. In reality, the reverse is true. The cone of vision is of necessity a narrow view of a scene.

# Types of perspective

Being a sphere, the eye perceives the lines of the horizon and all verticals as curves. You have to allow for this when you draw by not making your perspective too wide, otherwise a certain amount of distortion occurs.

Here we look at three types of perspective, starting with the simplest.

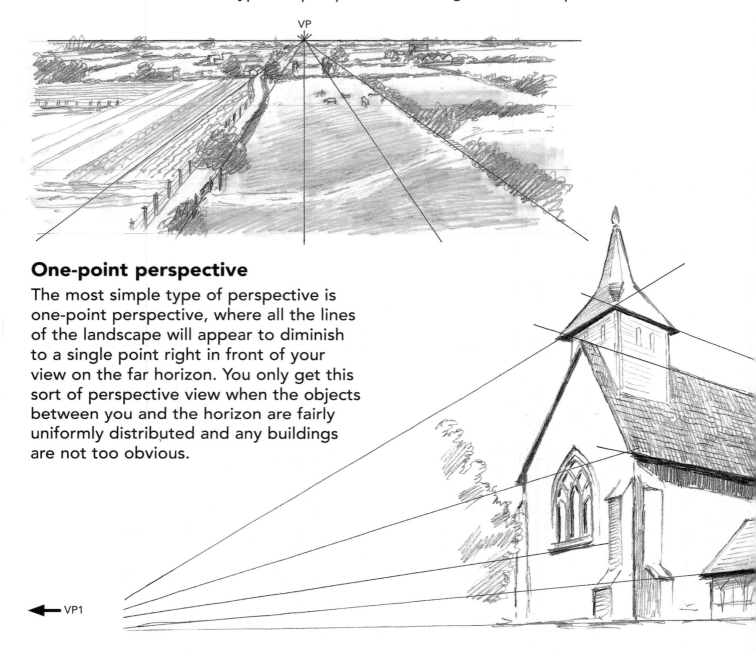

## One-point perspective

The most simple type of perspective is one-point perspective, where all the lines of the landscape will appear to diminish to a single point right in front of your view on the far horizon. You only get this sort of perspective view when the objects between you and the horizon are fairly uniformly distributed and any buildings are not too obvious.

## Two-point perspective

Where there is sufficient height and solidity in near objects to need two vanishing points (VP1 and VP2) at the far ends of the horizon line, two-point perspective comes into play. Using two-point perspective, you can calculate the three-dimensional effect of structures to give your picture convincing solidity and depth. Most of the vanishing points will be too far out on your horizon line to enable you to plot the converging lines precisely with a ruler. However, if you practise drawing blocks of buildings using two vanishing points, you will soon be able to estimate the converging lines correctly.

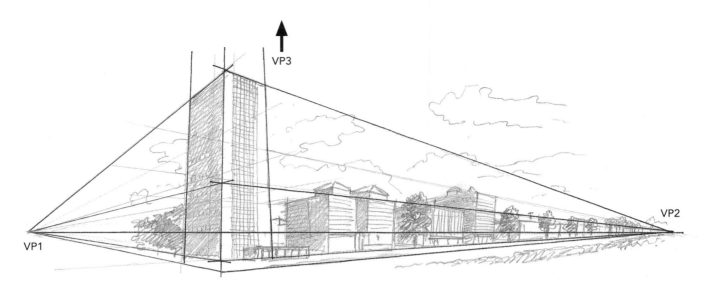

## Three-point perspective

When you come to draw buildings that have both extensive width and height, you have to employ three-point perspective. The two vanishing points on the horizon (VP1 and VP2) are joined by a third (VP3) which is fixed above the higher buildings to help create the illusion of very tall architecture. Notice in our example how the lines from the base of the building gently converge to a point high in the sky. Once again, you have to gauge the rate of the convergence. Often, artists exaggerate the rate of convergence in order to make the height of the building appear even more dramatic. When this is overdone, you can end up with a drawing that looks like something out of a comic book.

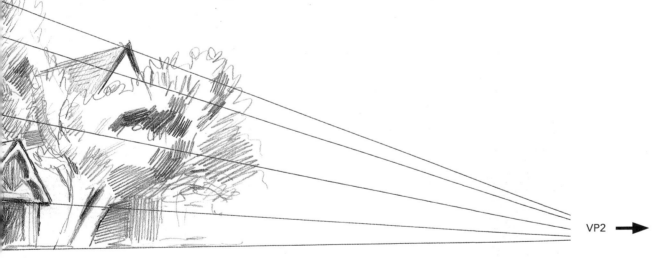

# Using perspective

After you have absorbed the terminology and theory of perspective, it is time to look at how this knowledge is used by artists to give an impression of depth when they are confronted by a real landscape. In the following examples, we identify the various features and objects that have been used to give space and depth to the picture plane.

Size and light give clues to the depth of this picture of the Bay of St Adresse (after Monet). Human figures and fishing boats give us the proportion of the close-up foreground. Across the expanse of water are dotted sailing vessels, which diminish in scale. Note the curve of the beach moving away to the left and then curving around to the right, and how the buildings on the shoreline diminish as they recede into the distance. On the far horizon we see small marks denoting vessels and buildings. Note how silhouette has been used, especially in the fishing boats, to proclaim their closeness to us in relation to the far distant shore.

In this second scene (also after Monet) of the River Thames near Westminster, there are various clues to distance, including the clever use of layers of tone. Most persuasive is the change in tonal values of the buildings and objects as they recede into the background, aided by the misty quality of the atmosphere. In the near foreground, the jetty is strongly marked in dark tone, contrasting with the embankment wall and the dark and light surface of the water. Behind this is the rather softer tone for the bulk of the tower of Big Ben and the small tugboat on the bright water. Beyond, other buildings are faintly outlined against a pale sky.

Objects are often used to achieve perspective, as we have already seen. In this drawing (after a picture by Andrew Wyeth), an old dump cart acts as a reference point between the viewer and the background. The device of taking something that can be related to the size of the human form quickly gives us information about the distance in front of the cart and the distance behind it.

This drawing of the entrance to the mountain town of Boveglio in Tuscany gives many clues to our position and that of the buildings in front of us. The angle of the steps upwards and the change in size of the windows provide information that helps us to detect how the path winds up the mountain into the old town.

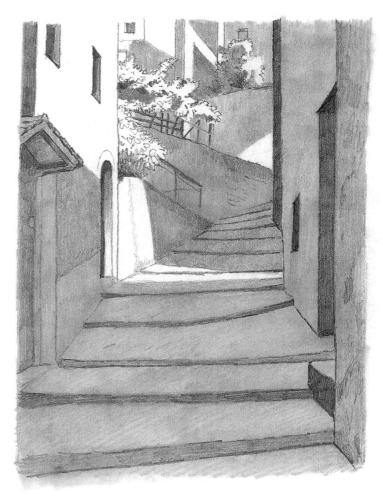

# Basic Elements of Landscape

When we begin to study landscape, the sheer amount of material available can be confusing and it can be difficult to know where to start. The first step is to identify the components we are contemplating drawing, starting with the vegetation and how it clothes the landscape. Next, consider the underlying structure of a scene, which is evident from the formation of rocks, hills and mountains. Water provides a large part of many landscapes. Still or moving, it is extremely important because of the brightness and reflection it gives within the shape of the countryside. At the edge of the land you may be able to view the sea, and this can be considered almost as a separate entity, so great can be its role. The sky is the backdrop to everything, and is constantly changing to give a new look to the substance of the landscape.

Your awareness of the make-up of the landscape will become second nature and part of the enjoyment you get from drawing. Keep looking and allow your view to both differentiate and harmonize all the various parts you are drawing.

## Trees in the landscape

When tackling a landscape with trees, novice artists often make the mistake of thinking they must draw every leaf. Survey such a scene with your naked eye, however, and you will soon discover that you can't see the foliage well enough to do this. You need to be bold, observing and simplifying the general appearance of different trees. The following series of drawings is intended to help capture the shapes of a range of common trees seen in full foliage and from a distance. You can see that differences in leaf type are indicated by marking the general texture and shape.

Oak

The Oak makes a compact, chunky, cloud-like shape, with leaves closely grouped on the mass of the tree.

Ash

By contrast, the Ash is much more feathery in appearance.

Lombardy poplar

The Poplar is indicated by long, flowing marks in an upwards direction.

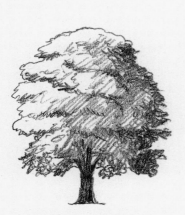

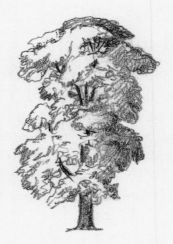

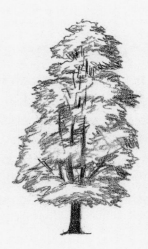

### Horse chestnut

### Elm

### Lime

Some trees, such as the Horse Chestnut, can be blocked in very simply, just needing a certain amount of shading to indicate the masses.

The Elm and Lime are very similar in structure. The way to tell them apart is to note the differences in the way their leaves layer and form clumps.

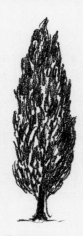

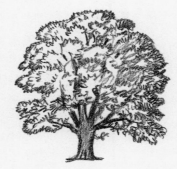

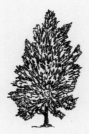

### Cypress

### Walnut

### Holly

The Cypress holds itself tightly together in a flowing, flame-like shape – very controlled and with a sharp outline.

The Walnut requires scrawling, tight lines to give an effect of its leaf texture.

The Holly tree is shaped like an explosion, its dark, spiky leaves all outward movement in an expressive organic thrust.

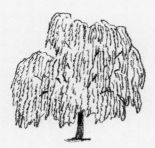

### Weeping willow

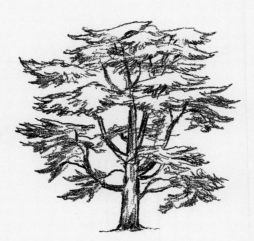

### Cedar of Lebanon

You will also have to take note of where a darker or lighter weight of line or tone is required. Compare, for example, the weight of line needed for trees with dense dark leaves, such as the Cypress and Holly, with the light tone appropriate to the Willow and Cedar.

# Foliage: the classical approach

Drawing trees can be quite daunting when first attempted. It is a common misconception that every leaf has to be drawn. This is not the case. In the next few examples you will find depictions by Italian, French and Dutch masters, each of which demonstrates how to solve the problem of showing masses of small shapes that build up to make larger, more generalized outlines.

In these examples, a lively effect of plant growth is achieved by the use of vigorous smudges, brushed lines and washes, and finely detailed penlines, often in combination.

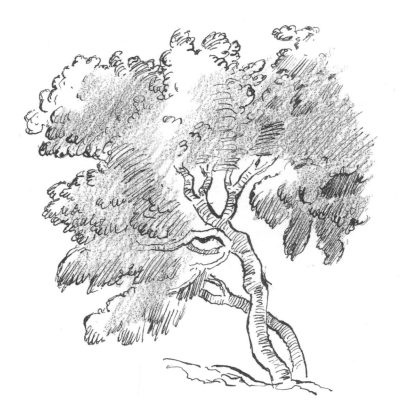

Notice the soft, almost cloud-like outline given to the groups of foliage in this example after Titian (drawn in pen, ink and chalk). No individual leaves are actually shown. Smudges and lines of tone make patches of light which give an impression of thick bunches of leaves. The branches disappear into the bulging form, stopping where the foliage looks most dense.

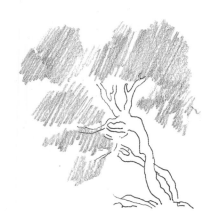

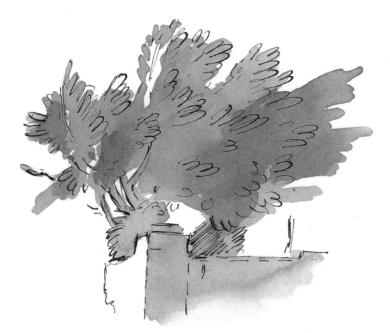

Despite the minimal drawing, this example after Giovanni Battista Tiepolo (in pen and ink) is very effective. The solidity of the wall has been achieved with a few lines of the pen. A similar technique has been used to capture the general effect of the longish groups of leaves. The splash of tone has been applied very freely. If you try this yourself, take time painting on the wash. Until you are sure of what you are doing, it is wise to proceed with care.

The approach in this drawing after François Boucher (in black chalk) is to put in the sprays of branches and leaves with minimal fuss but great bravura. The technique of using squiggles for bunches of leaves evokes the right image, as does drawing in the branches more heavily, but with no effort to join them up. The approach works because our eyes expect to perceive a flow of growth, and seen in context the leaves and branches would be easily recognizable.

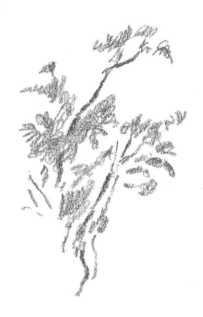

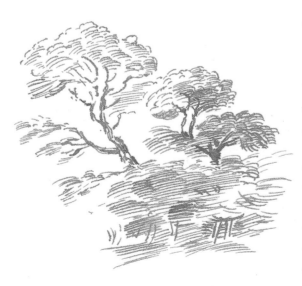

The emphasis in this example after Guercino is on giving unity to the whole picture while producing an adequate representation of trees in leaf. The lines around the outside edges of the clumps of leaves give a good impression of tree-like shapes. Simple uni-directional hatching, smoothing out as the lines get further from the edge, give the leafy areas solidity but without making them look like a solid wall. Darker, harder lines make up the branches and trunk. The suggestion of softer and harder tone, and the corresponding tonal contrasts, works very well.

With your first attempts at drawing foliage, try to get a general feel for the way branches and foliage spring out from the trunk of the tree, and also how the bunches of leaves fan and thrust out from the centre of the plant. Note from the examples shown below what gives a convincing effect: weaving, crinkly lines; lines following the general layering of leaves; uneven thicks and thins with brush or pen; or the occasional detail of leaves in the foreground to help the eye make the assumption that this is also seen deeper in the picture. Whatever type of foliage you draw, try to give a lively, organic shape to the whole.

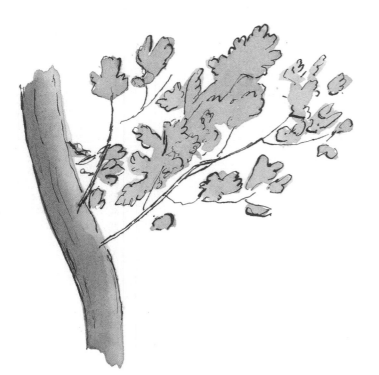

Very efficient methods have been used in this drawing of a branch (after Lorrain) to convince us of its reality. The combination of line and wash is very effective for branches seen against the light. If any depth is needed, just a few extra marks with the brush will supply it.

The two basic stages before the finished drawing are given below.

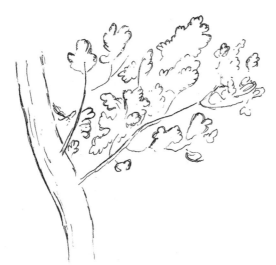

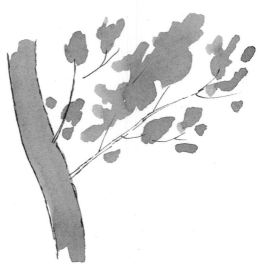

First, the outline shapes of the branch and leaves are drawn in pen. This approach is very similar to that adopted for the sketch after Titian on page 108.

Next, a wash of tone is applied over the whole area of the branch and each bunch of leaves.

There is no hesitation in this pen, ink and wash drawing after Rembrandt. Minimal patches of tone are just enough to give solidity to the trunk and ground. Look at the quick scribble of lines, horizontally inscribed across the general growth of the branches, suggesting there are plenty of leaves in the middle of the tree.

In this graphite drawing (also after Rembrandt), very firm, dark slashes of tone are accompanied by softer, more rounded scribbles to describe leaves at different distances from the eye. The growth pattern of the tree is rendered by a strong scrawl for the trunk and slighter lines for the branches.

This neat little copse of trees (after Philips Koninck), lit from one side with heavy shadows beneath, looks very substantial, even though the drawing is not very detailed. The carefully drawn clumps of leaves around the edges, and where some parts of the tree project towards us, help to give the impression of thick foliage. The closely grouped trunks growing out of the undergrowth are clearly drawn.

# Mountains, hills and rocks

Handling the skeleton of a mountain, hill or rock depends on the nature of the feature you are drawing. Your subject might be presented as a bare, hard mass against a clear, cloudless sky, or perhaps be softened by vegetation and/or cloud formations. The shape, texture and materiality of these natural features in the landscape are varied and require individual approaches. Below are two extremes for you to consider before we look at how to draw them.

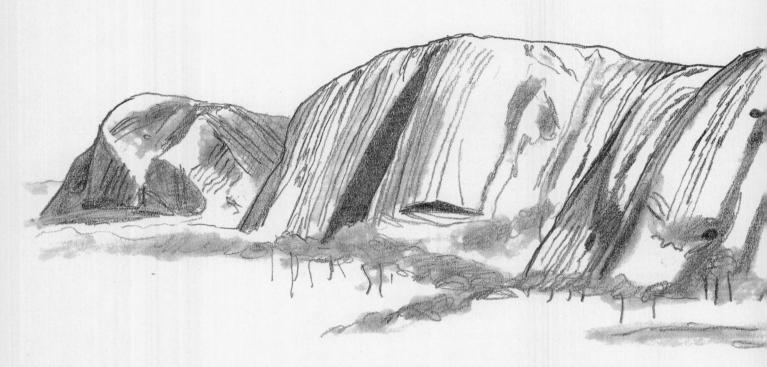

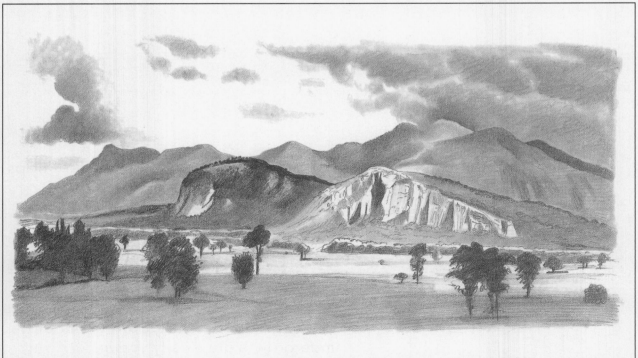

This depiction of Australia's Uluru (after Michael Andrews) accentuates the striations and folded layers of what is one of the world's most curious hill features. Little attempt has been made to create texture. The shadows are put in very darkly and sharply to give an effect of strong sunlight falling on the amazing shapes. The rock's strange regularity of form, devoid of vegetation, almost makes it look like a manufactured object. As a contrast, the trees at ground level are drawn very loosely and in faint, scribbly lines.

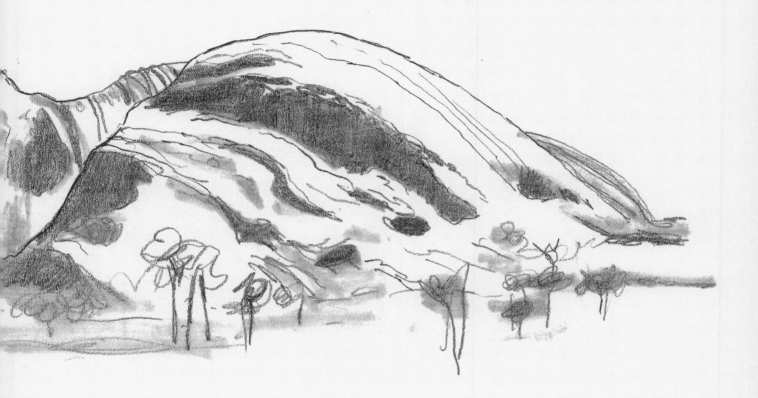

In contrast to the previous drawing, Moat Mountain (after Albert Bierstadt) includes several elements that combine to soften its aspect. The vegetation growing over the folds of the rocky slopes brings additional tonal values to the picture. The fairly well-worn appearance of the rocks, showing visible signs of glaciation in the remote past, has a softening effect. The dark clouds sweeping across the mountain tops and the silhouetted trees looming up from the plain in the foreground also help to unify the harmony of tone all over the picture.

# Rocks: analysis

The visual nature of a mountain range will change completely, depending on your viewpoint. Looked at from a considerable distance, the details recede, and your main concern is with the mountain's overall structure and shape. The nearer you get, the softer the focus of the overall shape and the greater the definition of the actual rocks. Here, we analyze two examples of views of rocks from different distances.

In our first example, from a mountain range in Colorado, the peaks and rift valleys are very simply shown, giving a strong, solid look to the landscape. The main shape of the formation and the shadow cast by the light defines each chunk of rock as sharply as if they were bricks. This is partially relieved by the soft misty patches in some of the lower parts. The misty areas between the high peaks help to emphasize the hardness of the rock. Let's look at it in more detail.

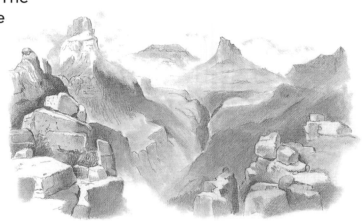

1.

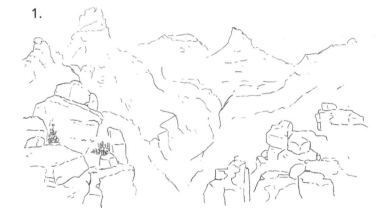

2.

1. Sketch in with a fairly precise line the main areas of the mountain shapes, keeping those in the background very simple. For the foreground shapes, clearly show the outlines of individual boulders and draw in details such as cracks and fissures.

2. The real effect comes with the shading in soft pencil of all the rock surfaces facing away from the light. In our example, the direction of the light seems to be coming from the upper left, but lit from the back. Most of the surfaces facing us are in some shade, which is especially deep where the verticals dip down behind other chunks of rock. The effect is to accentuate the shapes in front of the deeper shade, giving a feeling of volume. In some areas, large shapes can be covered with a tone to help them recede from the foreground.

All the peaks further back should be shaded lightly. Leave untouched areas where the mist is wanted. The result is a patchwork of tones of varying density, with the line drawing emphasizing the edges of the nearest rocks to give a realistic hardness.

You will find this next example which is drawn exclusively in line, including the shadows, a very useful practice for when you tackle the foreground of a mountainous landscape or a view across a valley from a mountainside. The cracks in the surfaces and the lines of rock formation help to give an effect of the texture of the rock and its hardness. The final effect is of a very hard, textured surface where there is no softness.

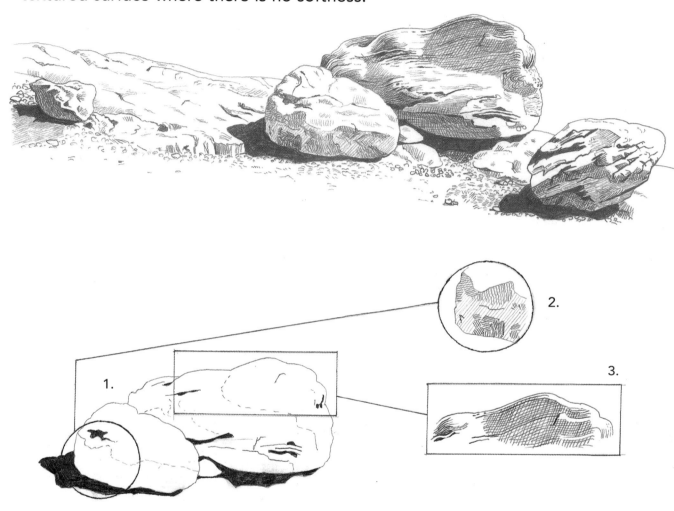

1. Draw in the outline as in the previous example, then put in areas of dark shadow as a solid black tone. Indicate the edges of the shaded areas by a broken or dotted line. Now carefully use cross-hatching and lines to capture the textured quality of the rock.

2. These particular rocks have the striations associated with geological stratas, and as these are very clearly shown, you can draw them in the same way. Be careful that the lines follow the bending shape of the stone surface, and when a group of them change direction, make this quite clear in your drawing. This process cannot be hurried; the variation in the shape of the rock demands that you follow particular directions. Some of the fissures that shatter these boulders cut directly across this sequence of lines. Once again, they should be put in clearly.

3. Now we come to the areas of shadow which give extra dimension to our shapes. These shadows should be put in very deliberately in oblique straight lines close enough together to form a tonal whole. They should cover the whole area already delineated with the dotted lines. Where the tone is darker, put another layer of straight lines, close together, across the first set of lines in a clearly different direction.

# Water features near and far

Water is a most fortunate feature to portray because it gives the landscape an added dimension of space, rather like the sky. The fact that water is reflective always adds extra depth to a scene. The drawing of reflections is not difficult where you have a vast expanse of water flanked by major features with simple outlines, as in our first example. Use the technique shown, which is a simple reversal, and you will find it even easier.

Here the water reflects the mountains in the distance and therefore gives an effect of expanse and depth as our eyes glide across it to the hills. The reflection is so clear because of the stillness of the lake (Wastwater in the Lake District), and the hills being lit from one side. Only the ripples tell us this is water.

The mountains were drawn first and the water merely indicated. The reflection was drawn afterwards by making a tracing of the mountains and redrawing them reversed in the area of the water (see inset, far right). This simple trick ensures that the reflection matches the shape of the landscape being reflected, but is only easy if the landscape is fairly simple in feature. The ripple effect was indicated along the edges of each dark reflection, leaving a few white spaces where the distant water was obviously choppier and catching the sun.

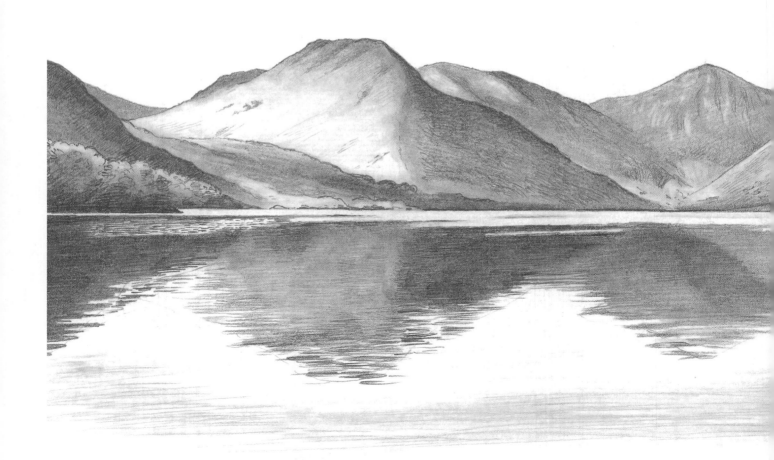

This view of Monet's pond at Giverny is seen fairly close up, looking across the water to trees and shrubs in the background.

The light and dark tones of these reflect in the still water. Clumps of lily pads, appearing like small elliptical rafts floating on the surface of the pond, break up the reflections of the trees. The juxtaposition of these reflections with the lily pads adds another dimension, making us aware of the surface of the water as it recedes from us. The perspective of the groups of lily pads also helps to give depth to the picture.

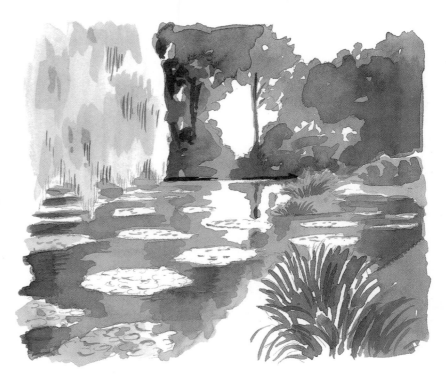

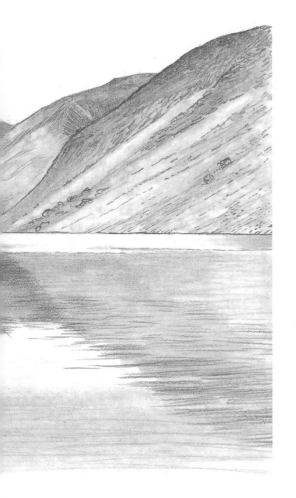

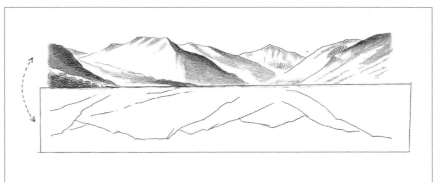

To draw a reflection, trace the mountains, then redraw them reversed in the water beneath.

# Water on the move

You need time to capture accurately the swirls and shifting reflections in moving water. Leonardo da Vinci is said to have spent many hours just watching the movement of water, from running taps to torrents and downpours, in order to be able to draw the myriad shapes and qualities which such features present. So a bit of study is not out of place here. If you are able to draw still reflections, that is a good start. You will find the same reflections, only rather more distorted, in moving water. We look next at a representative range of types of moving water for you to study.

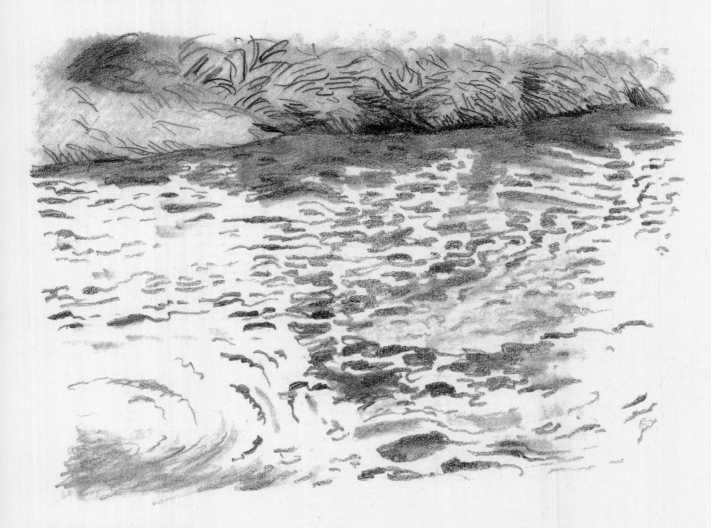

## Repeat patterns

Notice how in this moorland stream the surface of the water is broken up into dark and light rippling shapes that come about from the proximity of the stony bed of the stream to the surface. Everything that is reflected falls into this swirling pattern. After a few attempts, you will find it is not that difficult to draw. The trick is to follow the general pattern rather than trying to draw each detailed ripple to perfection. With this type of stream, the ripples always take on a particular formation which is repeated in slightly differing forms over and over again. Once you see the formation, it is just a question of putting down characteristic shapes and allowing them to fit together over the whole surface of the water, taking note of the dark tones in order to give structure to the whole scene.

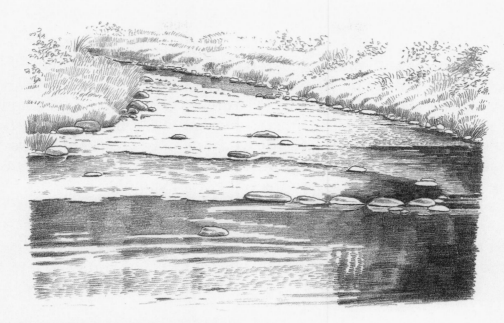

## Contrasting directions and tones

A small river running across shallows creates a minute series of rapids. There are small stones jutting above the surface to give structure to the area of water. Ensure that the marks you use to show the grassy banks contrast with the marks you use for the water. Nearly all the marks made for the banks are with a vertical bias, whereas all the marks made for the water have a horizontal bias.

Notice the very light patches of reflection wherever the water ripples over or close to stones. These occur because the light tends to flicker on the ripples of the more broken surfaces in the stream. Where the water is deeper or slowed down by a bend in the river, you will find the reflections of overhanging trees making strong, dark areas with much smoother ripples. Any stones projecting above the surface of the stream will help to define these different areas of tone.

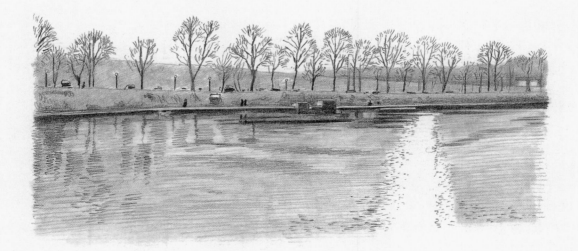

## Smoother, brighter, simpler surface

Large rivers present fewer problems to the artist than small streams, partly because of the depth and partly because of the width. With a large river, the flow of the water is smoother. Well built-up banks will ensure it is also very even. In this scene the sun is setting, and this cuts a bright path across the water, with reflections of the winter trees projecting into the surface nearer the bank.

# Falling water

One of the problems with drawing waterfalls is the immense amount of foam and spray that the activity of the water kicks up. This can only be shown by its absence, which means you have to have large areas of empty paper right at the centre of your drawing. Beginner artists never quite like this idea and usually put in too many lines and marks. As you become more proficient, however, it can be quite a relief to leave things out, especially when by doing so you get the right effect. The spaces provide the effect that you need.

The rapids at Ballysadare produce the most amazing expanse of white water. Most of the drawing has gone into the banks of the river, throwing into sharp relief the white area of frothing water. The four sets of small waterfalls are marked in with small pencil strokes, following the direction of the river's flow. The far bank is kept simple and the farthest away part is very soft and pale in tone.

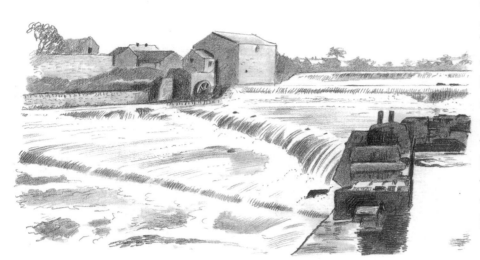

This drawing of Niagara (after Albert Bierstadt) looks at the Falls from below. The falling water is mostly left as white paper with just a few streaks marked to indicate it. The contrast between the almost blank water, the edges of the bank and the tone of the plunge pool gives a good impression of the foam-filled area as the water leaps down into the gorge it has cut in the rock.

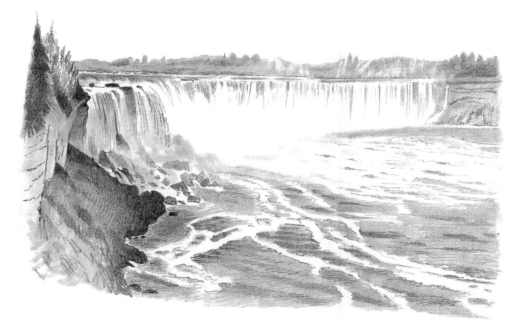

# Falling water: practice

The scale of High Force waterfall in the Pennines is of a different order to that of Niagara, and presents other challenges. Where Niagara is broad, High Force is narrow and, of course, the volume of water that rushes down its steep sides and over its series of steps is much less. As when drawing Niagara, it is mostly the strong tones of the banks that provide contrast with the almost white strip of the waterfall.

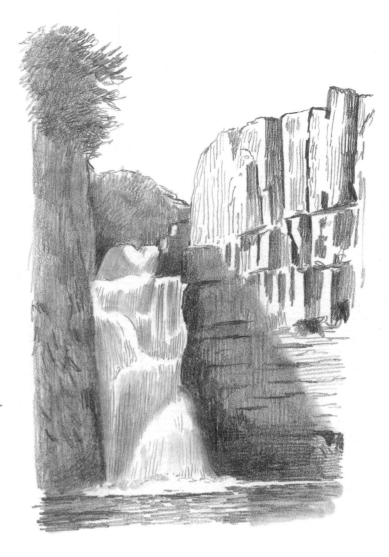

1. Start with the cliffs on either side. Where they are in shadow, use a dark tone to block them in. Where they are not, draw them in clearly. In our view, the area all around the falls is in shadow and it is this deep tonal mass that will help to give the drawing of the water its correct values. Leaving the area of the falls totally blank, put in the top edges of each ledge in the cliff face. Draw in the plunge pool and the reflection in the dark water at the base of the falls.

2. Leaving a clear area of white paper at the top of the ledges, indicate the downward fall of the water with very lightly drawn, closely spaced vertical lines. Don't overdo this. The white areas of paper are very important in convincing us that we are looking at a drawing of water.

# Sea: little and large

When you want to produce a landscape with the sea as part of it, you have to decide how much or how little of the sea you want to show. The viewpoint you choose may mean you have to draw very little sea, a lot of sea, or all sea. We examine these propositions in the next series of drawings, and look at ways of using the sea in proportion to the land.

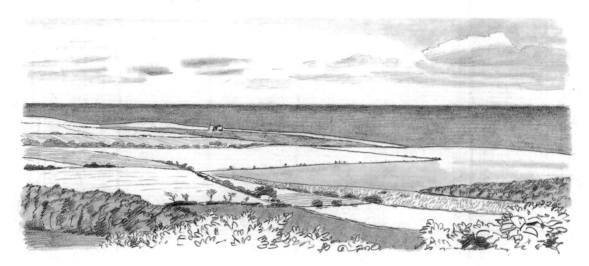

In our view of the Norfolk coast, the sea takes up about one-eighth of the whole picture. Because the landscape is fairly flat and the sky is not particularly dramatic, the wide strip of sea serves as the far distant horizon line. The result is an effective use of sea as an adjunct to depth in a picture. The calm sea provides a harmonious feel to the whole landscape.

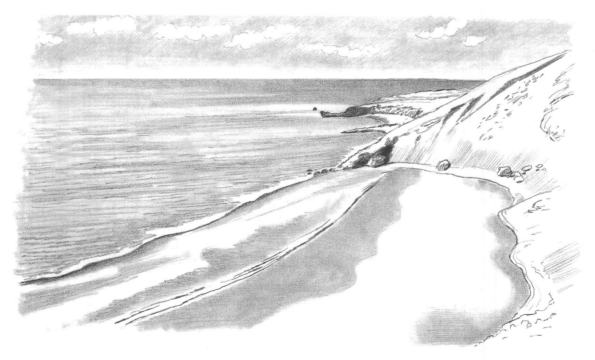

In the next scene, the sea takes up two-thirds of the drawing, with sky and land relegated in importance. The effect is one of stillness and calm, with none of the high drama often associated with the sea. The high viewpoint also helps to create a sense of detachment from everyday concerns.

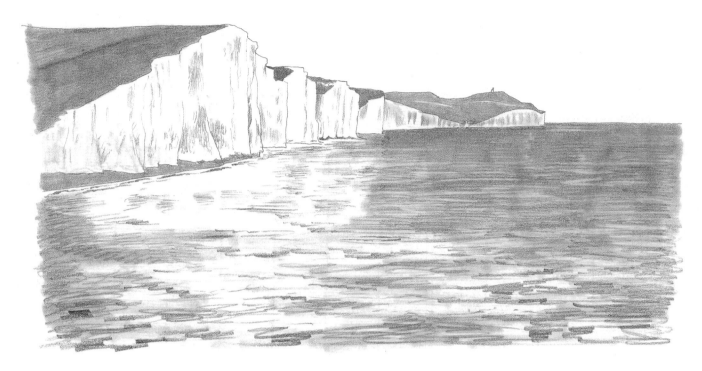

Such a large expanse of sea as this could be boring unless it was turbulent. However, what makes the scene interesting is the strip of solid earth jutting into the picture and dividing the sea from the sky. This transforms the sea into a foil for the rugged cliffs.

When the sea is the whole landscape, the result is called a seascape. Here, the boat with the three fishermen is just a device to give us some idea of the breadth and depth of the sea. If the sea is to be the whole scope of your picture, a feature like this is necessary to give it scale.

# Sky

The next series of pictures brings into the equation the basic background of most landscapes, which is, of course, the sky. As with the sea in the landscape, the sky can take up all or much of a scene, or very little. Here we consider some typical examples and the effects they create. Remember, you control the viewpoint. The choice is always yours as to whether you want more or less sky, a more enclosed or a more open view.

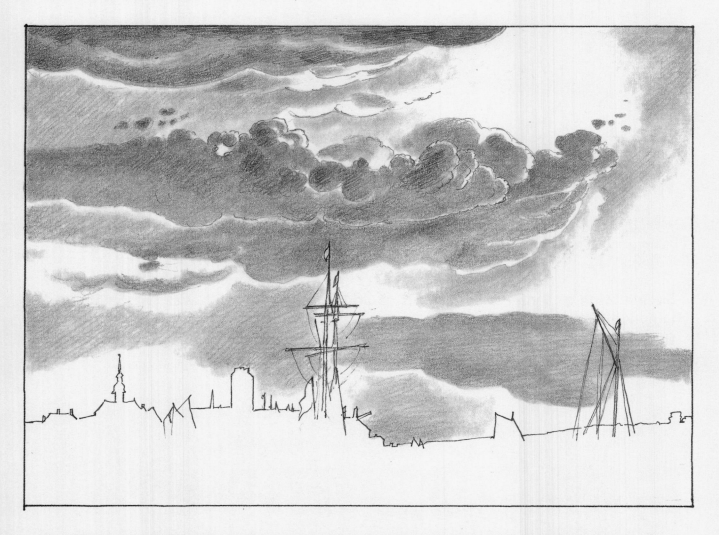

Our first example (after Albert Cuyp) is of a dramatic sky with a chiaroscuro of tones. Very low down on the horizon we can see the tops of houses, ships and some land. The land accounts for about one-fifth of the total area, and the sky about four-fifths. The sky is the really important effect for the artist. The land tucked away at the bottom of the picture just gives us an excuse for admiring the spaciousness of the heavens.

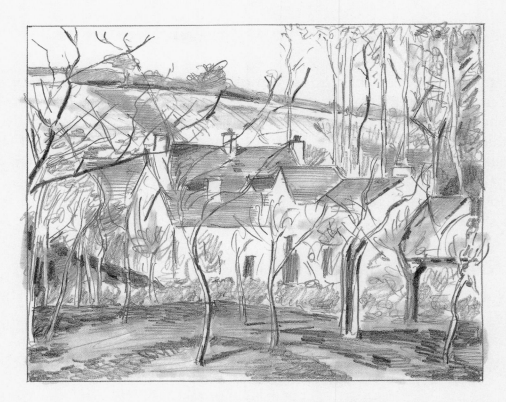

This country scene (after Pissarro) is a very different proposition. The downs behind the village, which is screened by the small trees of an orchard, allow us a glimpse of only a small area of sky beyond the scene. The fifth of sky helps to suggest space in a fairly cluttered foreground, and the latticework quality of the trees helps us to see through the space into the distance. It is important when drawing wiry trees of this type to capture their supple quality, with vigorous mark-making for the trunks and branches.

Constable's view of East Bergholt church through trees shows what happens when almost no sky is available in the landscape. The overall feeling is one of enclosure, even in this copy. Constable obviously wanted this effect. By moving his position slightly and taking up a different viewpoint, he could have included much more sky and banished the impression of a secret place tucked away.

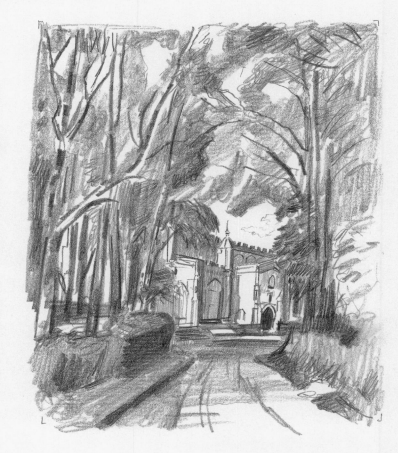

# Clouds

The importance of clouds to suggest atmosphere and time in a landscape has been well understood by the great masters of art since at least the Renaissance period. When landscapes became popular, artists began to experiment with their handling of many associated features, including different types of skies. The great landscape artists filled their sketchbooks with studies of skies in different moods. Clouded skies became a significant part of landscape composition, with great care going into their creation, as the following range of examples shows.

## After a follower of Claude Lorrain

This study is one of many such examples which show the care that artists lavished on this potentially most evocative of landscape features.

## After Caspar David Friedrich

One of the leading German Romantic artists, Friedrich gave great importance to the handling of weather, clouds and light in his works. The original of this example was specifically drawn to show how the light in the evening appears in a cloudy sky.

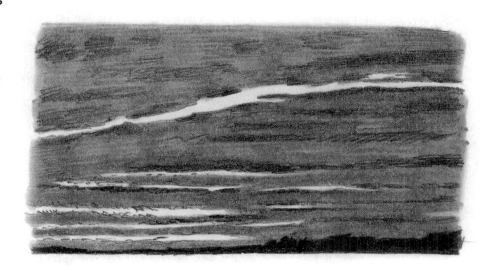

## After Willem van de Velde II

Some studies were of interest to scientists as well as artists, and formed part of the drive to classify and accurately describe natural phenomena.

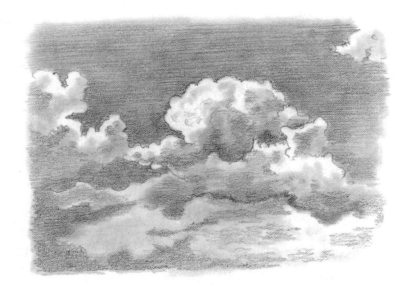

## After Alexander Cozens

The cloud effects are the principal interest here. The three evident layers of cloud produce an effect of depth, and the main cumulus on the horizon creates an effect of almost solid mass.

## After J. M. W. Turner

Together with many other English and American painters, Turner was a master of using cloud studies to build up brilliantly elemental landscape scenes. Note the marvellous swirling movement of the vapours, which Turner used time and again in his great landscapes and seascapes.

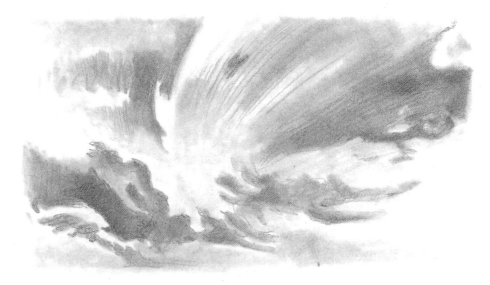

# Manipulating Space

The difference between the foreground, middleground and background is mainly one of distinctness. Foreground features are usually in the lower part of the picture, to either side or sometimes framing the whole view. Usually the main point of a picture is in the middleground. The background often holds the main feature – a mountain, for example – but even when it does not, it should never be regarded as of no account. A background such as a clear sky can be given interest, perhaps by the addition of a few atmospheric clouds.

It is best not to be too dogmatic about which area is the most important. All three grounds should work together to give the effect of space. It is very useful to decide how the grounds relate in a particular view. Once you have decided on their roles, you can then adapt your drawing techniques to emphasize the change that takes place as the eye moves into the depths of a picture. When you are next in a position to enjoy the view of a landscape, make the effort to work out which is your foreground and where it ends, which is your middleground and where it begins and ends, and where is your background. This systematizing will help you draw more convincingly.

## Foreground: leaves, grass and flowers

Plants drawn carefully instantly tell us that they are very close to the viewer and help to impart a sense of depth and space to a scene, especially when you contrast the detail of the leaves with the more general structure of whole trees further away. A very good practice is to draw in detail the leaves of plants in your garden, or even in pots in your house. This exercise is never a waste of time because it helps to keep your eye in and your hand exercised. The information you get from it about growth patterns will also help when you start on a full-scale landscape.

1. Our first example is of a fig bush with some vine leaves growing up from below a window and across the view of the fig. An exercise of this type gives you the chance to differentiate the closer plant from the further by altering your drawing style.

2. Tall grass, either ornamental or wild varieties, or cereal crops, can give a very open look in the forefront of a scene. The only problem is how much you draw – putting in too much can command all the attention and take away from the main point in a scene.

2.

3.

3. Drawing a single tuft of grass can be painstaking, but provides a useful reminder of the growth pattern of grass. Note how long, thin leaves bend out from the main plant with its seed-carrying stalk rising above them.

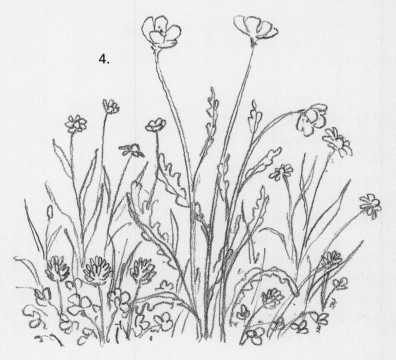

4.

4. A few clumps of flowers placed towards the front of a scene can quickly engage the eye and add to the freshness of your picture. Whatever variety of flower you choose, make sure you observe them closely to capture their habit and principal characteristics accurately.

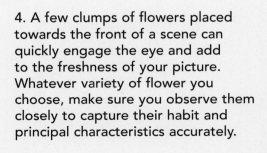

# Indicating distance

In most landscapes you visit, there will be objects that can work in your picture as an instant pointer to the distance beyond or the distance between the viewer and the object. In the drawings below, the subtler aspects have been purposely left out in order to show how foreground objects give definite clues about relative size and distance.

Here is a fence alongside a country road with an open field and trees behind it. The fence must stand at waist-height, giving the trees and spaces behind it a sense of distance, although these are drawn without any real effort to show distance variations. The croquet hoop provides another size indicator, but it is the fence that shapes our idea of depth here.

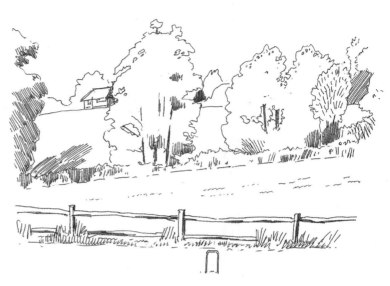

The large, chunky logs here, half-hidden in the long grass next to a low hedge, give a very clear indication of how close we are to them, and also how far we are from the stretch of hillside with its trees on the skyline.

The view on the right is across a steep valley I happened upon in an old village in Italy. On the opposite side, thickly wooded hills sweep up to the skyline. The diminutive-looking tower is in fact large enough to house a couple of bells.

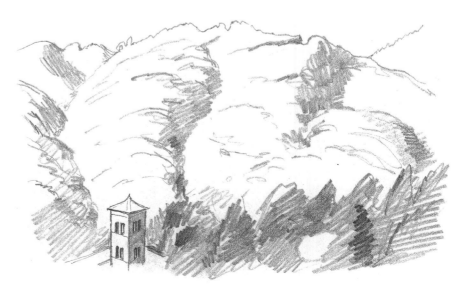

# Practising foreground features

Urban environments offer opportunities for practising drawing all sorts of objects you may want to include in your compositions as foreground details. A garden table and chairs, or machinery such as a bicycle are found in most households, and can be used creatively to make satisfying mini-landscapes. It is amazing how ordinary objects can add drama to a picture.

The bicycle lends an air of habitation to the blank corner on which it is balancing, with the vine curving around and up the brickwork. If part of the landscape could be seen past the corner, it would give a very sharp contrast between our position as viewers and whatever was visible behind. Even a small garden would give an effect of space. If the landscape were a street, the contrast would be even more dramatic.

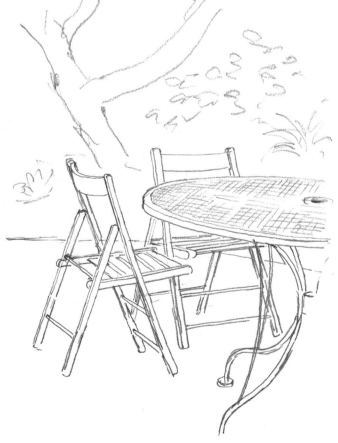

The faint indication of trees and bushes behind this sketch of chairs around a table gives a sense of open space, whether we are viewing the scene through a window or from a terrace outside. There is also an impression of life going on, but momentarily interrupted.

# Details of architecture

Architectural features abound in town and country, in fact anywhere there is human habitation. Any details of architecture that clearly give an impression of age and sometimes disrepair are always good points of interest to include in a landscape drawing.

Steps or the front of an ordinary house are the sorts of foreground details you might well want to include in a larger composition. The drawings here (above and right) are very good examples of the kinds of practice you will need if you are to develop your skills.

# Reflections of space

Water always works well in a landscape picture because it introduces a different dimension, as well as helping the viewer to gauge distance and space. Reflections of any kind present difficulties for the artist, but they are fascinating to draw. Once you begin to see how the tones and marks work, you will find them less problematical. Practising drawing puddles, ponds, lakes or rivers will quickly improve your ability to handle water. Use the ideas suggested in the following examples for practices of your own devising.

The puddles of rainwater on the path of an old country church help to produce an extra dimension of space as well as interest. What the wet path does very well is to define the flatness and space between the viewer and the walls and plants. The effect of the water on the path gives the surface a bright quality that contrasts well with the elements in the rest of the picture.

The pond in front of old houses is what takes our interest here. It provides a space that separates us from the buildings, but without obscuring anything. I have deliberately left out the details of the buildings to emphasize the pond's effectiveness in denoting distance. Note how the plants on the near side of the pond also act as visual indicators of distance. However, it is the smooth plane of the water, with its reflections of the darker parts of the houses, which forms our sense of space.

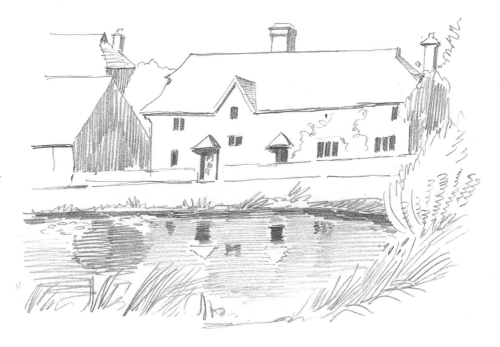

# The middleground

If a foreground has done its job well, it will lead your eye into a picture, and then you will almost certainly find yourself scanning the middleground. This is, I suppose, the heart or main part of most landscape compositions, and in many cases will take up the largest area or command the eye by virtue of its mass or central position. It is likely to include the features from which the artist took their inspiration, and which encouraged them to draw that particular view. Sometimes it is full of interesting details that will keep your eyes busy discovering new parts of the composition. Often the colour in a painting is strongest in harmony and intensity in this area. The story of the picture is usually to be found here, too, but not always; some notable exceptions will be among the examples shown here. The eye is irresistibly drawn to the centre and will invariably return there, no matter how many times it travels to the foreground or onto the background. The only occasion when the middleground can lose some of its impact is if the artist decides to reduce it to very minor proportions in order to show off a sky. If the proportion of the sky is not emphasized, the eye will quite naturally return to the middleground.

Let us now compare and contrast some treatments of the middleground, starting with two sharply contrasting examples.

NB: In order to emphasize the area of the middleground, I have shaded the foreground with vertical lines, and the extent of the background is indicated by dotted lines.

## A classical approach

The centre of this picture (after John Knox) contains all the points of interest. We see a beautiful valley of trees and parkland, with a few buildings that help to lead our eye towards the river estuary. There, bang in the centre, is a tiny funnelled steamship, the first to ply back and forth along Scotland's River Clyde, its plume of smoke showing clearly against the bright water. Either side of it on the water, and making a nice contrast, are tall sailing ships. Although the middleground accounts for less than half the area taken up by the picture, its interesting layout and activity take our attention.

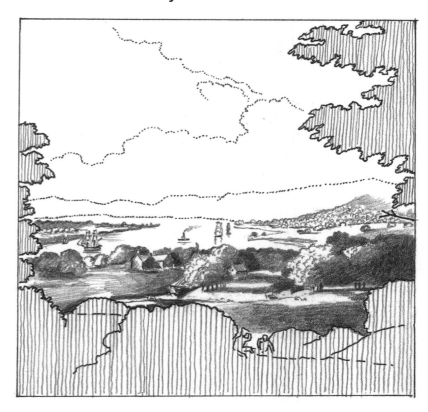

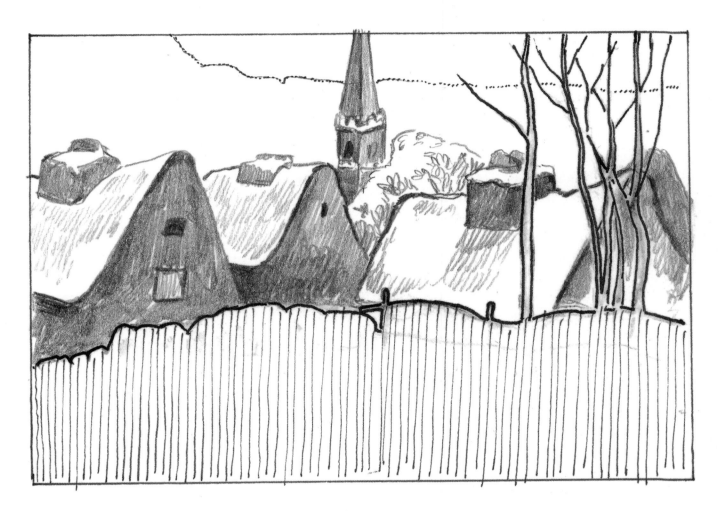

## An unusual approach

In this snow scene (after Gauguin), the foreground, middleground and background take up about the same amount of space each. The primary importance of the middle area is suggested by keeping both the foreground and background very simple and devoid of features. The only details we notice are the tree pattern stretching from the foreground across both the middle- and background, and the church steeple bisecting the background. The interest in the picture is framed between these two empty spaces, which are made to seem emptier still by the snow. By contrast, the central area is full of shape and colour.

# Creating a Landscape

I would now like you to plan out a landscape of your own, using the model provided here as guidance. You might also like to refer back to the chapter on Basics at the beginning of the book.

Sometimes you will go out and just happen on a view that you want to draw. This is often the basis of the way we choose our landscape pictures. But often it is not good enough simply to pick any view from wherever you happen to be. Whatever your level of expertise, there is a right way that produces a good result. The wrong way wastes your time and may put you off altogether. I am going to show you a useful way to choose a view, which will stand you in good stead for all future landscape endeavours.

Go to an area convenient to you, where you think you have a good chance of finding attractive views. Take a couple of sketchbooks (A3 or A4) and then move around the area, assessing the merits of various places that look interesting. The drawings and sketches you do at this stage are part of the preliminary work every artist undertakes in preparation for a final drawing. Then you can plan out a drawing incorporating all the features and details you expect to include in your drawing. On another occasion you will need to draw up a full-size outline sketch of the whole picture, and after incorporating all the information you have decided to include, you can embark upon your finished piece of work.

The whole exercise may take several days. As long as you are methodical and keep track of your progress, this time can be spaced out over several weeks. Don't hurry any aspect of the process, or the end result will suffer.

## Looking for the view

First, choose an area that you would like to draw. Most people prefer to draw a country scene, but if that is not very convenient, maybe there is a large park or country house with extensive grounds near where you live.

The countryside nearest my home is Richmond Park. I knew I would find good views across the landscape, this being the highest point in the area.

As you can see from the plan of my route, I undertook quite a hike to assess the various viewpoints. It was a lovely summer day, just right for drawing in the open. Part of the fun of this type of exercise is searching for scenes and details that spark your interest.

All the views and details referred to in the following pages are included in the map and key (facing page). You will need to draw up a similar map to ensure that you have a record of what you have done when you return to the scene later. Don't think you can rely on memory alone. You can't, and if you try, you will only succeed in ruining what is an immensely enjoyable and rewarding experience.

Start and Finish

## Key to Viewing Points and Features

| VP1 | View across parkland |
|---|---|
| VP1A | Detail of ferns |
| | |
| VP2A | View to left across park from hilltop |
| VP2B | View to centre left across park |
| VP2C | View to centre across park |
| VP2D | View to centre right across park |
| VP2E | View to right across park |
| | |
| VP3 | Shattered oak tree |
| VP4 | Large chestnut tree near café where I stopped for lunch |
| VP5 | Large log |
| VP6 | View of ponds in distance from hill |
| VP7 | View of ponds from lower down |

HILL TOP
Wood
VP5
VP6
HILL TOP
VP4
Lodge
Pond
Restaurant Cafe
VP7
Pond
Plantation
Pond
VP3
VP2 ABCDE
HILL TOP
Wood
VP1 A
Pond
Artist's route

# Setting out

As you can see from my map-diagram, I started from the gates of the park and walked slowly up the hill, looking back occasionally to see what the view was like. About halfway up the hill I thought the view looked quite interesting, so

From position 1

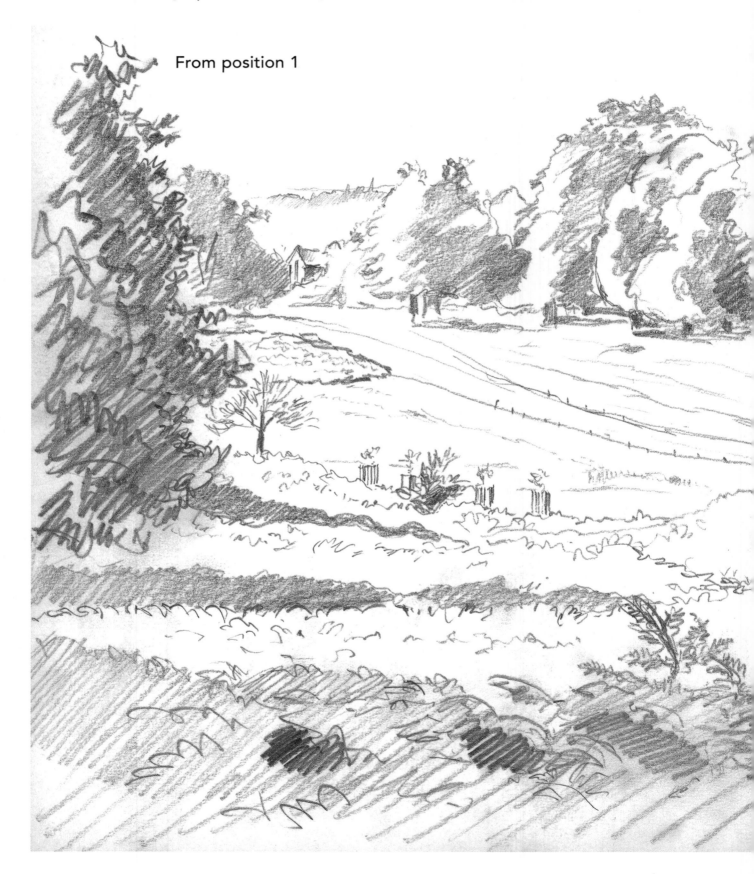

I sat down and sketched the main parts very simply (1). Much of the drawing is very minimal, like a sort of shorthand. This is because I am just looking for possibilities. The purpose is not to produce a finished picture. Some ferns caught my eye, and I drew them as a possible detail to provide local colour (1A).

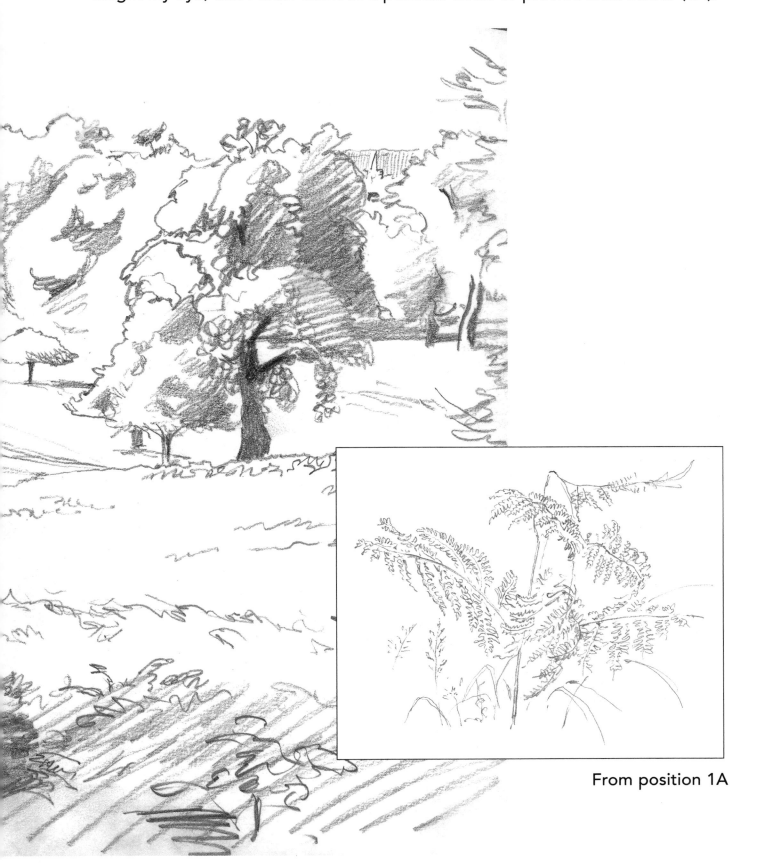

From position 1A

## An eye for detail

In any landscape you need to pay attention to details that might be included in the foreground. In the plantation area of the park I came across a superb blasted oak, mostly dead, its angular branches stabbing up into the sky. As you can see, it makes a good focal point, but would you place it centrally in your picture or to the right or left side? Compositional and structural aspects will strike you even at this stage, when your main aim is to decide where to draw from.

By this time I was hot and hungry. I went across to the café in the park, which has a very good view from its windows.

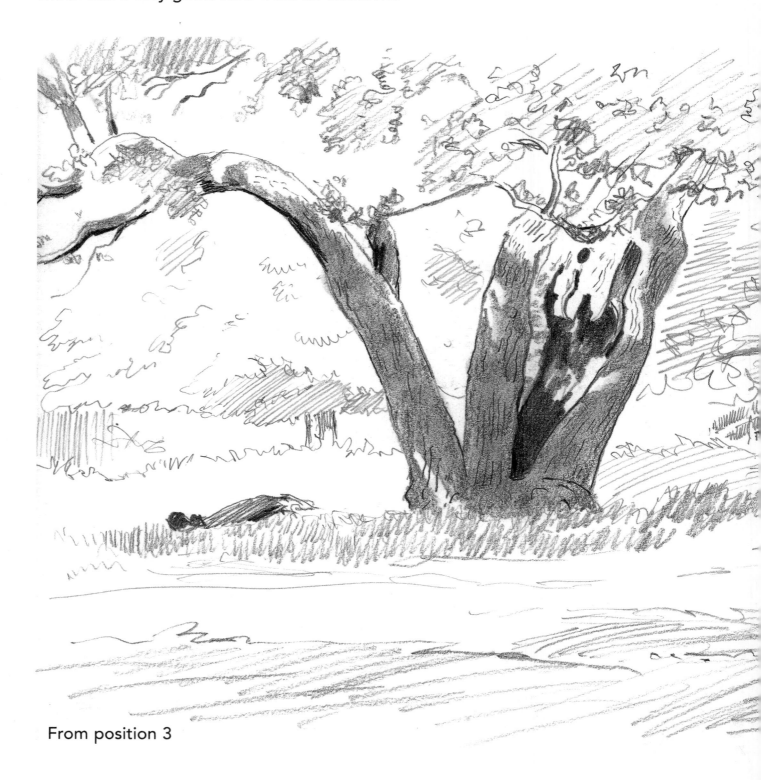

From position 3

As I walked through the gardens surrounding the café, a superb group of chestnut trees set up on a mount presented themselves. I couldn't resist doing another tree portrait (4). This sort of close-up is useful in a composition that includes a long-distance view because it helps to give an appearance of space. This time I produced a more finished sketch. Drawings of groups of trees are always useful, and the more information I have about them, the greater is the likelihood of including them in one of my landscapes.

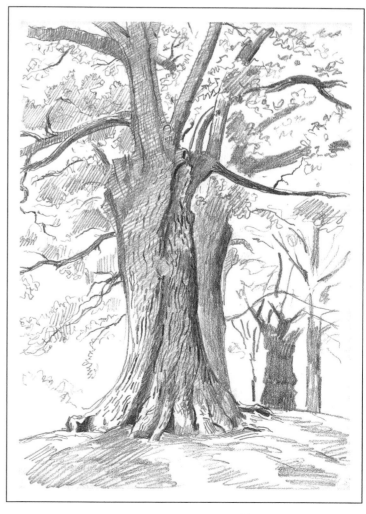

From position 4

# Decision time

Now comes the decision making, which will be based on your sketches and memory. If you are planning a complicated landscape, you might want to consider taking photographs as well as sketches.

Looking at all my sketches, I decided to opt for two particular views, but including one of the large trees or the log somewhere in the foreground.

I quite liked the look of the two centre views (2B and 2C) from the panorama, plus the river to the left. I considered shortening the view slightly, keeping the left-hand edge as a final point and placing the central area with the blasted oak towards the right-hand edge of the picture. Then I thought it would

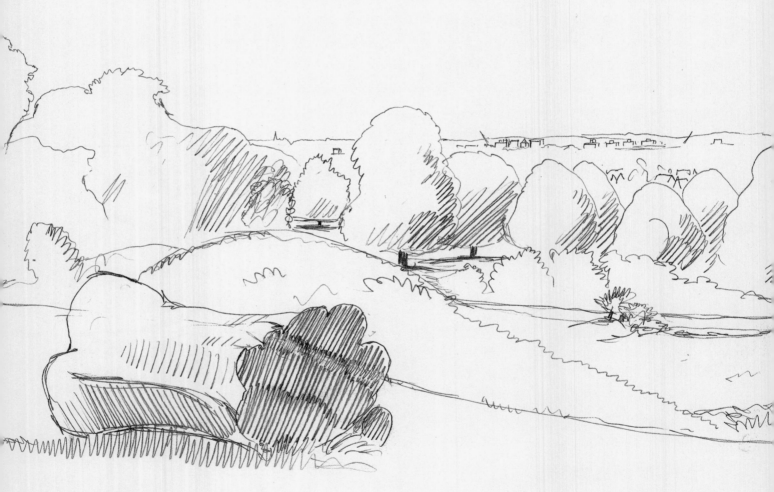

Created from positions 2A, 2C, 2D and 5

be an effective touch to introduce something nearer to the foreground – here is where one of my large trees or the large log would come in handy (5).

For my second option, I considered the long view of the ponds first. The trees on either side gave it a good frame, but it needed something else to give it interest. I decided to extend the central area with details taken from the closer view. But what about the foreground – should I add anything there? I thought not, to avoid the picture looking crowded.

Which of these two possibilities did I go for? In the end, I opted for the part-panoramic view. The next stage was to draw up a diagram of how I thought this view might work.

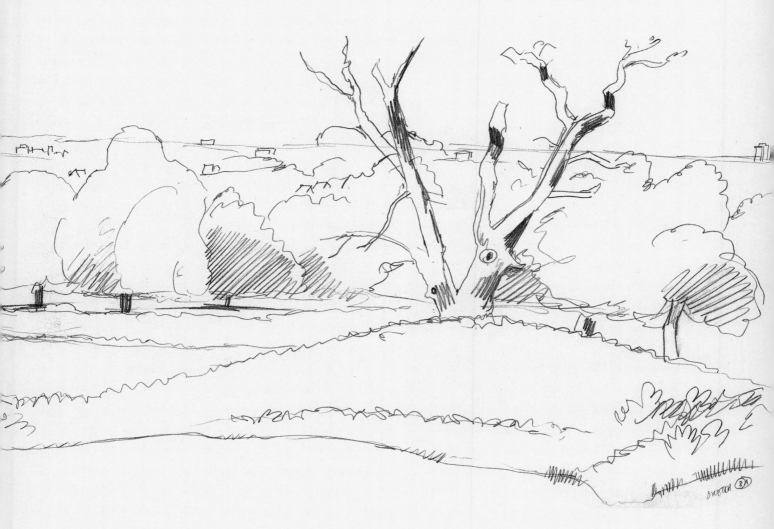

# The outline drawing

The penultimate stage is to make an outline drawing of the whole scene as you intend to produce it, full-size. You need to include all the details that are to go in your final picture. These can be taken from your sketches, but only if you

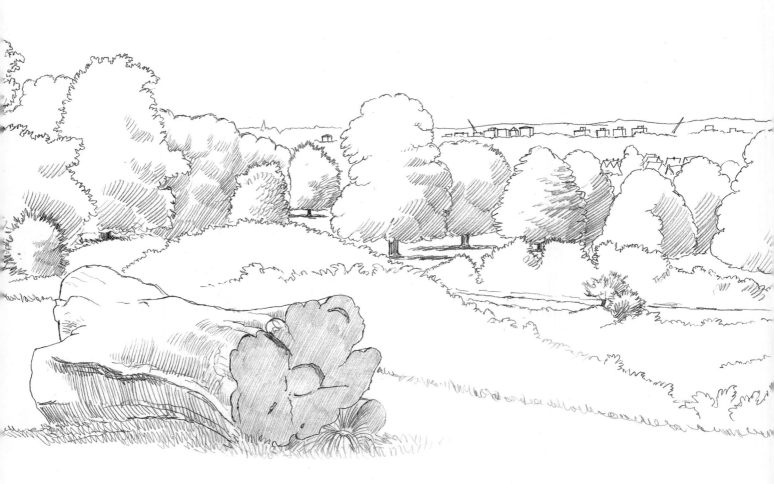

have all the information you need. If you find yourself lacking in information, you will have to go back to your location, but this time taking your original sketches with you and the diagrammatic drawing.

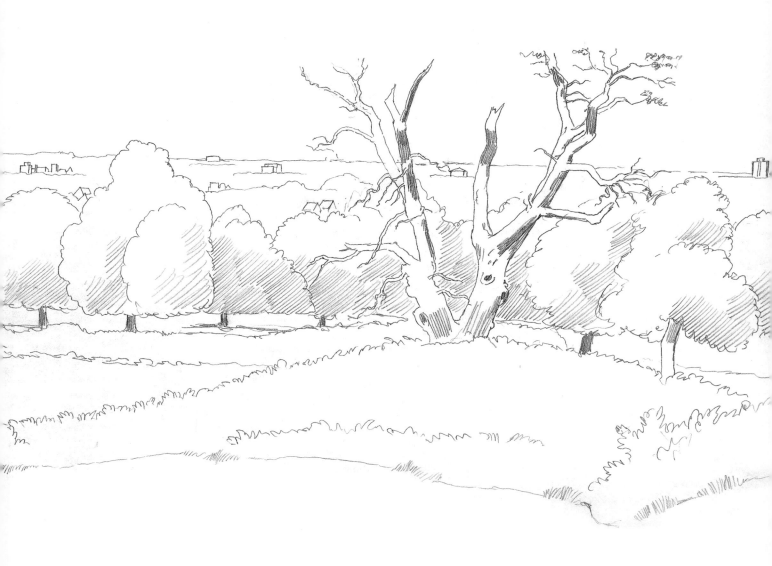

## The finished drawing

Now comes the final effort. This must not be hurried, and if it takes longer than one day, so be it. Recently I completed a picture of the interior of a studio I work in, just for practice, and it took me two full days. I used pencils of various grades, a stick of charcoal for soft shadows, and a stump to smudge some of the mark-making to keep it subtle. The second day was taken up with doing a colour sketch in oils. Never allow time to be a problem.

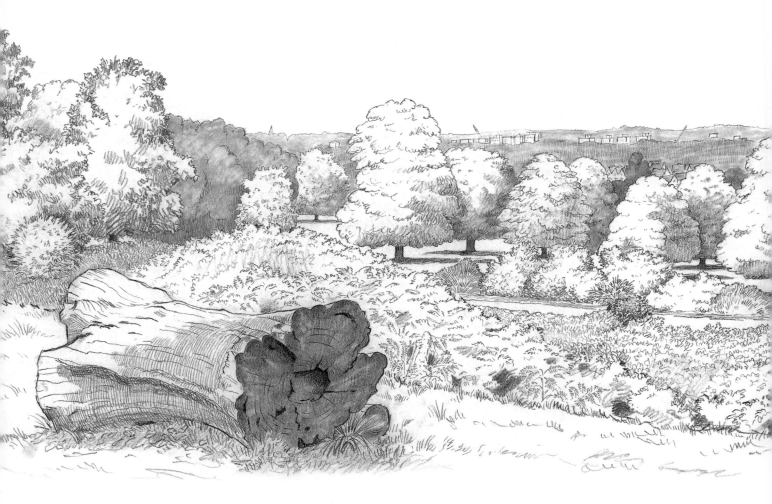

Everything at this stage depends on your artistic development and your attitude. A large part of the resulting judgement of you as an artist will be based on how well you can produce finished drawings. Although talent can bring that extra-special touch to a work, a great deal can be accomplished with persistence and endeavour. Indeed, talent without these other two qualities will not go far. It is only through hard work and a willingness to learn from our mistakes and the example of others that any of us can improve.

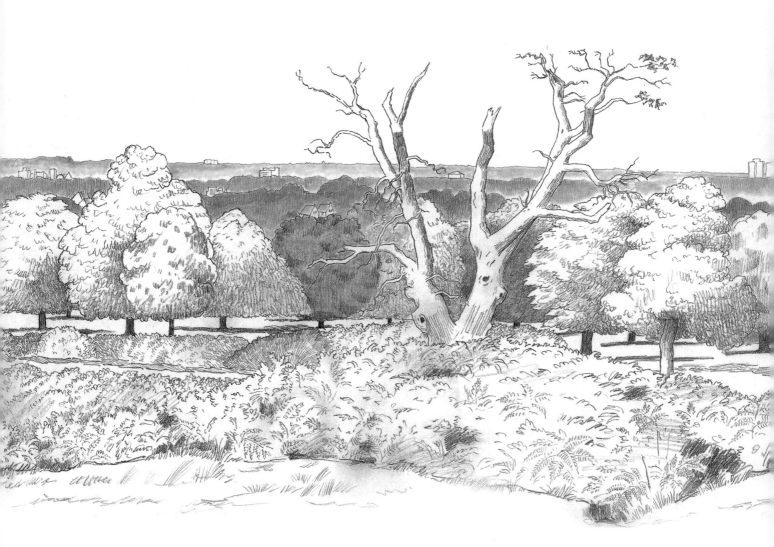

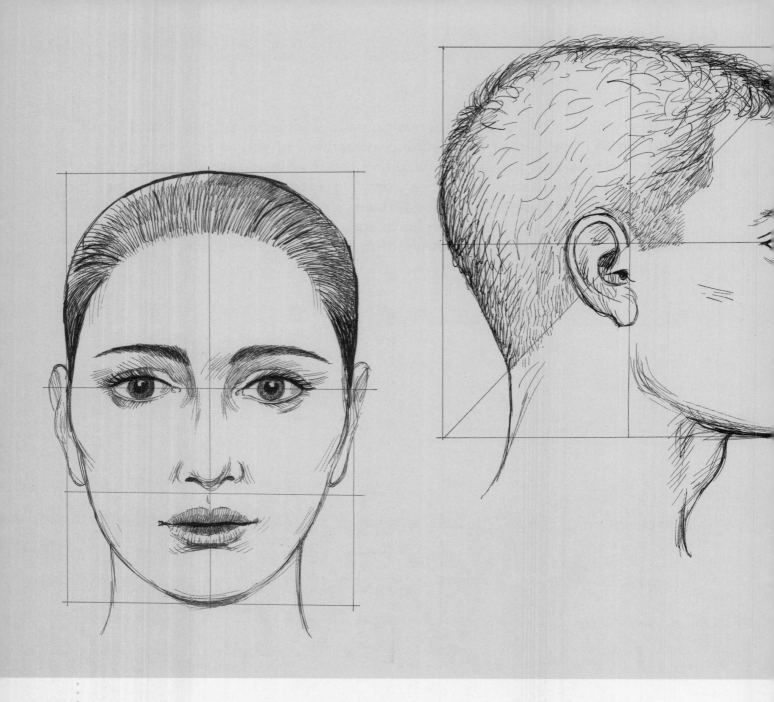

# Figures and Faces

For many artists, figure drawing is the pinnacle of their studies and also the most difficult theme to master. Whether drawing from a live model sitting in a studio, sketching people going about their daily lives or copying a person from a photograph, everything begins with an understanding of what lies beneath the skin. This chapter starts with an examination of human

physiology, providing the groundwork necessary for making your figures look solid and real. There is guidance on planning your compositions and choosing your subject's pose or activity, and then figures and faces are examined in detail, revealing the best methods for working out proportions, getting the lighting right and producing a lifelike, full-scale portrait.

# Understanding Anatomy

Before beginning to draw people, we first need to explore the basic physiology of the human body, looking at the proportions, the structure and the obvious variations between male and female, child and adult. To draw the human figure successfully, it is essential to have some acquaintance with what lies beneath the skin; if you lack that, your drawing will at best have a superficial slickness, and at worst will not be at all convincing.

## Proportions of the human figure

Here I have drawn a front view and a back view of the male and female body. The two sexes are drawn to the same scale because I wanted to show how their proportions are very similar in relation to the head measurement. Generally, the female body is slightly smaller and finer in structure than that of the male, but of course sizes differ so much that you will have to use your powers of observation when drawing any individual.

These drawings assume the male and female are both exactly the same height, with both sexes having a height of eight times the length of their head. This means that the centre of the total height comes at the base of the pubis, so that the torso and head are the upper half of this measure, and the legs account for the lower half. Note where the other units of head length are placed, for example the second unit is at the armpits. This is a useful scale to help you get started.

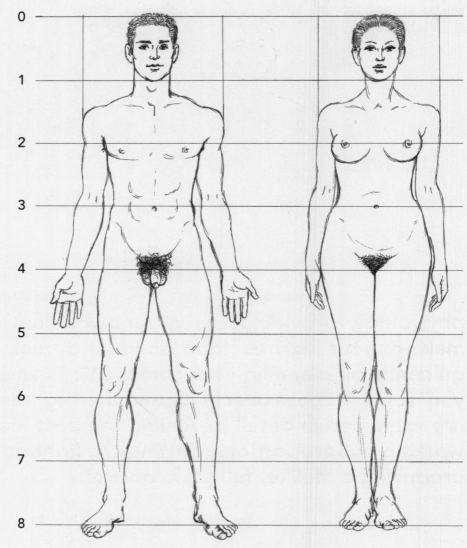

Even if these diagrams seem a bit academic, don't be tempted to skip the diagrams to get on quickly to drawing the whole figure. Putting in the groundwork at this stage will make your figures look more solid and more real, and will make viewers see exactly the human quality you wish to portray. You probably will not remember all the scientific names any more than I do, but the effort to learn something about them is never wasted and, in my experience, often comes back to help you when you least expect it. When you come to draw a figure from life, you may also wish to refer back to these diagrams to clarify in your own mind what you have actually seen and drawn.

These two examples are of the back view of the two people on the facing page, with healthy, athletic builds. The man's shoulders are wider than the woman's, and the woman's hips are wider than the man's. This is, however, a classic proportion, and in real life people are often less perfectly formed. This is a good basic guide to the shape and proportion of the human body.

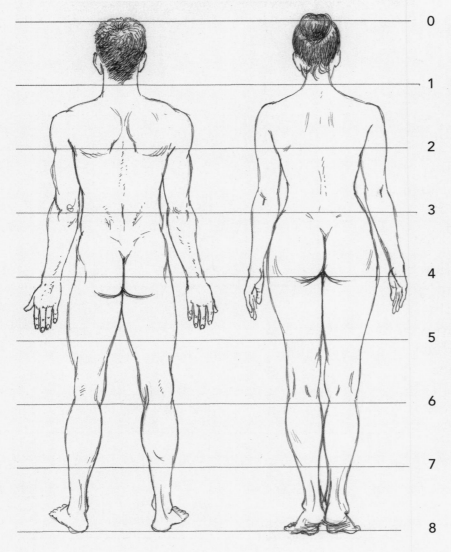

0

1

2

3

4

5

6

7

8

The man's neck is thicker in relation to his head, while the female neck is more slender. Notice also that the female waist is narrower than the man's, and the general effect of the female figure is smoother and softer than the man's more hard-looking frame. This is partly due to the extra layer of subcutaneous fat that exists in the female body: mostly the differences are connected with childbirth and child rearing; women's hips are broader than men's for this reason too.

# Proportions of children

The proportions of children's bodies change very rapidly, and because children grow at very different speeds, what is true of one child at a certain age may not always be true of another. Consequently, the drawings here can only give a fairly average guide to children's changes in proportion as they get older. The first factor, of course, is that a child's head is much smaller than an adult's, and only achieves adult size at around 16 years old.

The thickness of children's limbs varies enormously, but often the most obvious difference between a child, an adolescent and an adult is that the limbs and body become more slender as part of the growing process. In some types of figure there is a tendency towards puppy fat, which makes a youngster look softer and rounder. The differences between shoulder, hip and wrist width that you see between male and female adults are not so obvious in a young child, and boys and girls often look similar until they reach puberty.

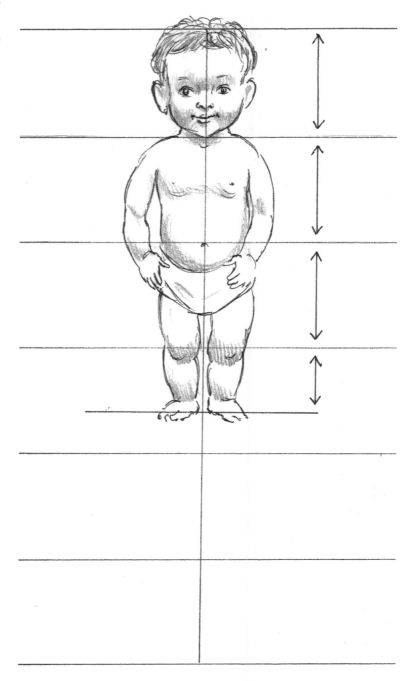

At the beginning of life, the head is much larger in proportion to the rest of the body than it will be later on. Here I have drawn a child of about 18 months old, giving the sort of proportion you might find in a child of average growth. The height is only three and a half times the length of the head, which means that the proportions of the arms and legs are much smaller in comparison to those of an adult.

At the age of about six or seven, a child's height is a little over five times the length of the head, though again this is quite variable. At about 12 years, the proportion is about six times the head size. Notice how in the younger children the halfway point in the height of the body is much closer to the navel, but this gradually lowers until it reaches the adult proportion at the pubic edge of the pelvis where the legs divide. What also happens is that the relative width of the body and limbs in relation to the height gradually becomes slimmer, so a very small child looks very chubby and round, whereas a 12-year-old can look extremely slim for their height.

# The skeleton

Learning the names of the bones that make up the human skeleton and how they connect to each other throughout the body may seem rather a dry exercise, but they constitute the basic scaffolding upon which the body is built, and to have some familiarity with this element of the human frame will really help you to understand the figures you draw.

Front view (anterior)

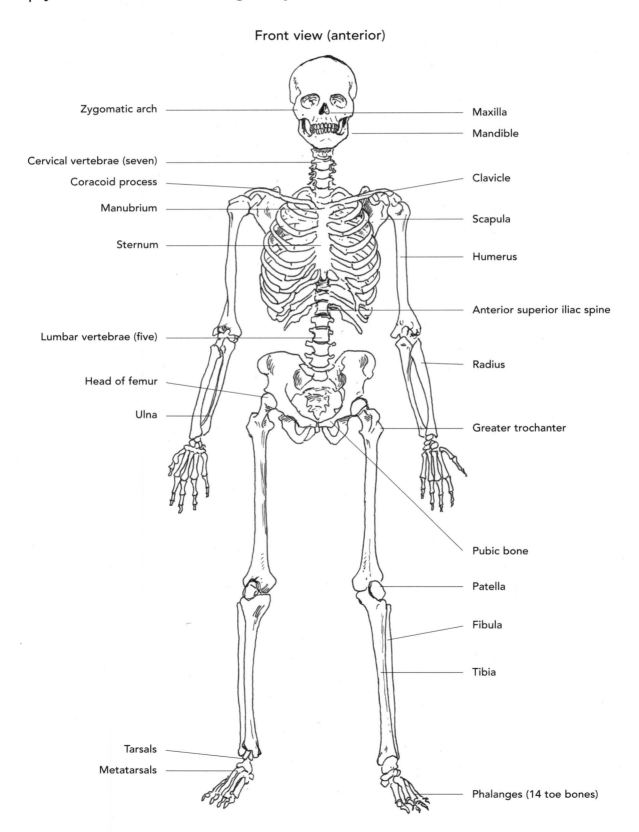

Zygomatic arch

Cervical vertebrae (seven)

Coracoid process

Manubrium

Sternum

Lumbar vertebrae (five)

Head of femur

Ulna

Tarsals

Metatarsals

Maxilla

Mandible

Clavicle

Scapula

Humerus

Anterior superior iliac spine

Radius

Greater trochanter

Pubic bone

Patella

Fibula

Tibia

Phalanges (14 toe bones)

Just making the attempt to copy a skeleton, especially if you get a really close-up view of it, will teach you a lot about the way the body works. It is essential that you can recognize those places where the bone structure is visible beneath the skin, and by inference get some idea about the angle and form of the bones even where you can't see them. Most school science laboratories have carefully made plastic skeletons to draw from, or if you know an artist or art school where there is a real one, that is even better. It will be time well spent.

Back view (posterior)

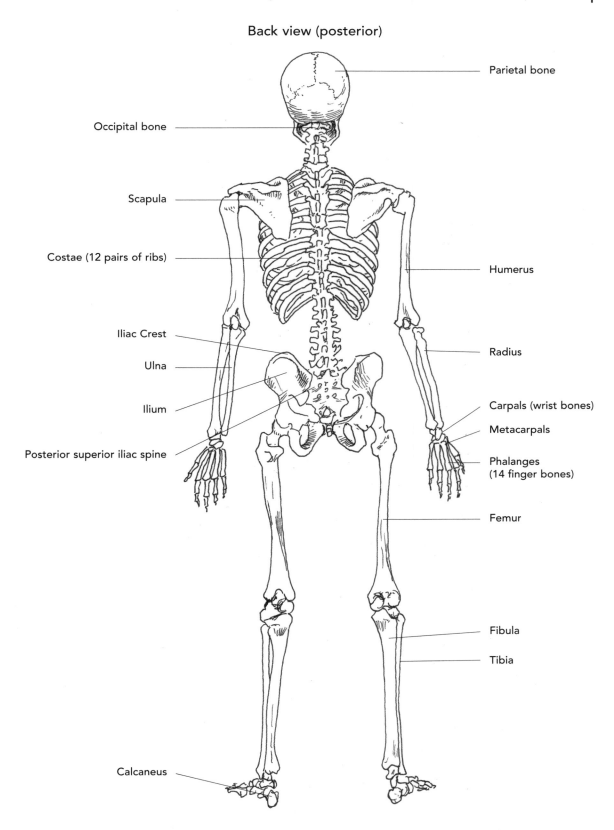

Parietal bone

Occipital bone

Scapula

Costae (12 pairs of ribs)

Humerus

Iliac Crest

Ulna

Radius

Ilium

Carpals (wrist bones)

Metacarpals

Posterior superior iliac spine

Phalanges
(14 finger bones)

Femur

Fibula

Tibia

Calcaneus

# Musculature

After studying the skeleton, the next logical step in understanding human anatomy is to examine the muscular system. This is more complicated, but there are many good books showing the arrangement of all the muscles and how they lie across each other and bind around the bone structure, giving us a much clearer idea of how the human body gets its shape.

Front view (anterior)

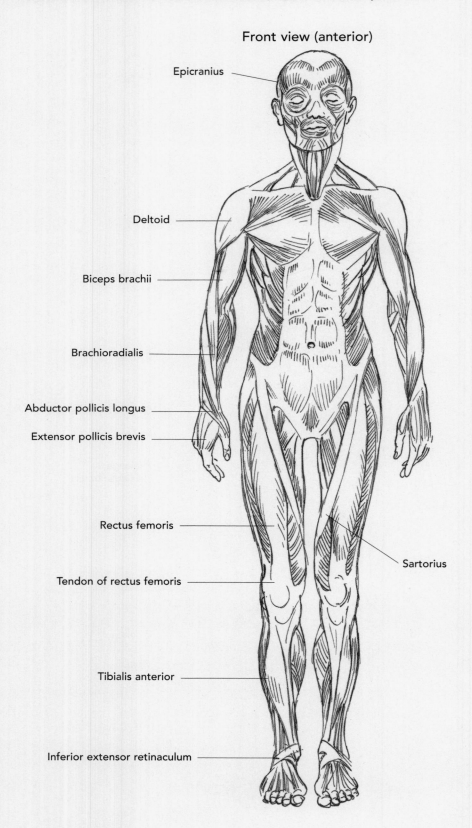

Epicranius

Deltoid

Biceps brachii

Brachioradialis

Abductor pollicis longus

Extensor pollicis brevis

Rectus femoris

Sartorius

Tendon of rectus femoris

Tibialis anterior

Inferior extensor retinaculum

As artists, our primary interest is in the structure of the muscles on the surface. There are two types of muscles that establish the main shape of the body, and these are either striated or more like smooth cladding. The large muscles are the most necessary ones for you to know, and once you have familiarized yourself with these, it is only really necessary to investigate the deeper muscle structures for your own interest. If you can remember the most obvious muscles, that is good enough for the purposes of drawing figures.

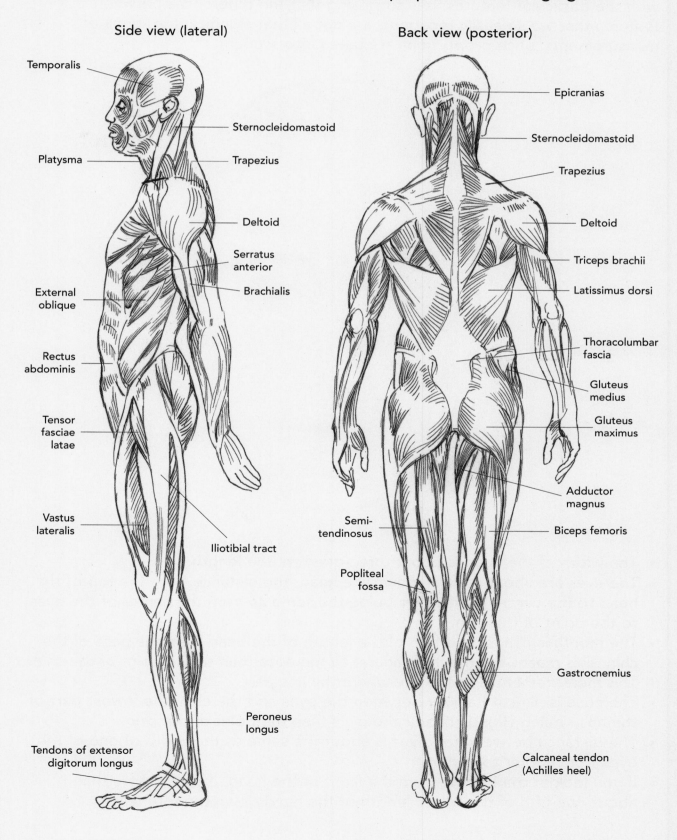

Side view (lateral)

Temporalis
Sternocleidomastoid
Platysma
Trapezius
Deltoid
Serratus anterior
Brachialis
External oblique
Rectus abdominis
Tensor fasciae latae
Vastus lateralis
Iliotibial tract
Peroneus longus
Tendons of extensor digitorum longus

Back view (posterior)

Epicranias
Sternocleidomastoid
Trapezius
Deltoid
Triceps brachii
Latissimus dorsi
Thoracolumbar fascia
Gluteus medius
Gluteus maximus
Adductor magnus
Semi-tendinosus
Biceps femoris
Popliteal fossa
Gastrocnemius
Calcaneal tendon (Achilles heel)

# The head

The first and most obvious detail of the human figure is the head, with its major role in defining the figure's appearance. Shown here are the basic proportions of the head, both from the front and in profile. There are obvious differences between people's faces, especially between those of males and females, but at this stage we will just look at a youthful adult head and not concern ourselves with the particular features. It is surprising that the differences between features that we so easily recognize are not all that significant in terms of measurements, once proportions are taken into account.

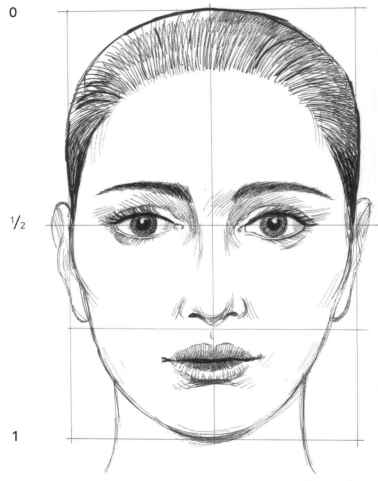

- The width of the head is about three-quarters the length.
- The eyes are about halfway down the head, the distance from the top of the head to the centre of the eyes being the same as from the centre of the eyes to the point of the chin.
- The mouth is almost one-fifth of the length of the head from the base of the chin. This means the mouth is nearer to the nose than to the point of the chin. This measurement is to the line where the lips part.
- The nose is almost halfway between the eyes and the chin, the lowest part of the nose being slightly nearer the eyes than the point of the chin.
- The distance between the eyes is about the same as the width of one of the eyes from corner to corner.
- If you look at the hairline from the front of the head, it is not more than about one-fifth of the whole length of the head down the forehead.

When you are drawing the human figure, it is important to treat the head as part of the whole shape and not be too caught up by the facial features. The main shape of the skull is the most important form in relation to the whole figure. There are a few essential points to look out for: don't make the eyes too big; don't make the features too large for the whole head; and from the side, don't project the jaw too far forward. These are all typical beginners' mistakes, so watch out for them.

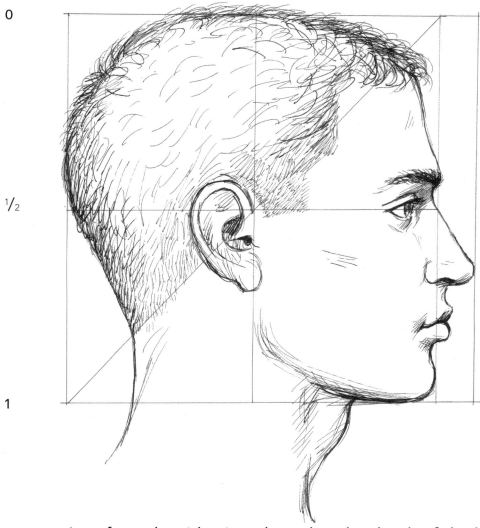

- The proportions from the side view show that the depth of the head from the front of the forehead to the back of the head comes out at about the same measurement as the width of the head. However, the nose projects beyond this point.
- From the side, the hairline (provided the subject has got all their hair) takes up about half the area of the head in a diagonal line across the whole shape of the head.
- The ear projects into this area, and the hair may not cover the line around the higher part of the forehead. Just in front of the ear, the hair will project across this line a little.

# Bones and muscles of the head

As with the rest of the human frame, the appearance of the head is dictated by the underlying bone structure and the muscles that cover it. Because the bones are close to the surface, it is easier to discern their form than in most other parts of the body – particularly if the subject is thin, when you may even be able to see the bumpy surface of the bone at the temple.

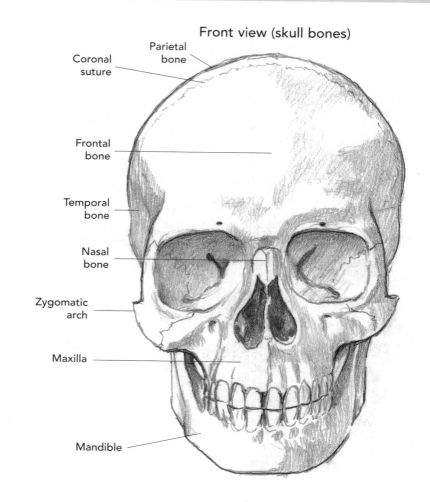

**Front view (skull bones)**

Coronal suture

Parietal bone

Frontal bone

Temporal bone

Nasal bone

Zygomatic arch

Maxilla

Mandible

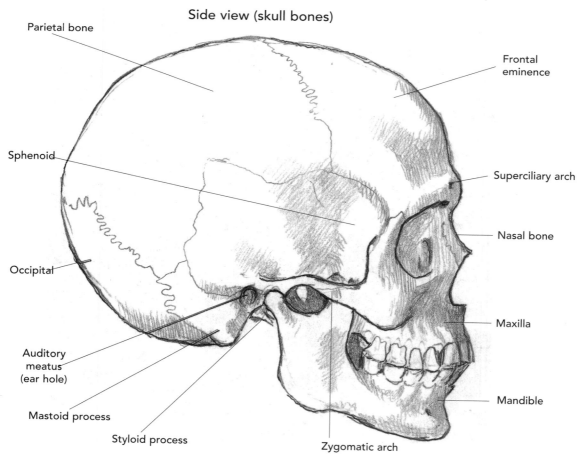

**Side view (skull bones)**

Parietal bone

Sphenoid

Occipital

Auditory meatus (ear hole)

Mastoid process

Styloid process

Zygomatic arch

Frontal eminence

Superciliary arch

Nasal bone

Maxilla

Mandible

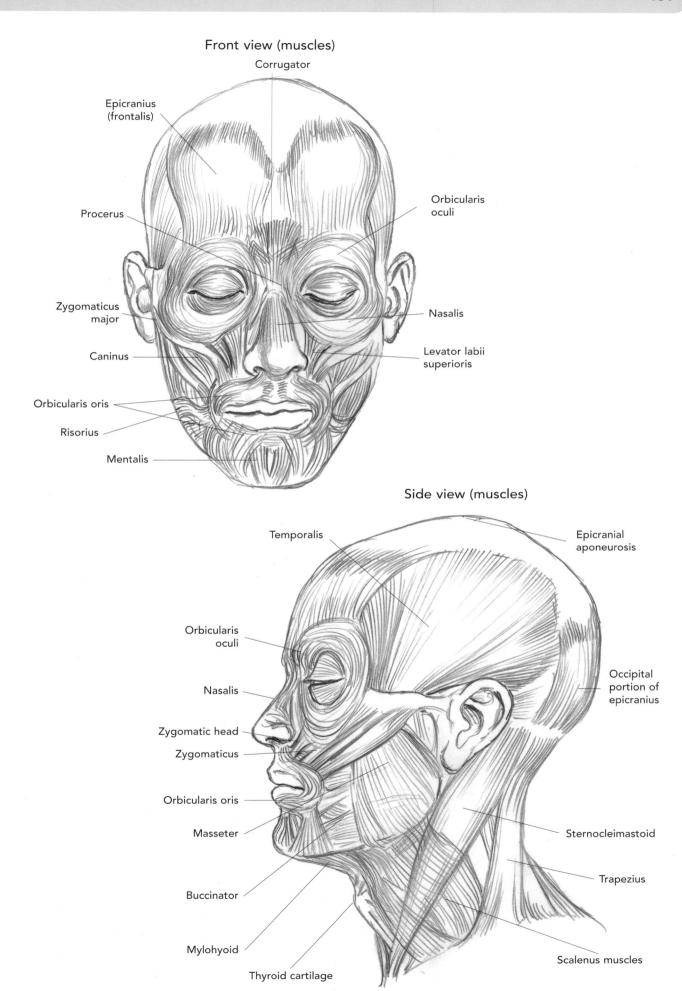

## Front view (muscles)

Corrugator

Epicranius (frontalis)

Procerus

Orbicularis oculi

Zygomaticus major

Nasalis

Caninus

Levator labii superioris

Orbicularis oris

Risorius

Mentalis

## Side view (muscles)

Temporalis

Epicranial aponeurosis

Orbicularis oculi

Nasalis

Occipital portion of epicranius

Zygomatic head

Zygomaticus

Orbicularis oris

Masseter

Sternocleimastoid

Buccinator

Trapezius

Mylohyoid

Thyroid cartilage

Scalenus muscles

# The head from different angles

Here I have drawn the head seen from a variety of different angles. In the main there are no particular details of the face – just the basic structure of the head when seen from above, below and the side. Notice how the line of eyes and mouth curve around the shape of the head; if you omit to show this, the features will not fit in with the curve of the head when viewed from an angle. When seen from a low angle, the curve of the eyebrows becomes important, as does that of the cheekbones – so you should study these carefully.

Sometimes the nose appears to be just a small point sticking out from the shape of the head, especially when seen from below. The underside of the chin also has a very characteristic shape, which is worth noting if you want your drawing to be convincing. Conversely, when seen from above, the chin and mouth almost disappear, but the nose becomes very dominant. From above, the hair becomes very much the main part of the head, whereas when seen from below the hair may be visible only at the sides.

# The muscles of the torso

When you draw the torso of a human being, it is very important to have some idea of what the muscle structure is like underneath the skin. The drawings here show the major muscle groups, the visibility of which will depend upon the fitness of the figure you are drawing. The popularity of working out in the gym to achieve a toned body means that you should not find it too difficult to find someone with a well-developed torso to pose for you, so that you can make the most of the musculature shown here.

Front view

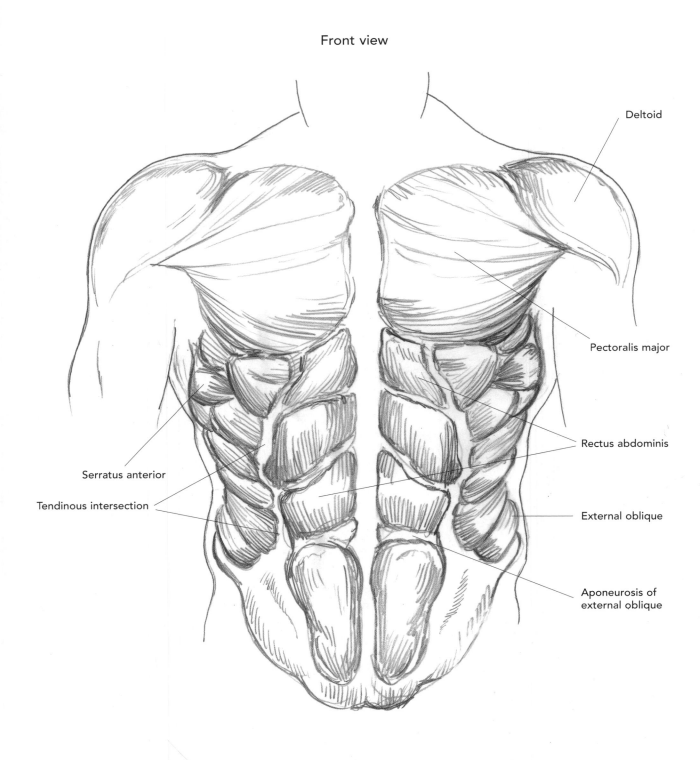

Deltoid

Pectoralis major

Serratus anterior

Tendinous intersection

Rectus abdominis

External oblique

Aponeurosis of external oblique

Back view

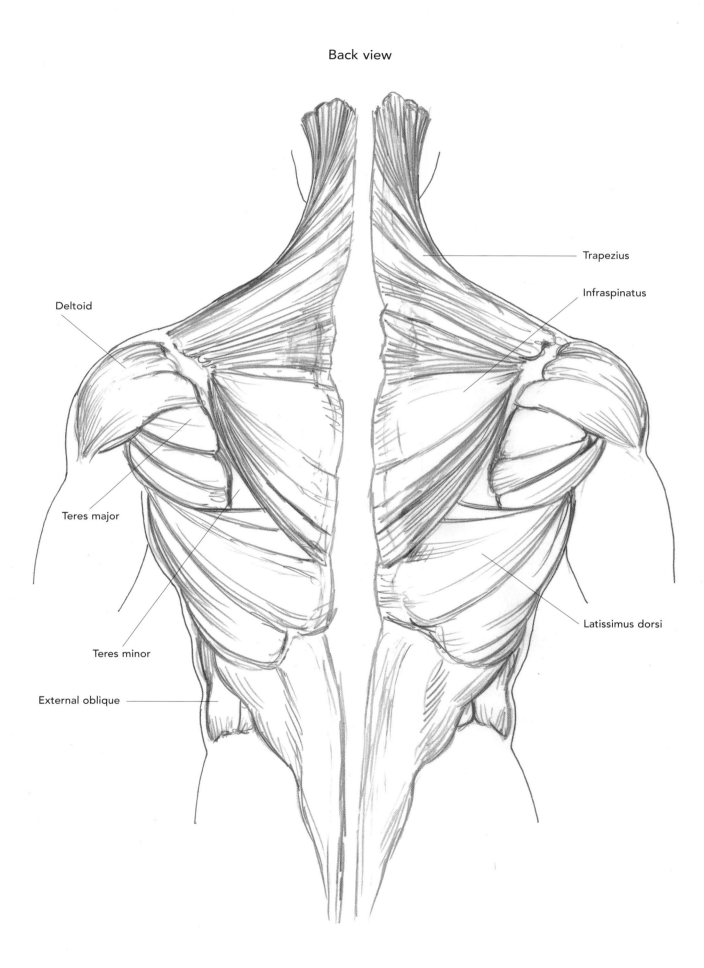

Deltoid

Teres major

Teres minor

External oblique

Trapezius

Infraspinatus

Latissimus dorsi

# The torso

Male and female torsos present very different surfaces for the artist to draw. Because men are usually more muscular than women, light will fall differently on the angles and planes of the male body, and there will be more shadowed areas where the skin curves away from the light. The viewer will understand these darker areas as showing muscular structure. In the case of the female torso, the shadowed areas are longer and smoother, as the planes of the body are not disrupted by such obvious muscle beneath the skin. Many of the people you draw from life will not be as well toned as these models, which is where the infinite variety that makes figure drawing so rewarding starts to show.

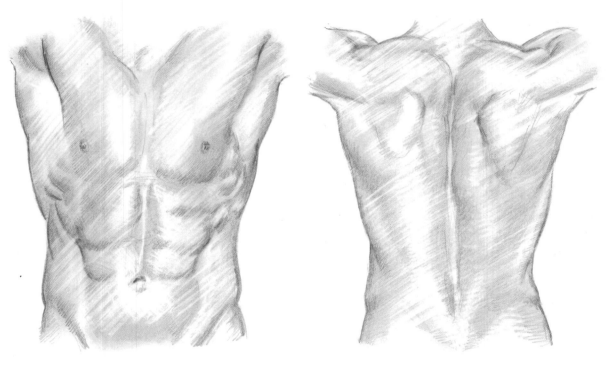

The masculine torso – shown here from the front, back and side – has a very distinctive set of muscles, which are easily visible on a reasonably fit man. I have chosen a very well-developed athletic body to draw, which makes it very clear what lies beneath the skin. Some of the edges of the large muscles are sharply marked, while other edges are quite soft and subtle.

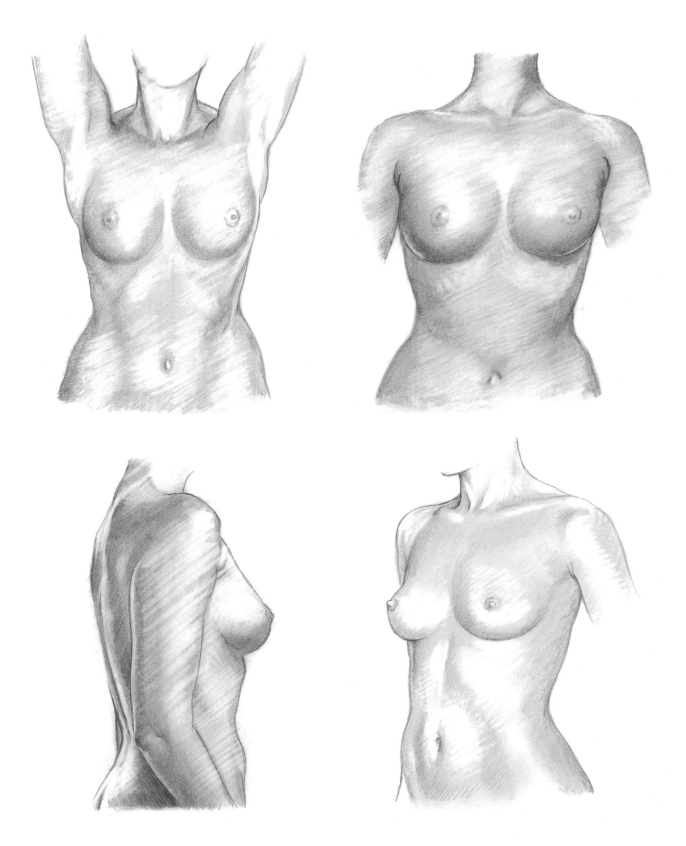

This particular female figure is also very young and athletic, and many women will not have quite this balance of muscle and flesh. Generally speaking, the female figure shows less of the muscle structure because of a layer of subcutaneous fat that softens all the harsh edges of the muscles. This is why women always have a tendency to look rounder and softer than men.

# The torso: bending and stretching

In these drawings, you can see how the spinal cord is such a good indication of what is happening to the body when it bends and stretches. The curves of the spine help to define the pose very clearly, and it is best to take note of them before you start drawing a figure. All the other parts of the body's structure can then be built around that. Even if you can't see the spine, some idea of its curves will always help to keep your drawing convincing.

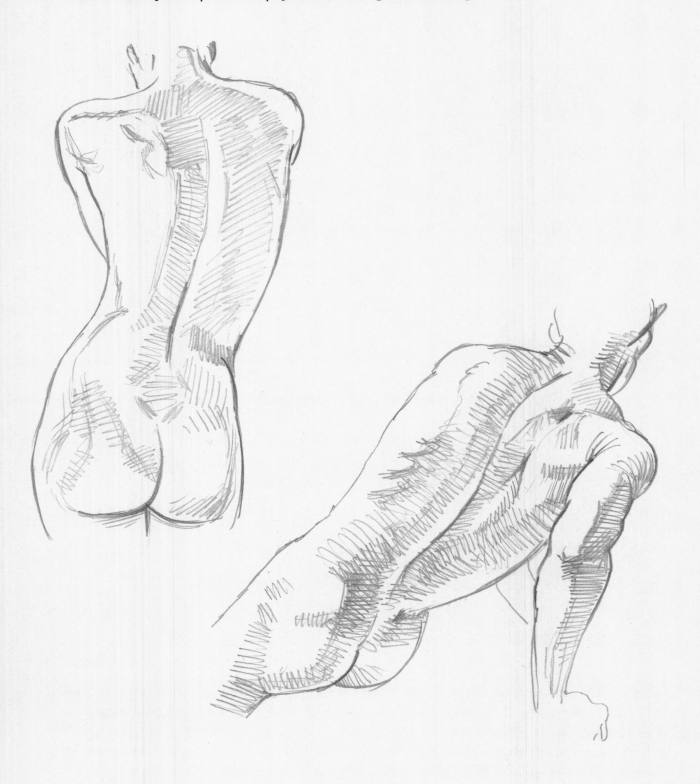

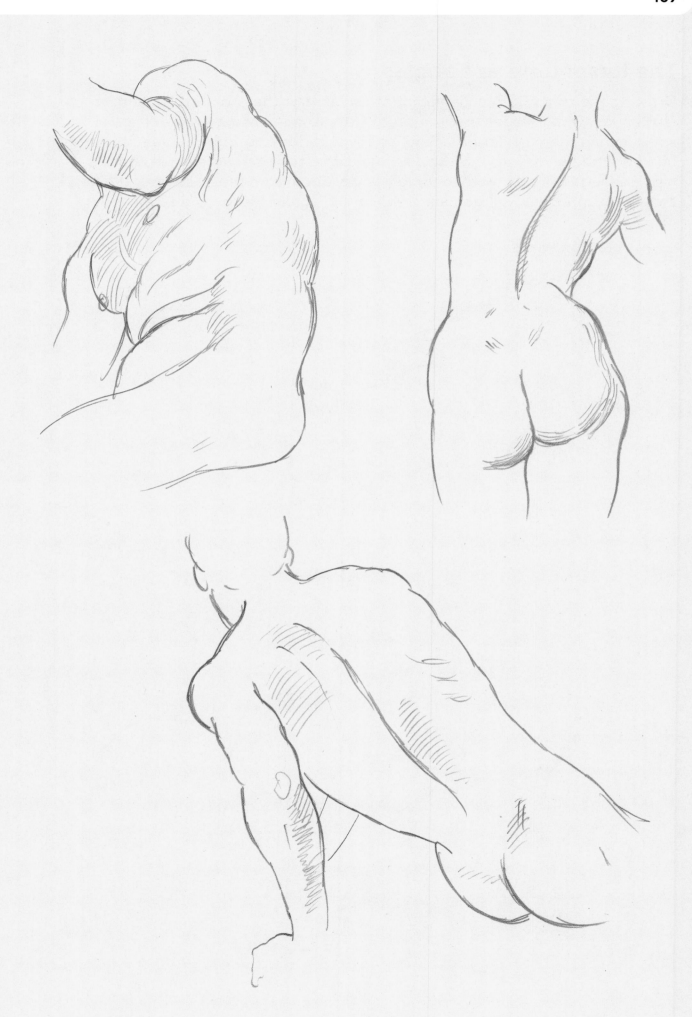

# The torso: different angles

Drawing the torso from a viewpoint at one end or the other presents new challenges. Don't forget that the part of the torso furthest away will look smaller than the part closer to you, so if you're looking from the feet end, the head will be minimized, the shoulders and chest will be quite small and the hips and legs will be correspondingly large. Seen from the head end, the head, shoulders and chest will dominate, while the legs will tend to disappear.

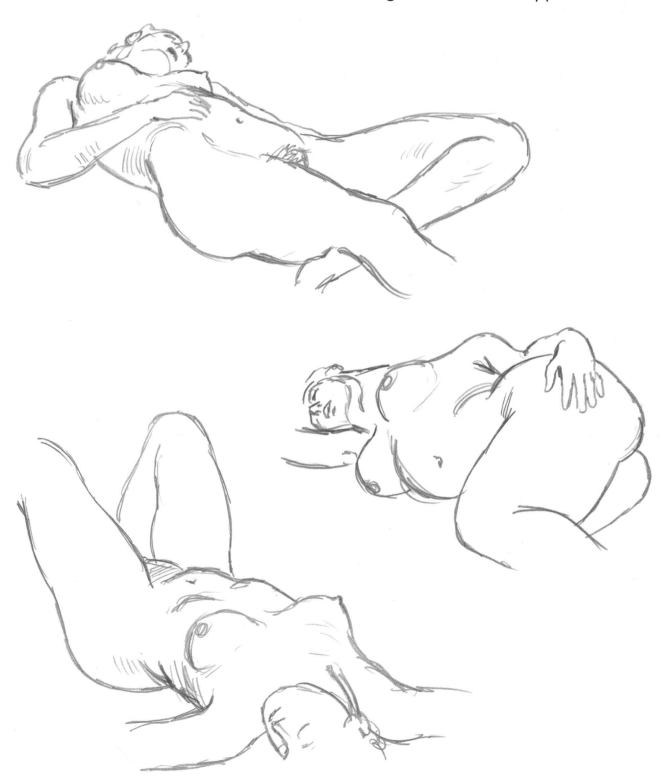

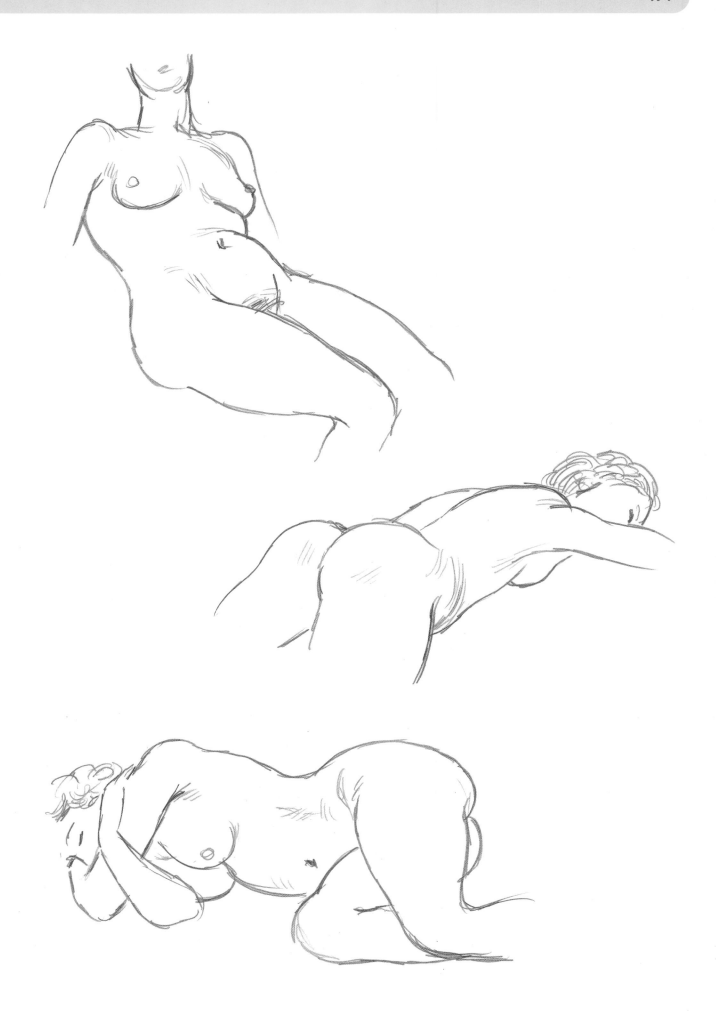

# Anatomy of the hand, arm and shoulder

Forearm and hand bones

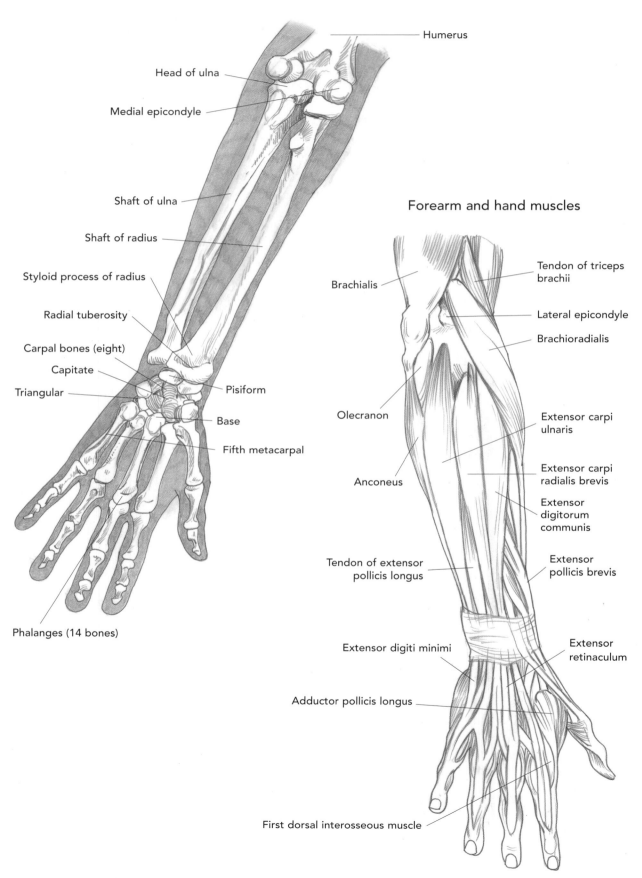

Forearm and hand muscles

Humerus

Head of ulna

Medial epicondyle

Shaft of ulna

Shaft of radius

Styloid process of radius

Radial tuberosity

Carpal bones (eight)

Capitate

Triangular

Pisiform

Base

Fifth metacarpal

Phalanges (14 bones)

Brachialis

Tendon of triceps brachii

Lateral epicondyle

Brachioradialis

Olecranon

Extensor carpi ulnaris

Extensor carpi radialis brevis

Extensor digitorum communis

Anconeus

Tendon of extensor pollicis longus

Extensor pollicis brevis

Extensor digiti minimi

Extensor retinaculum

Adductor pollicis longus

First dorsal interosseous muscle

## Shoulder and upper arm bones

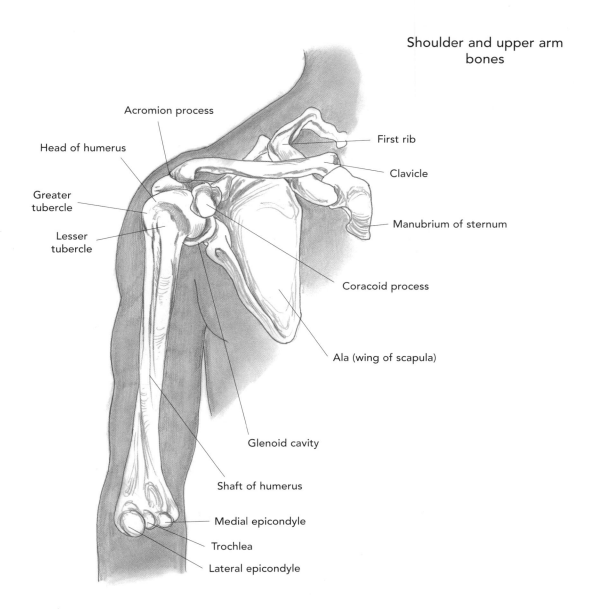

Acromion process

Head of humerus

Greater tubercle

Lesser tubercle

First rib

Clavicle

Manubrium of sternum

Coracoid process

Ala (wing of scapula)

Glenoid cavity

Shaft of humerus

Medial epicondyle

Trochlea

Lateral epicondyle

## Shoulder and upper arm muscles

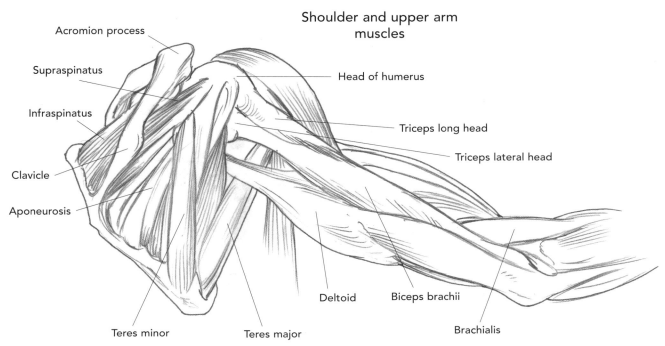

Acromion process

Supraspinatus

Infraspinatus

Clavicle

Aponeurosis

Head of humerus

Triceps long head

Triceps lateral head

Teres minor

Teres major

Deltoid

Biceps brachii

Brachialis

# Arms and hands

The narrowness of the arm makes the musculature show much more easily than in the torso, and it is even possible to see the end of the skeletal structure at the shoulder, elbow and wrist. This tendency of bone and muscle structure to diminish in size as it moves away from the centre of the body is something that should inform your drawings. Fingers and thumbs are narrower than wrists; wrists narrower than elbows; elbows narrower than shoulders. As always, it is a matter of observing carefully and drawing what you actually see before you.

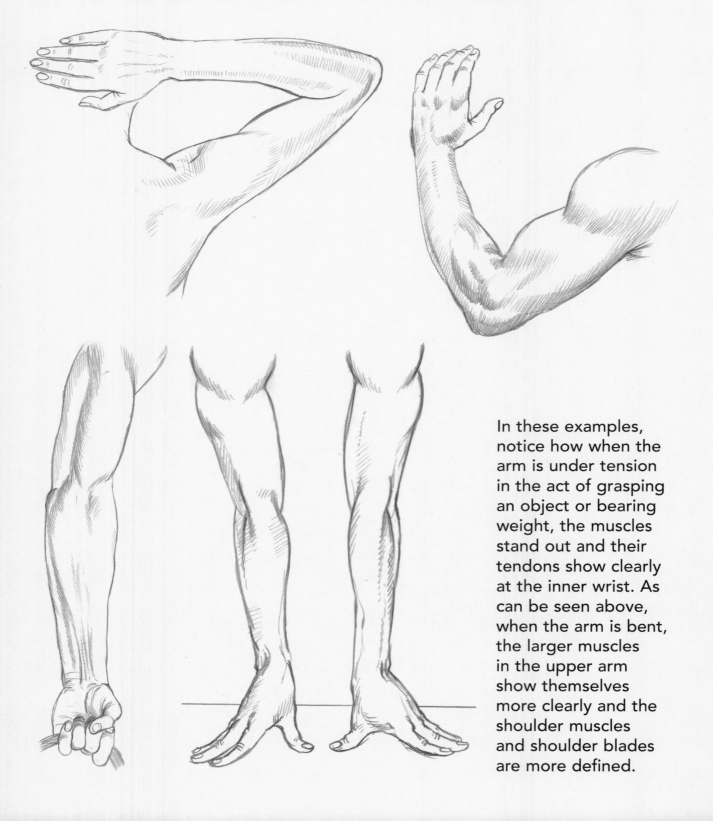

In these examples, notice how when the arm is under tension in the act of grasping an object or bearing weight, the muscles stand out and their tendons show clearly at the inner wrist. As can be seen above, when the arm is bent, the larger muscles in the upper arm show themselves more clearly and the shoulder muscles and shoulder blades are more defined.

# Hands

Many people find hands difficult to draw. You will never lack a model here as you can simply draw your own free hand, so keep practising and study it from as many different angles as possible. The arrangement of the fingers and thumb into a fist or a hand with the fingers relaxed and open create very different shapes, and it is useful to draw these constantly to get the feel of how they look. There is inevitably a lot of foreshortening in the palm and fingers when the hand is angled towards you or away from your sight.

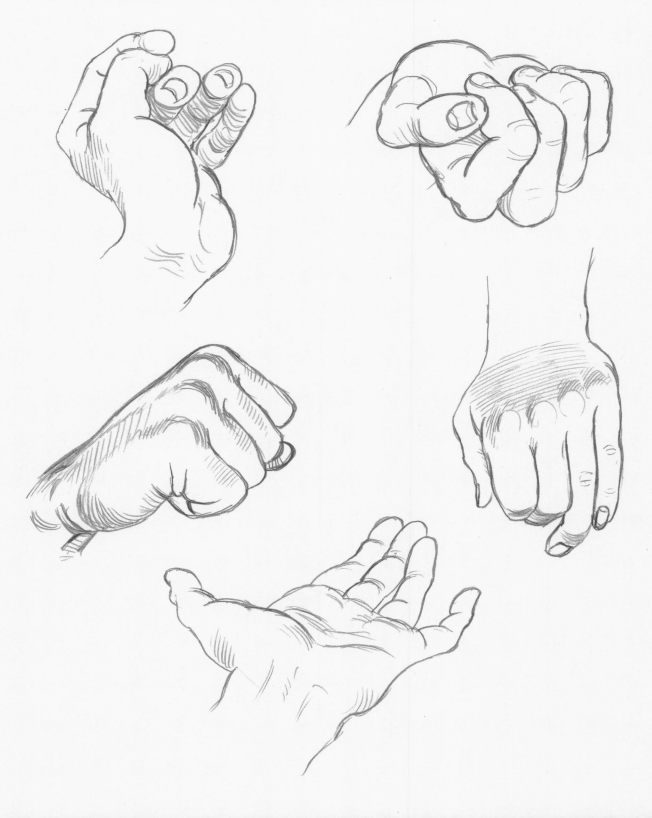

# Anatomy of the upper leg

The upper part of the leg is similar to the upper arm in that the bone that supports it is single and very large; in the case of the leg, it is the largest in the body, and the muscles are large and long in shape. The hip area is defined by the pelvis, the upper edges of which usually can be seen above the hip bones. One of the longest muscles is the sartorius, which stretches from the upper pelvis to below the knee joint.

Upper leg bones

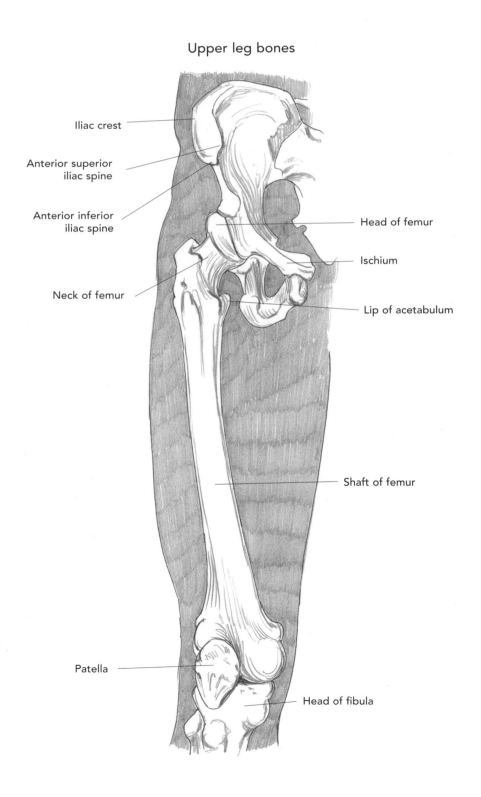

Iliac crest

Anterior superior iliac spine

Anterior inferior iliac spine

Neck of femur

Head of femur

Ischium

Lip of acetabulum

Shaft of femur

Patella

Head of fibula

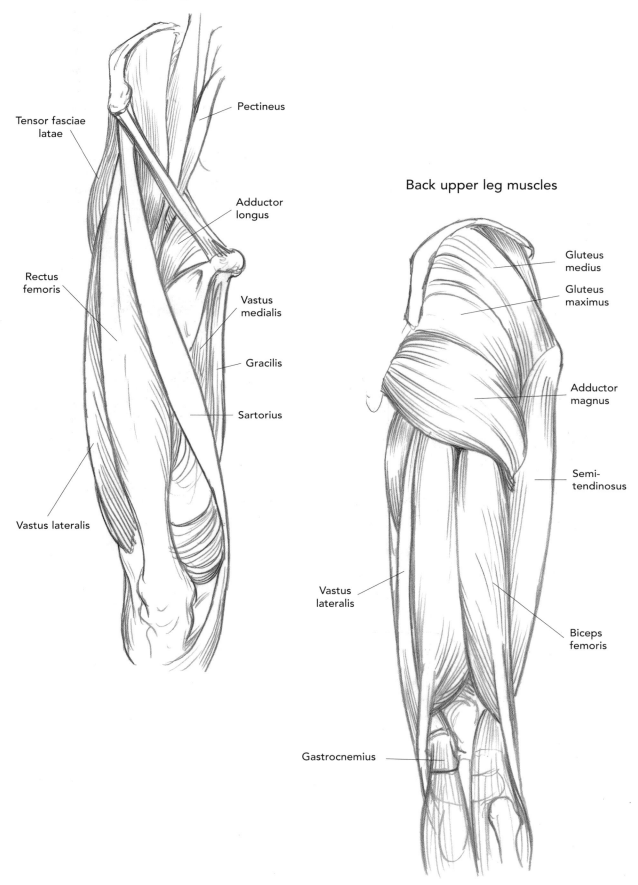

Front upper leg muscles

Back upper leg muscles

Tensor fasciae latae

Pectineus

Adductor longus

Rectus femoris

Vastus medialis

Gracilis

Sartorius

Vastus lateralis

Gluteus medius

Gluteus maximus

Adductor magnus

Semi-tendinosus

Vastus lateralis

Biceps femoris

Gastrocnemius

# Anatomy of the lower leg and foot

Lower leg and foot bones

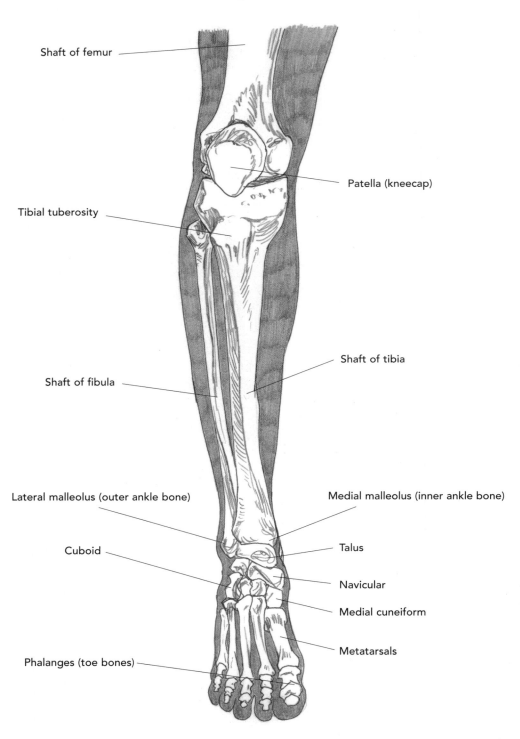

Shaft of femur

Patella (kneecap)

Tibial tuberosity

Shaft of tibia

Shaft of fibula

Lateral malleolus (outer ankle bone)

Medial malleolus (inner ankle bone)

Cuboid

Talus

Navicular

Medial cuneiform

Metatarsals

Phalanges (toe bones)

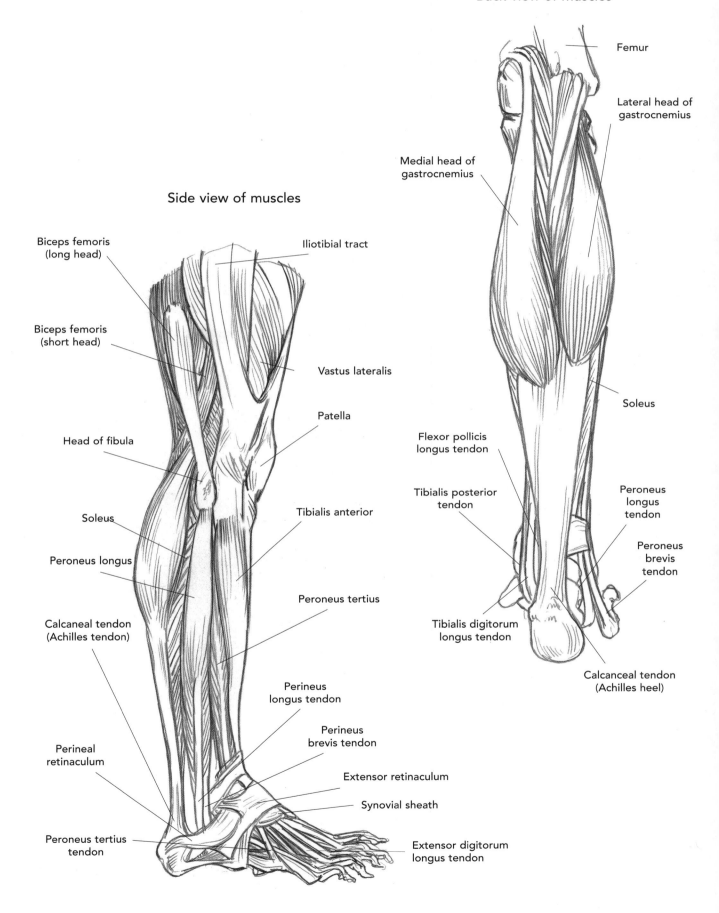

Back view of muscles

Femur

Lateral head of gastrocnemius

Medial head of gastrocnemius

Soleus

Side view of muscles

Biceps femoris (long head)

Iliotibial tract

Biceps femoris (short head)

Vastus lateralis

Patella

Head of fibula

Flexor pollicis longus tendon

Tibialis posterior tendon

Peroneus longus tendon

Soleus

Peroneus brevis tendon

Peroneus longus

Tibialis anterior

Calcaneal tendon (Achilles tendon)

Peroneus tertius

Tibialis digitorum longus tendon

Calcanceal tendon (Achilles heel)

Perineus longus tendon

Perineus brevis tendon

Extensor retinaculum

Perineal retinaculum

Synovial sheath

Peroneus tertius tendon

Extensor digitorum longus tendon

# Complete side views

From the side, you will see that the muscles in the thigh and the calf of the leg show up most clearly, the thigh mostly towards the front of the leg and the calf towards the back. The large tendons show mostly at the back of the knees and around the ankle. Notice the way the patella changes shape as the knee is bent or straightened. As with the arms, the bones and muscles in the leg are bigger towards the body, and smaller towards the extremities.

# Complete back views

The back view of the legs shows the interesting reverse of the knee joint and looks very round and smooth, especially in the female form.

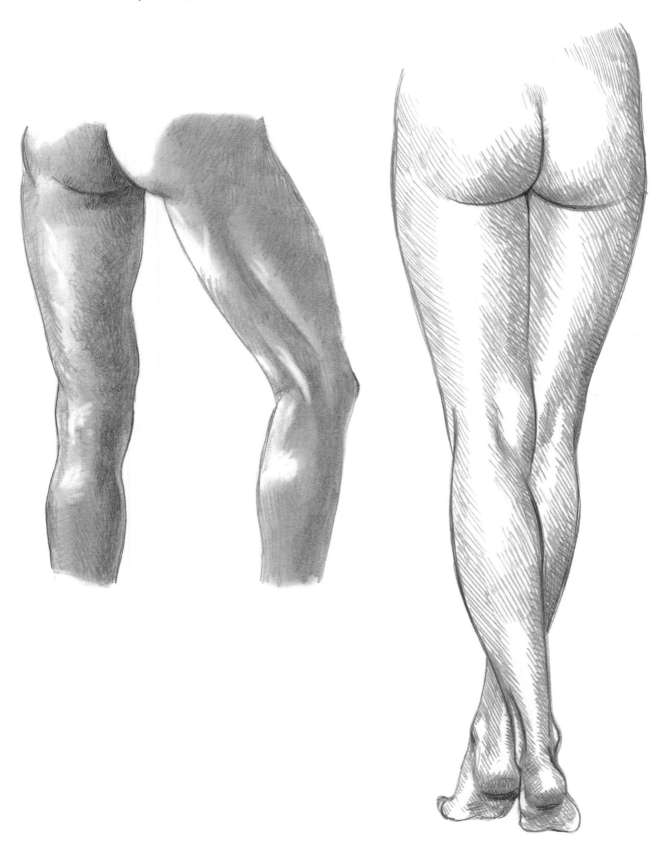

The view of bent legs shows the distinctive effect that bending has on the knee joint, producing a largish area of flat, padded bone structure. Foreshortening the view of the legs produces all sorts of interesting views of the larger muscles, which are less well defined.

# Feet

The bone structure of the foot is quite elegant, producing a slender arch over which muscles and tendons are stretched.

The lower part of the foot is padded with soft subcutaneous matter and thicker skin.

Notice how the toes, unlike the fingers, tend to be more or less aligned, although the smaller toes get tucked up into small, rounded lumps.

The inner ankle bone is higher than the outer, which helps to lend elegance to this slender joint. If the difference in the position of the ankle bones is not noted, the ankle becomes a clumsy shape. The small bump of the ankle bone is most noticeable from the front or back view, but if the source of light is right, it can also show clearly from a side view.

# Four basic stages of drawing a figure

For the beginner first embarking on drawing a whole figure, the tendency is to become rather tense about the enormity of the task. The presence of a real live model, as opposed to a still-life object, can make you feel that your work may be judged and found wanting by both your subject and the members of the life class you are in, and you may also feel that you cannot work at your leisure.

To begin with, just think in terms of simple shapes rather than visualizing a finished drawing that you feel you are not capable of achieving. You can stop your drawing at any stage – there is no need to feel that you have to press on to a conclusion that you are not ready for.

Starting very simply, with a seated male figure as an example, here are some easy ways to work your way into the task of drawing it.

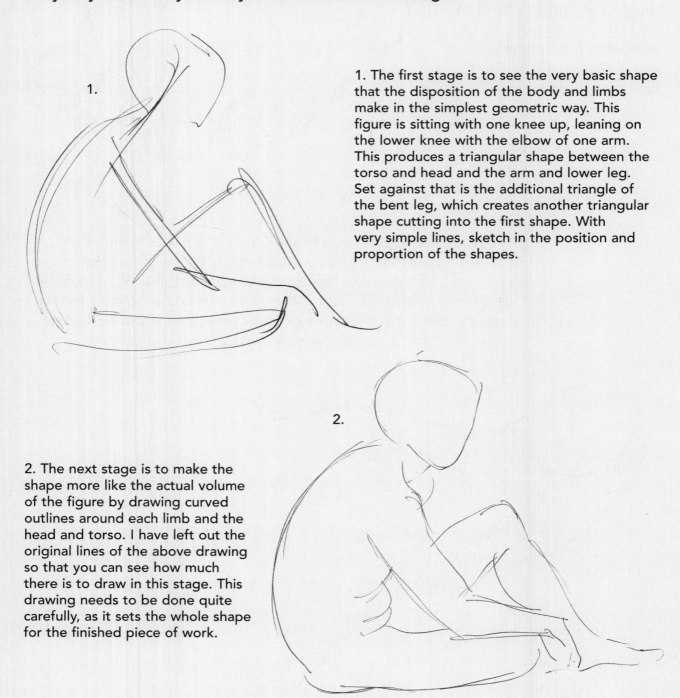

1.

1. The first stage is to see the very basic shape that the disposition of the body and limbs make in the simplest geometric way. This figure is sitting with one knee up, leaning on the lower knee with the elbow of one arm. This produces a triangular shape between the torso and head and the arm and lower leg. Set against that is the additional triangle of the bent leg, which creates another triangular shape cutting into the first shape. With very simple lines, sketch in the position and proportion of the shapes.

2.

2. The next stage is to make the shape more like the actual volume of the figure by drawing curved outlines around each limb and the head and torso. I have left out the original lines of the above drawing so that you can see how much there is to draw in this stage. This drawing needs to be done quite carefully, as it sets the whole shape for the finished piece of work.

3. The next step is to block in the changes in the planes of the surface, as shown by the light and shade on the body. This process needs only to be a series of outlines of areas of shadow and light. At the same time, begin to carefully define the shapes of the muscles and bone structure by refining your second outline shape, adding subtleties and details. Now you have a good working drawing that has every part in the right place and every area of light and shade indicated.

At this stage, you will want to do quite a bit of correcting to make your shapes resemble your model. Take your time and work as accurately as you can, until you see a very similar arrangement of shapes when you look from your drawing to the model.

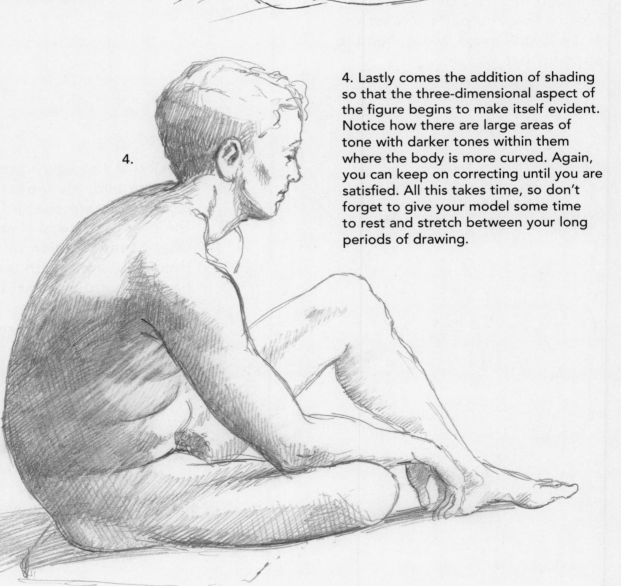

3.

4.

4. Lastly comes the addition of shading so that the three-dimensional aspect of the figure begins to make itself evident. Notice how there are large areas of tone with darker tones within them where the body is more curved. Again, you can keep on correcting until you are satisfied. All this takes time, so don't forget to give your model some time to rest and stretch between your long periods of drawing.

# Figures in perspective

Once you feel confident with the early stages of getting figures down on paper, you are ready to tackle the bigger challenge of seeing the figure in perspective, where the limbs and torso are foreshortened and do not look at all like the human body in a conventional pose.

To examine this at its most exaggerated, the model should be lying down on the ground or a low platform or bed. Position yourself so that you are looking from one end of the body along its length, giving you a view of the human figure in which the usual proportions are all changed. Because of the laws of perspective, the parts nearest to you will look much larger than the parts further away.

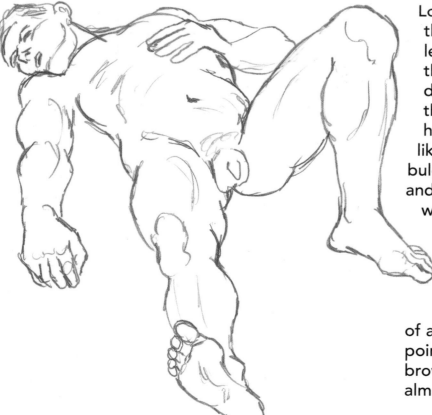

Looking at the figure from the feet end, the feet and legs look enormous and the chest and head almost disappear in relation to them. The arms, with the hands towards you, look like a series of rounded bulges, with the large hands and fingers looking much wider than they are long.

Sometimes the shoulders can't be seen and the head is just a jutting jaw with the merest suggestion of a mouth, an upwardly pointing nose, and the eyes, brows and hair reduced to almost nothing.

## Changing ends

Standing at the head end, you will find
that everything has to be reassessed
again. This time the head is very large,
but you can mostly see just the top
of it and the shoulders and chest or
shoulder blades, which bulk large.

As the eye travels down towards the
legs, the most noticeable thing is how
short and stubby they look from this
angle. The feet may stick up if the
model is on his or her back, but the
legs themselves are just a series of
bumps of thighs, knees and calves.

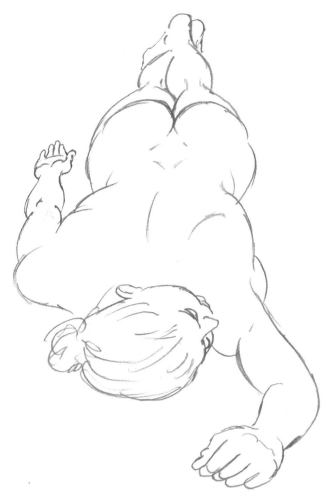

Try measuring the difference between the
legs and the torso and you will find that
although you know the legs are really half the
length of the whole figure, from this angle
they are more like a quarter of the full length.
Not only that, but the width of shoulders
and hips is vastly exaggerated so that the
body looks very short in
relation to its width.
Most students new
to this view of the
figure draw it far
too long for its
width because
they have in
their mind the
proportions of
how the figure
looks when
standing up. Make
sure you observe the
figure carefully to avoid this.

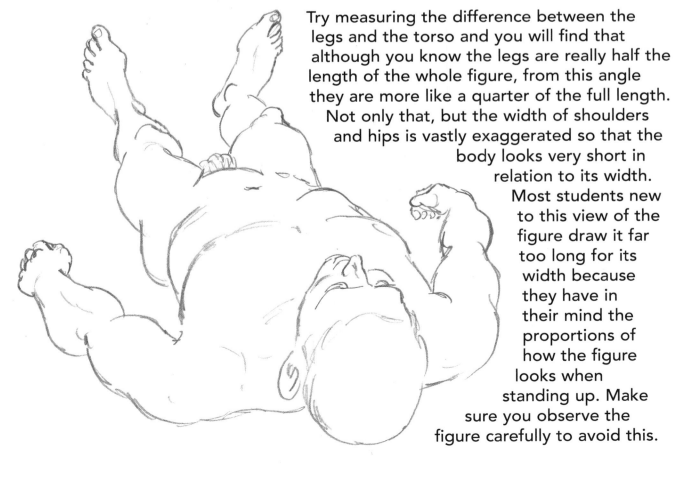

# Expressing volume

Showing the volume of the figure will make your drawings look convincingly solid. You can make a small figure appear weighty by blocking in areas of tone – a technique used by artists when the drawing is to be painted, since it clarifies how the area of tone and colour should be painted. Contour lines also give the impression of the roundness of the head and body.

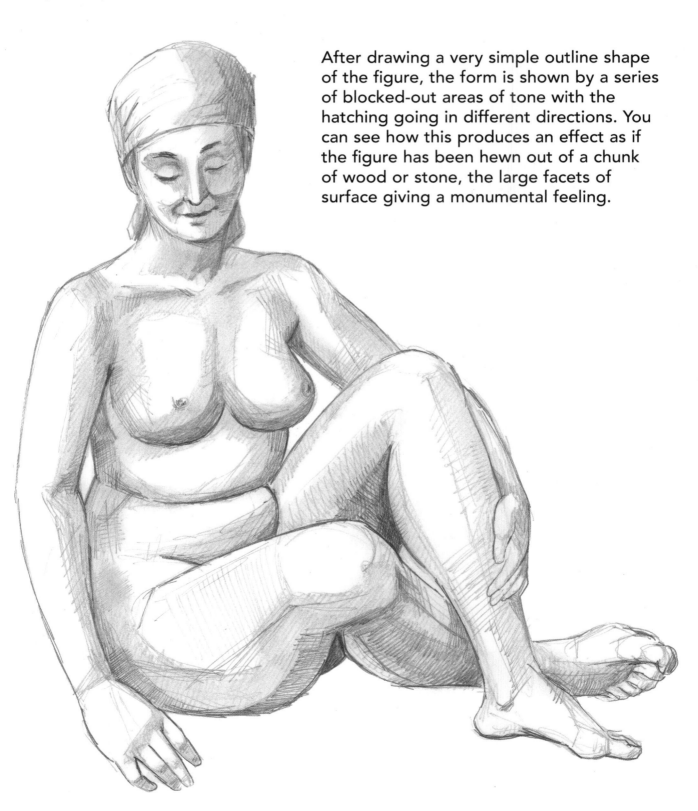

After drawing a very simple outline shape of the figure, the form is shown by a series of blocked-out areas of tone with the hatching going in different directions. You can see how this produces an effect as if the figure has been hewn out of a chunk of wood or stone, the large facets of surface giving a monumental feeling.

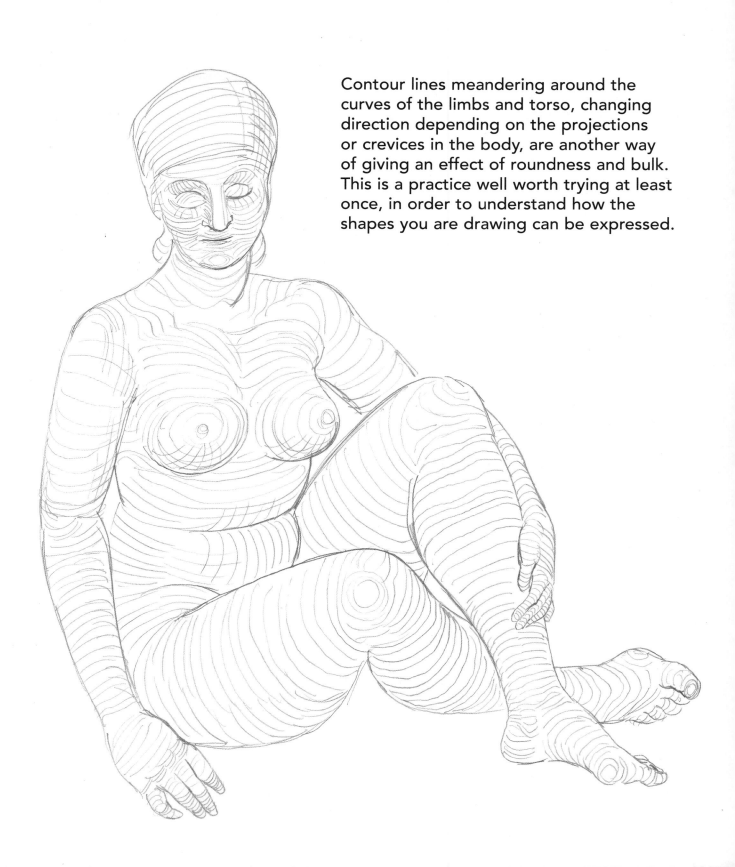

Contour lines meandering around the curves of the limbs and torso, changing direction depending on the projections or crevices in the body, are another way of giving an effect of roundness and bulk. This is a practice well worth trying at least once, in order to understand how the shapes you are drawing can be expressed.

# Mapping the body

A more gradual and time-consuming approach that many artists favour is to decide exactly where each point of the figure appears to be in relation to all the other points around the figure from your viewpoint. Thus, a mark is made at the top of the head, for example; then, very carefully, another mark at the back of the head; then the point where the eyes are, all in relation one to another. This is a very time-consuming method, but most artists who use it are assured of producing very accurate renderings of the forms in front of them.

Conversely, you can map the body very quickly using scribbles that delineate the form quite accurately but without much detail. Try different techniques to see whether the freer or more painstaking approach suits your personality best.

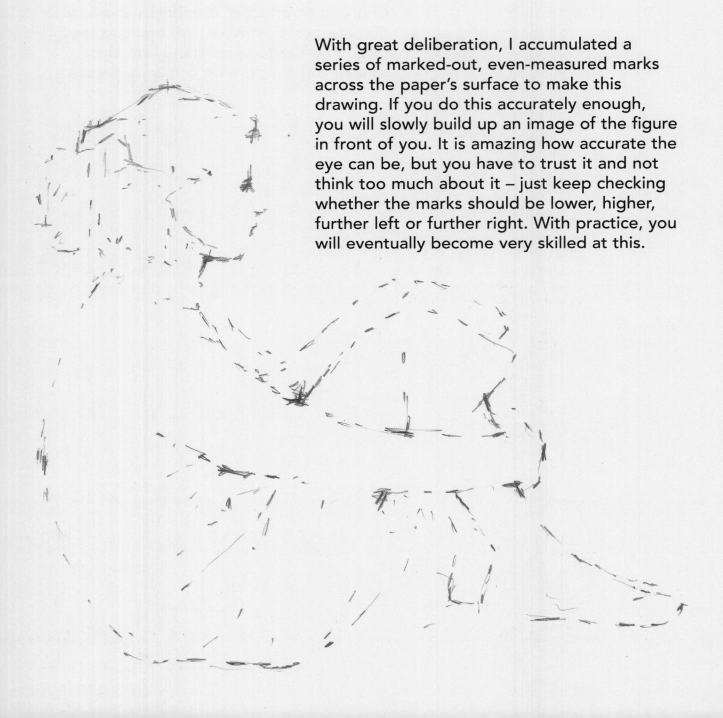

With great deliberation, I accumulated a series of marked-out, even-measured marks across the paper's surface to make this drawing. If you do this accurately enough, you will slowly build up an image of the figure in front of you. It is amazing how accurate the eye can be, but you have to trust it and not think too much about it – just keep checking whether the marks should be lower, higher, further left or further right. With practice, you will eventually become very skilled at this.

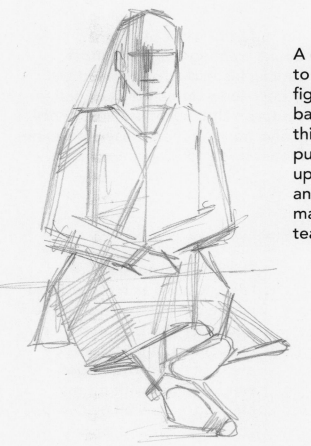

A quicker way is to use geometric marks to define the shape and proportions of the figure in front of you in very simple and basic strokes. No details are necessary for this method until all your main strokes are put in to your satisfaction. You will build up the marks and textures quite quickly, and sometimes you will have to erase some marks to put in greater detail, but this does teach you to sum up shapes rapidly.

A fast way that can work very well if you are sketching people who are in motion is to draw with a scribble technique, hardly taking your pencil off the paper while you scrawl marks that give some idea of the form in front of you, without going into too much detail. What these drawings lack in detail they often gain in vigour and liveliness.

# Drawing with tone

So far in this chapter we have been examining different ways of drawing with line, so it is quite a departure to think about creating a figure almost entirely from tone. Instead of following an outline, instead you will need to consider laying down tones that will not only describe volume but also define edges. You can use a range of different media to do this, such as a soft pencil smudged with a stump, charcoal, crayon, ink and wash, and an eraser to define some of the lighter areas by going over the tones and reducing them.

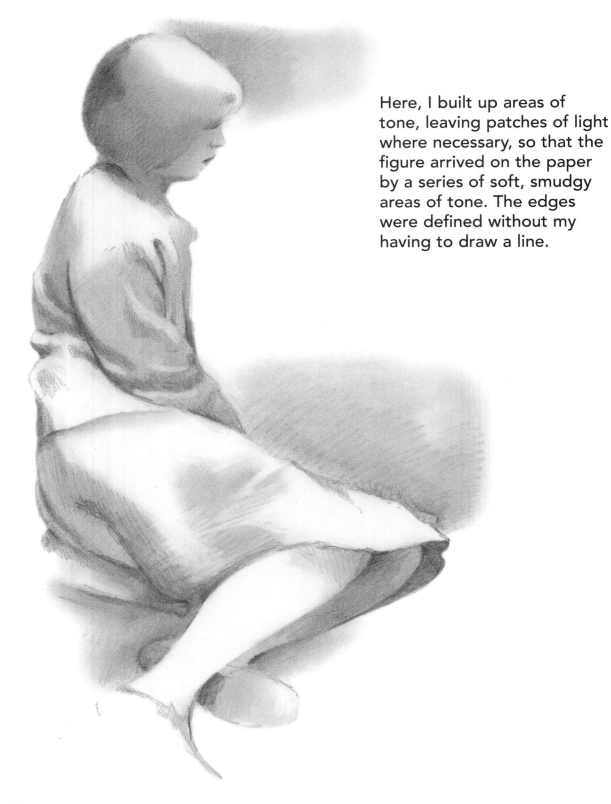

Here, I built up areas of tone, leaving patches of light where necessary, so that the figure arrived on the paper by a series of soft, smudgy areas of tone. The edges were defined without my having to draw a line.

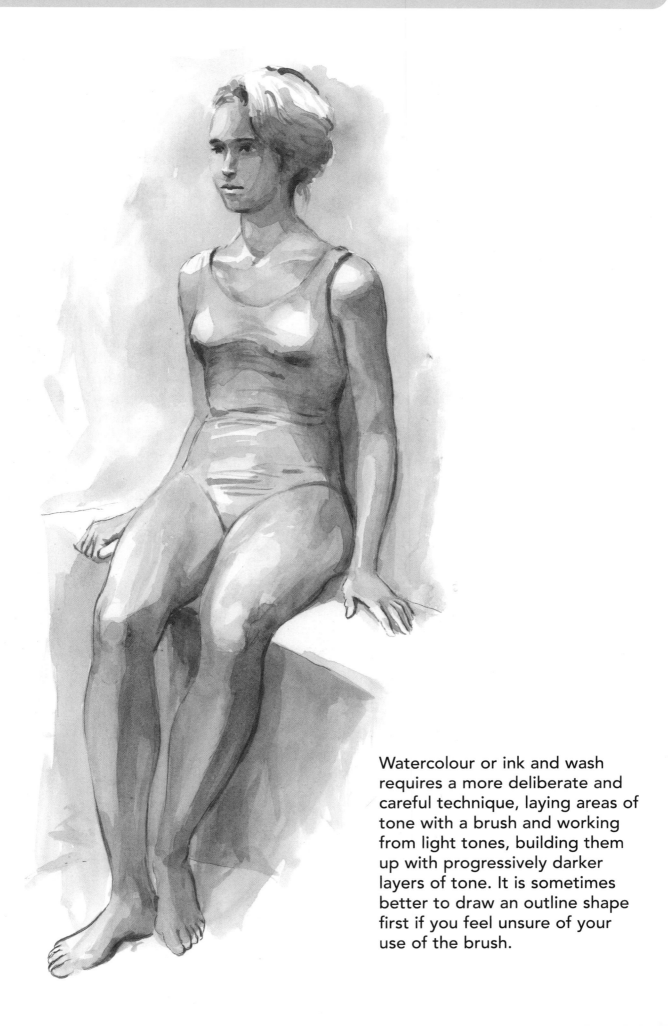

Watercolour or ink and wash requires a more deliberate and careful technique, laying areas of tone with a brush and working from light tones, building them up with progressively darker layers of tone. It is sometimes better to draw an outline shape first if you feel unsure of your use of the brush.

# Drawing from Life

Drawing a figure from life is the time-honoured way for students to improve their skills, and there different ways of doing it, both formal and informal. The majority of artists, and particularly students, carry a sketchbook around with them. While professional artists tend to use sketchbooks in the more formalized way of keeping them as reference sources, even they often carry a small one around just in case the opportunity for a quick sketch presents itself.

There is no substitute for drawing directly from life, and no better way to develop your skills of observation and your hand/eye coordination. Although copying photographs and other drawings is good practice, it does not give the heightened perception that comes from drawing the real thing.

In order to improve your figure drawing, consider the possibilities for finding models. One obvious way of doing this is to go out and look at people. Find a place that is busy with human activity and make many drawings as quickly as you can. For more detailed study, joining a local class is ideal. You will get the benefit of two or three hours of drawing, with expert advice from the tutor. Or, you can persuade a member of your family or a friend to pose for you. You may not be able to expect too much from them as far as the time they will give you and the poses they will adopt, but if any of your friends are also interested in drawing, there might be a possible trade-off of alternating as artist and model.

## Making quick sketches

One of the best ways to learn to draw figures without worrying about the results is to take your sketchbook to a busy event in the summer where people are enjoying their leisure time. You will see all sorts of characters, both stationary and in motion, and if they are engrossed in their activities, you will not feel self-conscious about sketching them.

Draw as few lines as you possibly can, leaving out all details. Use a thick, soft pencil to give least resistance between paper and drawing medium, and don't bother correcting errors. Keep drawing almost without stopping. The drawings will gradually improve, and what they will lack in significant detail they will gain in fluidity and essential form. Only draw the shapes that grab your eye. Don't make choices; just see what your eye picks up quickly and what your hand can do to translate this vision into simple shapes. This sort of drawing is never a waste of time, and sometimes the quick sketches have a very lively, attractive quality.

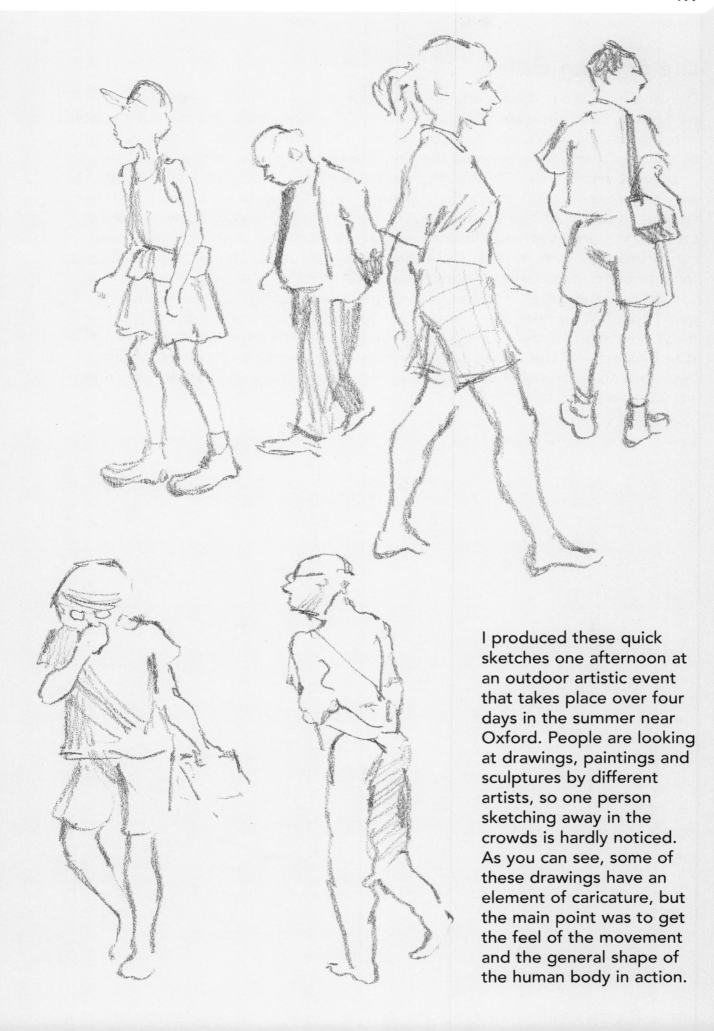

I produced these quick sketches one afternoon at an outdoor artistic event that takes place over four days in the summer near Oxford. People are looking at drawings, paintings and sculptures by different artists, so one person sketching away in the crowds is hardly noticed. As you can see, some of these drawings have an element of caricature, but the main point was to get the feel of the movement and the general shape of the human body in action.

# Life drawing classes

Drawing from life is the foundation of all drawing, and of course this is particularly so in the case of figure drawing. The human body is the most subtle and difficult thing to draw, and you will learn more from a few lessons in front of a model than you ever could drawing from photographs or the like.

In most urban areas, life drawing classes are not too difficult to come by, and if there is an adult education college or an art school that offers part-time courses, that would be the best way in which to improve your drawing. Even professional artists attend life drawing classes whenever possible, unless they can afford their own models. Note that these classes are limited to people over the age of 16, due to the presence of a nude model.

One of the great advantages of life classes is that there is usually a highly qualified artist teaching the course. The dedication and helpfulness of most of these teachers of drawing will enable you gradually to improve your drawing step by step, and the additional advantage of having other students – from beginners to quite skilful practitioners – will encourage your work by emulation and competition.

# Drawing friends

The greatest difficulty when drawing your friends is to persuade them to sit still for long enough. A professional model is accustomed to holding a pose, but you may need to offer your friends some inducements to get them to do the same. Don't try to make them remain still for too long; even professional models get rests, and someone not used to it may find it difficult to sit still for longer than 20 minutes. In that time you should be able to take in the whole figure, even if it is not very detailed, and you will gain excellent drawing practice.

Indoors, make sure that you sit near a large window but without direct sunlight falling into the room. Place yourself side-on to the window and get your friend to sit in an interesting but comfortable pose – not too complicated, or they will find it difficult to maintain the position.

Draw outdoors as well when you are able to, because the light is different and you can often see much more clearly when the light is all around the figure. Try to do it on a day on which the sun is not strong: a cloudy, warm day is best, because the light is even and the forms of the figure show more clearly.

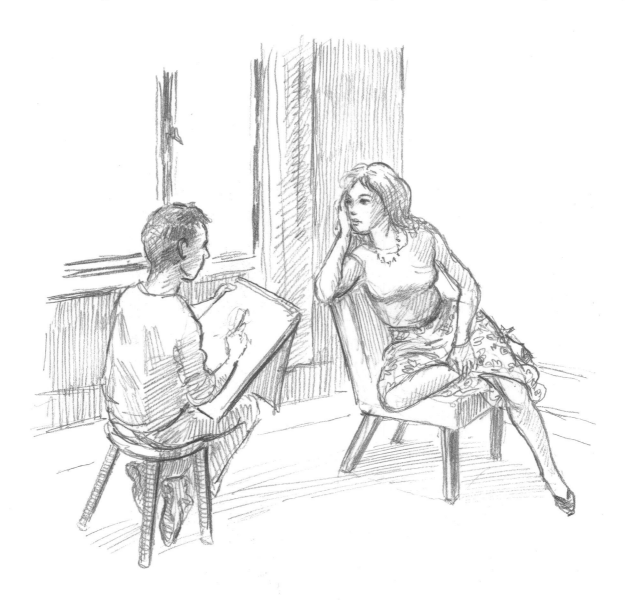

# Lighting the model

In order to make your drawing work effectively, it is necessary to take into consideration the way the light falls onto the figure. Natural light is the norm in life drawing, except in winter when it may not be available for sufficient hours. In the northern hemisphere, most artists' studios have north-facing windows, because they give light without the harsh shadows caused by sunshine. With this light the shadows tend to be even and soft, showing small graduations in tone so that the changes of surface direction can be quite easily seen.

In this drawing of a model in a north-lit studio, a typical even light is spread across the space, giving wide gradations in the tonal quality of the shadows on the form. Note how the angle of the light causes the shadows to fall on the left side of her body from our viewpoint, and beneath her chin and breasts.

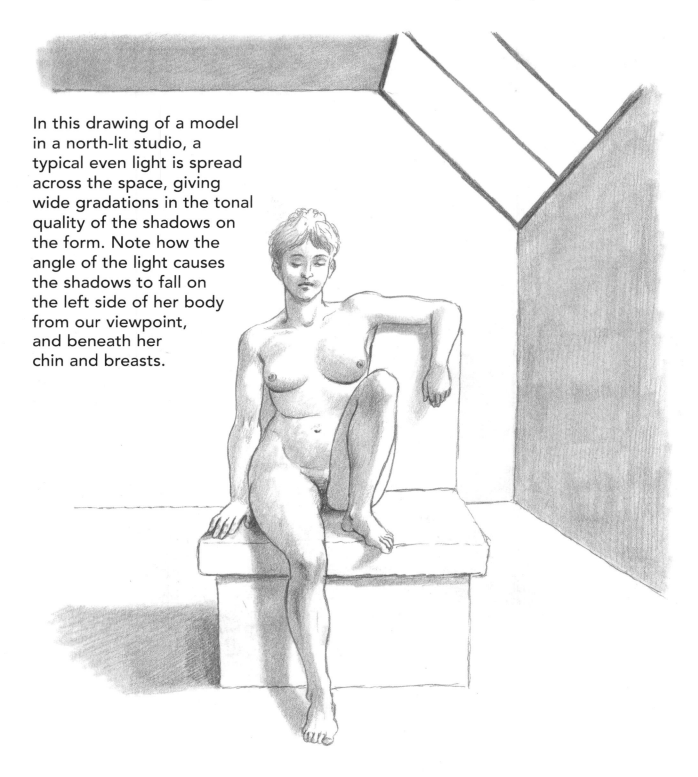

# Lighting from the side

This picture gives a clear indication of how strong, directional light produces harsh shadows and very brightly lit areas. This can produce very dramatic pictures: the Italian artist Caravaggio, for example, was known to have had massive arrays of candlepower to light his models in order to produce his very dramatic contrasts in light and shade, known as chiaroscuro.

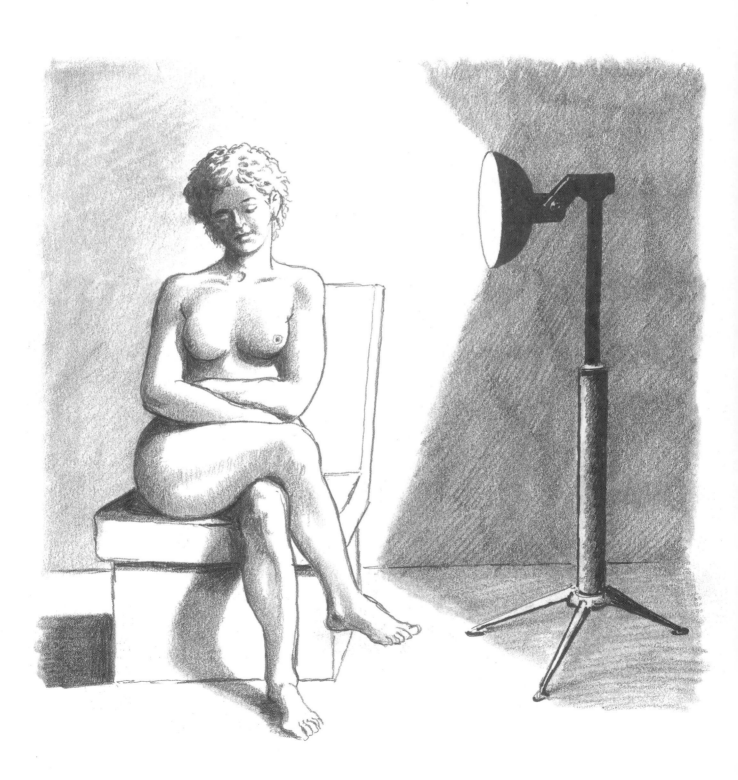

# Composition

When you first begin to study figure drawing, your aim is to draw the model from a range of viewpoints as you build up your understanding of how the human body looks. The experience you gain by doing this is of enormous help to the development of the artistic skills necessary to cope with drawing the figure. However, there will come a time when a quick drawing will no longer be the point, and you will want to draw the figure either to be seen as a completed picture or to fit into a composition with other figures. This section of the book looks at the composition of the figure both in relation to the shape of the paper you are using and in conjunction with other figures.

Bringing composition into the equation requires a slightly different approach to your drawing. First, looking at the model in front of you, you will need to make sure he or she is in exactly the pose you wish to draw, and then decide whether your angle in relation to the model is what pleases you most or if you should change your position to gain a different viewpoint.

Next, you will have to consider objectively how the shape that you see will be placed on the surface upon which you are drawing. Will the position on the paper divide up the space in an interesting way if you draw it to one side, in the middle, or above or below the centre point? You are now considering the relationship of the shape of the figure within the boundaries of the surface you are working on, and in doing this you are composing your drawing.

This process becomes more complex when there is more than one figure, and as you will probably not draw them all at the same time, you will have to consider their relationship to each other and how they will fit into the space. It may be necessary to make several drawings of models in different poses and then assemble them to produce your composition. This may mean changing the scale of one or more of the figures. However, no matter how much time it takes, this is the most interesting part of figure composition because it is the intellectual process of turning ordinary sketches into art.

## Framing the picture

A very useful tool to help you to achieve interesting and satisfying compositions is a framing device such as the one shown opposite. It can be made cheaply by cutting it out of card to any size and format that you wish to work on. Holding it in front of you in order to look through it, then moving it slightly up and down and from left to right will allow you to examine the relationship between the figure and the boundaries of the paper and visualize your composition before you actually begin to draw. This will also help you to see the perspective of a figure at an angle to you, as the foreshortening becomes more evident. Dividing the space into a grid will assist you in placing your figure accurately within the format when you draw it.

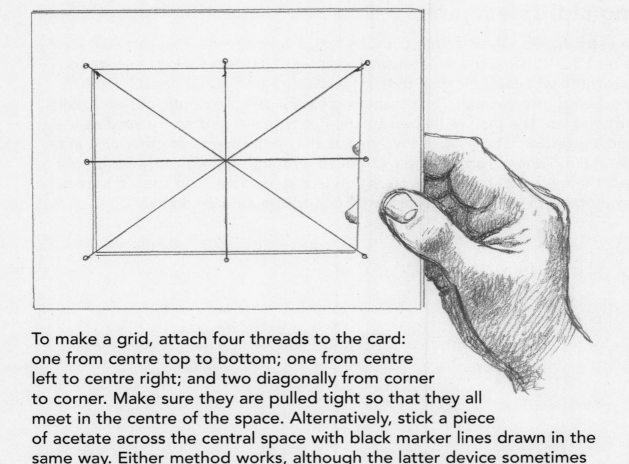

To make a grid, attach four threads to the card: one from centre top to bottom; one from centre left to centre right; and two diagonally from corner to corner. Make sure they are pulled tight so that they all meet in the centre of the space. Alternatively, stick a piece of acetate across the central space with black marker lines drawn in the same way. Either method works, although the latter device sometimes reflects the light, which stops you seeing your model so easily.

Here, the edges of the frame are placed so that the figure appears to stretch from the upper right-hand corner to the lower left-hand corner. The centre of the picture is taken up by the torso and hips, and the figure is just about balanced between the upper and lower parts of the diagonal line. This would give you a picture that covered the whole area of your surface, but left interesting spaces at either side. You will find that it is quite often the spaces left by the figures that help to define the dynamics of your picture and create drama and interest.

# Using multiple figures

As an example of a three-figure composition, I have drawn 'The Three Graces' by Peter Paul Rubens, the great master painter of Flanders. He chose as his models three well-built Flemish girls, posed in the traditional dance of the graces, hands intertwined. Their stances create a definite depth of space, with a rhythm across the picture helped by the flimsy piece of drapery used as a connecting device. The flow of the arms as they embrace each other also acts as a lateral movement across the picture, so although these are three upright figures, the movement in the composition is very evident. The spaces between the women seem well articulated, partly due to their sturdy limbs.

# Dynamic energy

When you are deciding on your composition, you will have some theme in mind that will influence the way you pose and draw the model. Generally, the pose falls into one of two types: the dynamic, energetic pose, or the relaxed, passive pose. Shown here are two examples of ways to produce the former, showing power, energy or movement. We understand the message they carry partly because of the associations we have with particular movements of the body and partly because of the activities the figures are engaged in.

In a classic fashion pose, this model is thrusting out one hip, and both her elbows and bent knee are also pushed out to create strong angles. Although we are aware that this is a static pose, it has movement implicit in the arched torso, the bending of the arms and the attitude of head, feet and shoulders.

These two figures are apparently startled, turning to see something that may be surprising. They are looking above the head of the artist, bending towards each other, their arms seeming to indicate disturbance. The movements of the bodies, their juxtaposition to each other and the apparent focus of their attention outside the picture frame all help to produce a dynamic, energetic set of forms, which we read as movement. The way the figures are framed also helps this feeling, with the outstretched arm of the man almost touching the top edge, and their legs being out of sight below the knees. The diagonal forms of the two torsos, leaning in towards each other away from the lower corners of the frame, also help this appearance of action.

# Relaxed poses

Here, the basis of the pose is more relaxed, without the active dynamism of the poses on the previous page. This is, of course, a much easier way to pose a model, because most people can keep still in a comfortable reclining or sitting position. When you want to work for a longer period of time and create more detailed drawings, you will always have to rely on more static poses.

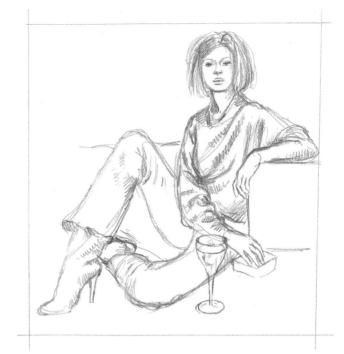

Sitting upright on the floor, this model has her legs bent, one tucked underneath the other. Her fashionable appearance and the wine glass on the floor in front of her help to give a static easy-going composition which looks as if she is engaged in a conversation at a party. The arrangement of the legs crossing each other and the arms bent around the torso help to give a fairly compact appearance to the arrangement.

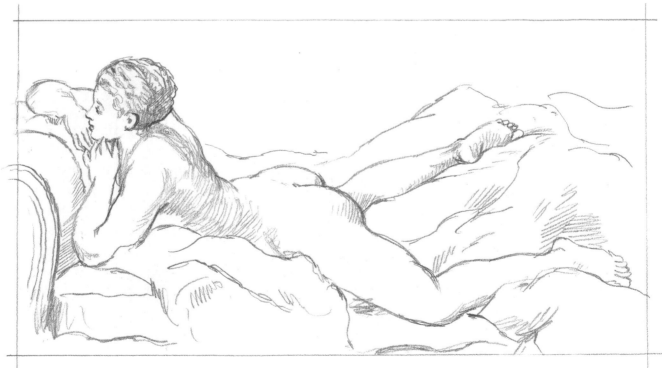

In this drawing, based on a work by the 18th-century French painter François Boucher, a nude girl is reclining on a couch, posing for the artist. Although her head is erect, supported by her hands, and her back is hollowed, she is in a pose that doesn't suggest action on her part at all. The side view of a reclining pose is always the most calm and peaceful in its effect.

# Geometric groups

The use of geometric shapes to compose and 'control' a group of figures is a well tried method of picture composition. It can become a straitjacket if it is taken too seriously, but it is a good method to use as a guide because it puts a strong underlying element into the picture. All the obvious geometric shapes can be used – a circle, a triangle, a rectangle, a parallelogram – although this can lead to a rather forced composition if you are not careful.

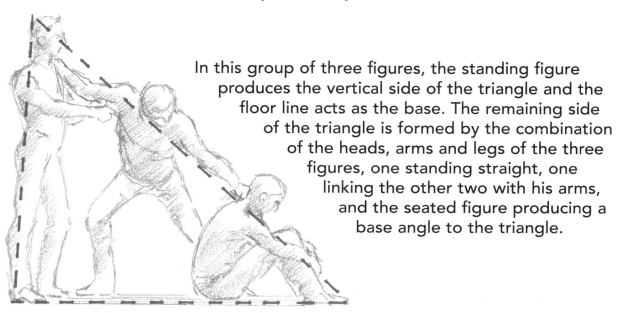

In this group of three figures, the standing figure produces the vertical side of the triangle and the floor line acts as the base. The remaining side of the triangle is formed by the combination of the heads, arms and legs of the three figures, one standing straight, one linking the other two with his arms, and the seated figure producing a base angle to the triangle.

A circular composition is unusual and lends itself mostly to dance movements of groups of figures. This group of three couples suggests some formal movement which could develop into a dance, with the lower edge of the circle indicated by two females about to stand up but still sitting or kneeling. The gestures of two of the male and female figures with their outstretched arms help to create the circle and the beginning of a dynamic, dancing movement.

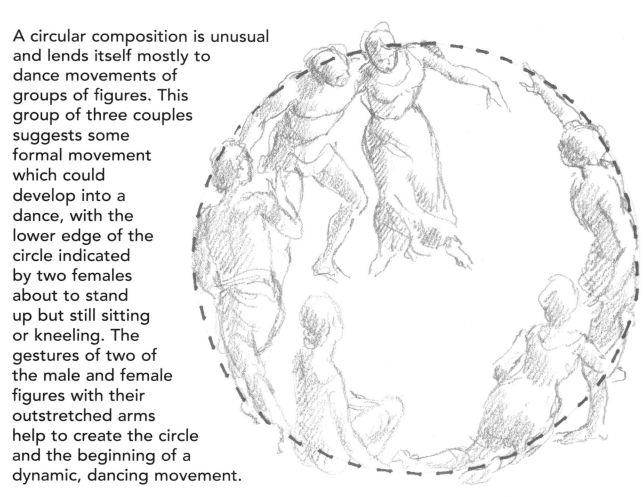

# Figures in Action

Once you have begun to produce drawings that look like convincing pictures of human beings, you will soon want to have a go at drawing figures in movement. This is more difficult, but artists are helped a lot by photographs which have caught the mobile figure and show us how the movement breaks down into its various parts, and by videos which can be freeze-framed. Nothing quite takes the place of quick sketches of people moving about, but obviously you need to have a good enough memory to get some sort of reference drawing onto paper immediately after you have seen a fleeting movement. You can then supplement this by looking at photographs of people in similar motion.

It is helpful to ask someone to model for you, slowly performing the action you want to study. This way you can draw the action at different stages, out of which you can pick a final image. Observation is the key to drawing movement, and you have to keep watching people and noticing how their balance changes, how their arms move, how their weight shifts and how their head turns.

Part of the problem with drawing figures in motion is that to get the best pose of the figure, you have to choose a moment where the maximum dynamic of the movement is shown. This is sometimes best at a difficult-to-pose point – for example, as the foot leaves the ground. This point can often show the quality of the movement more effectively than the most obvious image we have in our minds of how a particular action looks. It is also necessary to consider the sort of marks you make in order to give the effect of the moving body. Sometimes a fluid, loose line works better, while at other times a sketchy, angular line will give a more effective description of what is happening.

There are many ways of approaching the drawing of figures in motion, but the key to the exercise is observation; once you begin to see how movements progress, the images tend to remain in your mind even after they have been completed so that you can draw them from memory. At this stage of your composition you need to be flexible, take chances and not worry too much if the drawing goes wrong. Constant practice will gradually eliminate the obvious mistakes and help you to produce convincing drawings of moving figures.

## Walking and running figures

Photographs are a great boon to the artist wanting to discover just how the parts of the body relate to each other as the model moves, but they should be used with caution, as copying from a photograph can produce sterile results. An artist should be looking not just to make an accurate drawing of lines and shapes, but also to express the feeling of the occasion in a way that can be understood by the viewer – look particularly at the styles of depiction chosen here. Study photographs, but stamp your own mark as an artist on your drawings.

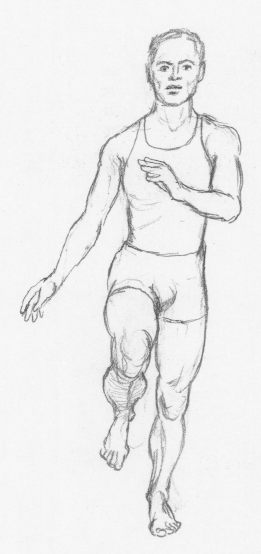

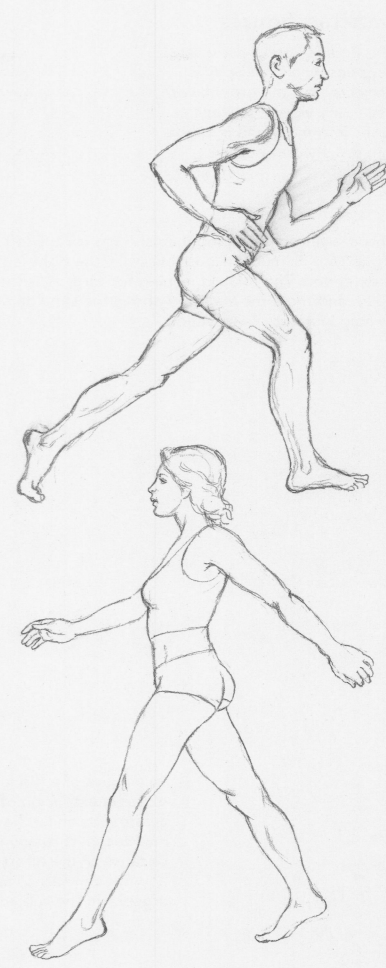

The figures shown here are quite precisely based on photographs of people walking and running. A photograph gives you one particular moment in the action, and because you can draw it with a precise line given the benefit of a still image from which to copy, the final result tends to look slightly formalized. This produces a certain stiffness in the drawing, which you can overcome by more direct experience.

# Dancing figures

The figures here show what happens when the body is projected off the ground with necessary vigour; in some cases informally and in others in more stylized poses.

This drawing of a leaping man shows how the left leg is bent as much as possible while the right leg is extended. The torso is leaning forward, as is the head, and the arms are lifted above the shoulders to help increase his elevation.

This figure of a girl leaping in dance mode shows extreme extension of the legs and arms in order to create a balanced figure in mid-air. Notice how the muscles, particularly in the thighs, are very evident because of the effort involved in the action. Notice how the pencilling reflects the energy and sense of urgency in the subject matter.

The sinuous shape of this girl indicates a slower sort of dance, which is accented by the movement of the dress blowing up in the wind. Notice how the lines of the drawing follow the flow of the figure, with no attempt at an exact rendering of her form.

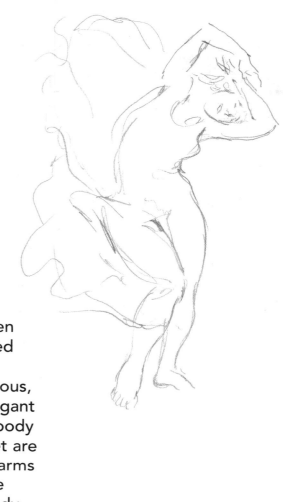

This figure is taken from a film of Fred Astaire dancing, engaged in vigorous, balanced and elegant movement. The body is turned, the feet are tapping and the arms are swinging. The turning of the body is balanced by the disposition of the legs and arms and head.

In a classic version of simple ballroom dancing, this girl leans back slightly, the man's arm around her waist. Her skirts and hair swing out while his stepping feet direct the movement of the dance. Again, the drawing is kept minimal with just enough movement in the clothing to show its type, but with no details evident.

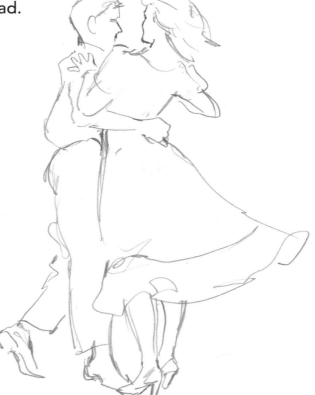

# Seated and reclining figures

Sitting or reclining are hardly considered to be movements, and yet the dynamics of the figures shown here do suggest a quality for potential activity, as their poses suggest imminent movement.

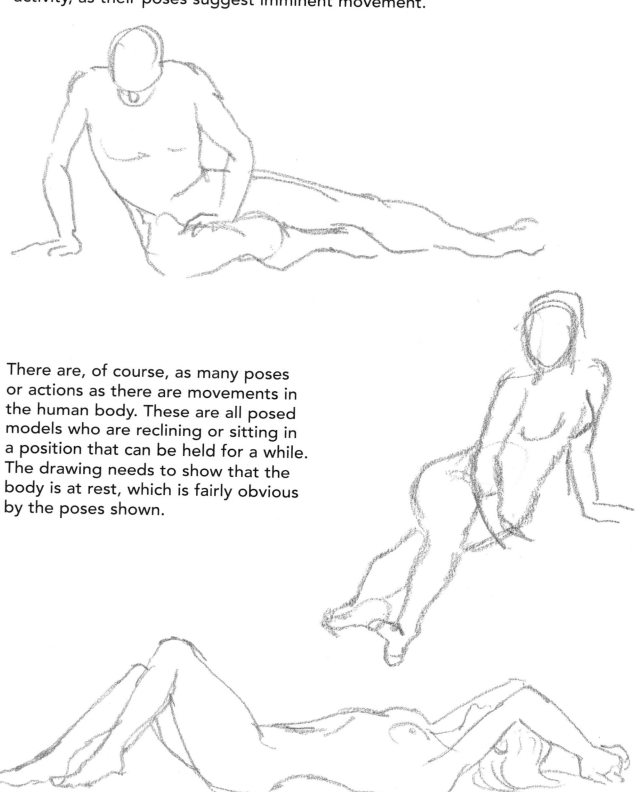

There are, of course, as many poses or actions as there are movements in the human body. These are all posed models who are reclining or sitting in a position that can be held for a while. The drawing needs to show that the body is at rest, which is fairly obvious by the poses shown.

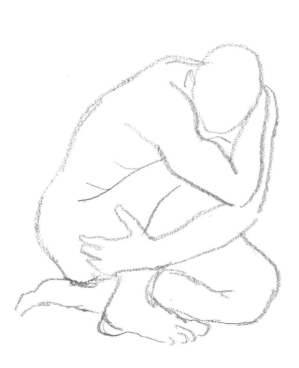

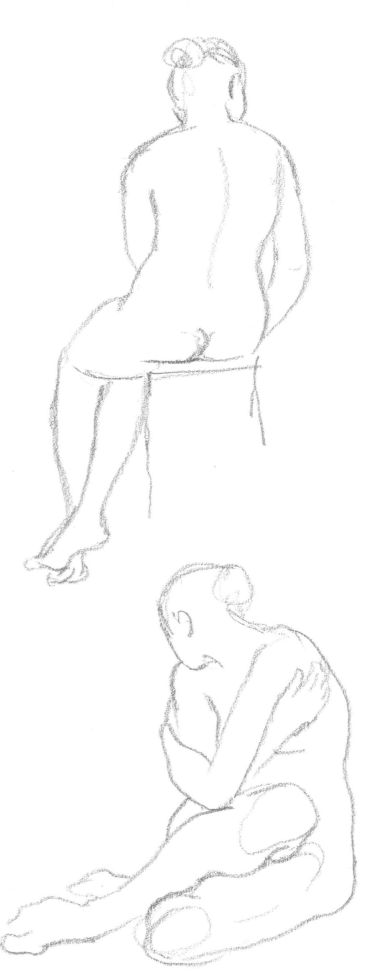

These are slightly more tightly organized poses than those on the page opposite. This often gives a more sculptural quality to the arrangement and produces a more contained effect in a drawing. The poses also present some different challenges to the artist: foreshortening and form are two areas that will need more attention when drawing these models.

# Figures in Detail

Earlier in this chapter I drew the skeleton and musculature of the body as a preliminary to drawing quite anonymous figures engaged in various activities. As you become more skilled you will want to characterize your figures, and to do this you need to learn more about how the human figure is constructed and drawn in finer detail.

Start by taking each part of the figure and look at it from many different angles. You will never finally draw every possible view of every different type of human figure because the variety is too great, but you should be able to get a very good vocabulary of figure details that will eventually make all the difference between whether your drawing carries conviction or not.

You can even use yourself as a model, drawing parts of your body in front of a mirror. This is very useful when no other models are around, although you need to be very objective about your own body.

Don't forget that although it is very useful to draw from photographs, you will learn more by drawing from life. This means that you need to use your friends and family as models. Probably only professional models will pose nude for you, but you can spend hours drawing the parts of body that are more readily seen. And if you take your sketchbook with you when you are at a swimming pool or on the beach, you will have plenty of nearly-nude models around.

The overall understanding of the construction and shapes of the human body is very necessary to draw well, but eventually one has to fine-tune one's knowledge by observing every detail and learning how that detail can be drawn from all viewpoints. This experience is never wasted and can make all the difference to a drawn figure, which without it might lack conviction because of a poor understanding of how to draw a hand or a foot.

By drawing the parts of the body repeatedly and extensively, you will begin to build up a clear and realistic picture of how the human form looks. Eventually it will be possible to draw a fairly accurate human being directly from your imagination, but it takes time to do that well and even after years of practice I find that I still need to regularly draw the human figure from a model in order to keep my technique fresh and convincing.

## The head

Although this chapter is concerned with figure drawing as a whole, the head is one of the most important components of the body and therefore deserves close attention. Study of its form and shape is necessary so that it will look natural in your drawings of figures. Here, we look at it from all angles and get some idea of its dimensions and characteristics.

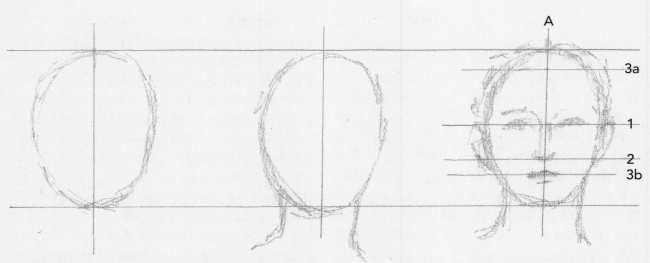

Getting the basic proportions of the head right is the starting point, and these drawings show how the features are distributed. The eyes are placed halfway between the top of the head and the base of the chin (1); the end of the nose comes to about halfway down the lower half of the face (2); and the hairline and the mouth are roughly the same distance from the top edge and the bottom edge of the head (3a and 3b). Draw a central line across which the features are balanced (A).

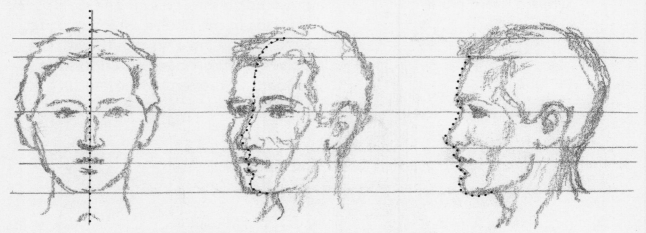

Looking at these views of the head as it moves round from full-face to profile, notice how the central line (dotted) maintains its position relative to the eyes, nose, mouth and chin. The proportional positions of the features down the length of the head remain the same as long as the head is not tilted backwards or forwards.

This trio of heads shows how you can reduce the complexities of the form into simple blocked-out shapes. Notice that the eyes are just planes across the sockets. The nose and mouth don't really appear, but you have to make sure that the shape has the general prow-like look of the lower face. The forehead, in contrast, is broad and relatively flat, but be careful that you do not lose the roundness of the head.

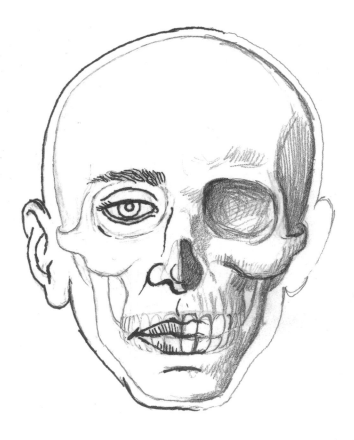

These diagrammatic heads explain how the shape of the head is formed. The first shows the structure of the skull inside the fleshier shape of the head and how the eyeball sits in the socket of the skull, the nose cartilage forms its shape around the nasal cavity, the mouth and lips lie across the ridges of the teeth, and the ears sit just at the back of the zygomatic arch.

The diagram below shows how the various muscle groups are placed in the facial features. Listed here are all the expressions that are produced on the surface of the face when these muscles go into action. The groups of muscles in the cheek, which connect parts of the jaw and mouth with the upper skull, produce an enormous amount of movement on the face.

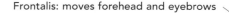

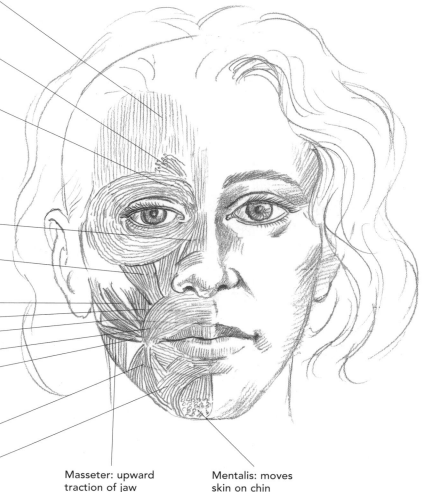

Frontalis: moves forehead and eyebrows

Corrugator: pulls eyebrows together

Orbicularis oculi: closes eye

Levator labii alaeque nasi: lifts lip and wrinkles nose

Levator labii: raises upper lip

Zygomaticus minor
Levator anguli oris: raises angle of mouth
Zygomaticus major: upward traction of mouth
Obicularis oris: closes mouth, purses lips
Risorius: lateral pulling on angle of mouth (as in grinning)

Depressor anguli oris: downward traction of angle of mouth

Depressor labii inferioris: downward pulling of lower lip

Masseter: upward traction of jaw

Mentalis: moves skin on chin

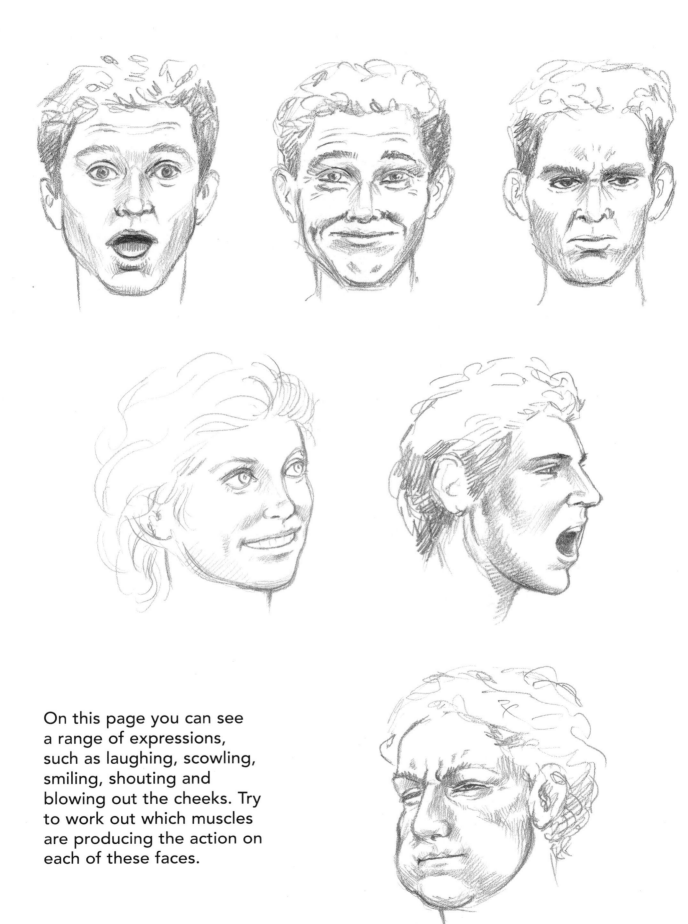

On this page you can see a range of expressions, such as laughing, scowling, smiling, shouting and blowing out the cheeks. Try to work out which muscles are producing the action on each of these faces.

# The torso

Next, we shall look at the torso, the main trunk of the body from which the head and limbs depend.

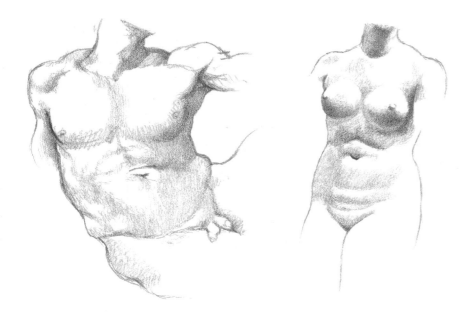

Here I show two classical interpretations of the human physique at its most beautiful and powerful, produced by the great Renaissance artist Michelangelo. On the left is the torso of Adam, the first man, and on the right is the body of the goddess Venus, in a Roman copy of a Greek original.

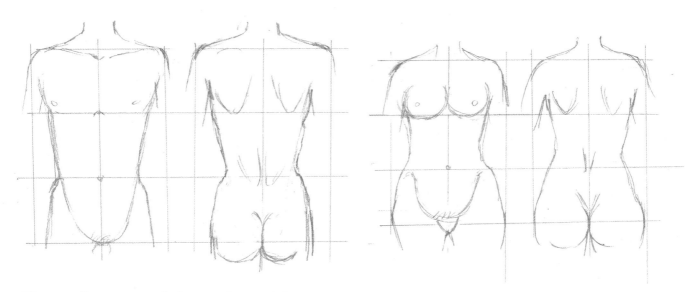

These diagrams of the male and female torso show their proportions. The central vertical line is divided horizontally by four lines which denote, from top to bottom: the top edge of the clavicles (collar bones); the lower end of the sternum; the level of the navel; and the lower edge of the pubic bone. Seen from the back, the same lines mark the top of the clavicles, the lower edge of the shoulder blades, the small of the back at the level of the navel, and the base of the sacrum of the iliac. The latter is hidden by the fleshy part of the buttocks. The female proportions are the same, but generally on a slightly smaller scale. The main difference is the widest point, which on the man is invariably the shoulders and on the woman may be the hips instead. The divisions are all one head-length apart from each other, so there is a proportion of about three head-lengths to the torso.

The side views indicate the other obvious differences between male and female torsos.

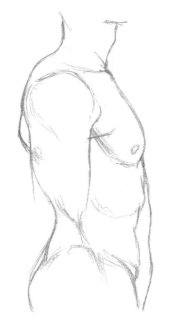

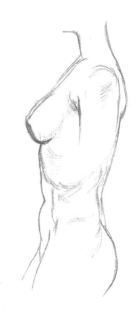

This detailed drawing of the back of a male torso shows the disposition of the muscles, and the diagram next to it shows what happens to these divisions when the body bends.

The female back view shows a smoother-looking figure, because a woman's muscles are usually more hidden than a man's, producing more harmonious, gentle changes from plane to plane. When looking at the divisions from the back, notice the curving of the spine, which can change the look of the proportion.

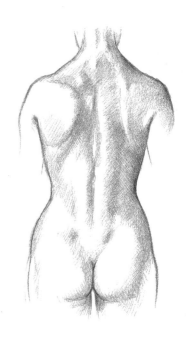

# The arms

The upper limb is a very flexible part of the anatomy, and there will never be enough examples of the different views you can get of the arm. I have tried to show some of the most obvious and characteristic poses. The three main views are the whole length of the arm, the view from the hand towards the shoulder, and the view from the shoulder towards the hand.

Here is a selection of arms, both male and female, seen from different angles. Notice the relationship of the size of the hand with the length of forearm and upper arm. See how flexible the arm is as it moves up and down, bends and stretches. Some of the muscles show clearly, while others disappear. When the arm is pointing towards the viewer, the roundness of each part becomes much larger than the length. Because the arm can twist as well as bend, it has a variety of shapes that it can make in the air – all well worth studying closely.

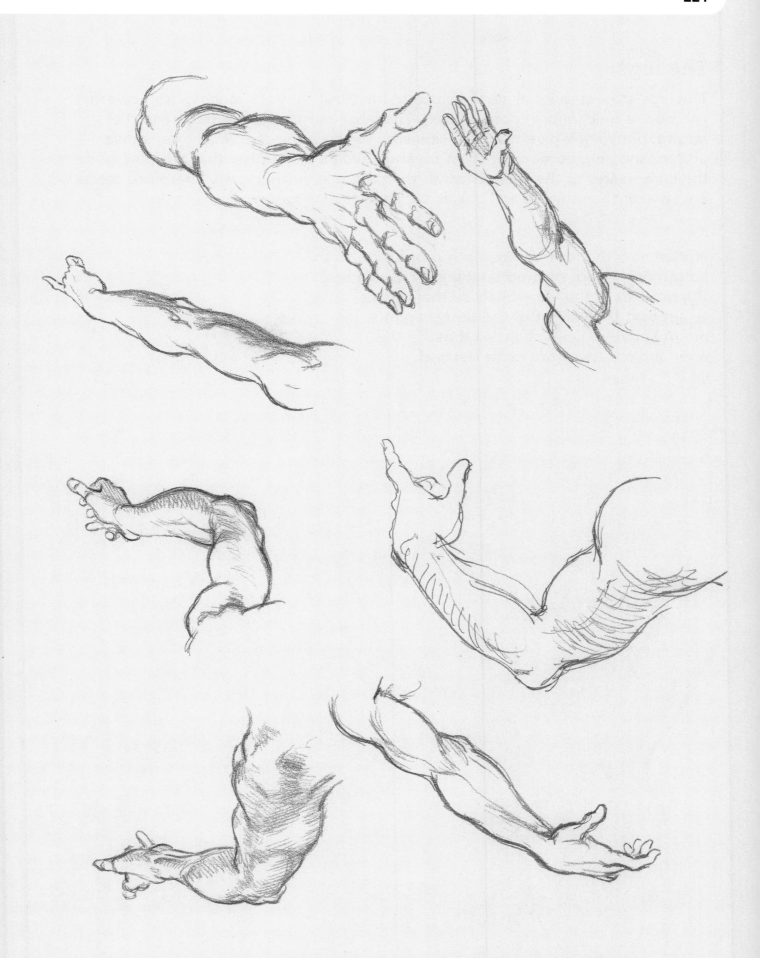

# The legs

The legs are not quite as flexible as the arms, but they are much more powerful, and so are much more robustly built. The large muscles in the thigh and the strong, bony knee give the leg a similarity to the trunk of a small tree, so we understand connotations of strength and solidity. Remember that any part of the limb nearer to the torso is wider than the part further away, therefore calves are smaller than thighs, and ankles are smaller than knees.

Notice how the foot compares in proportion to the length of the leg. Also note how easy it is to see the muscles in the leg – because the leg has to support the weight of the body, leg muscles are much more powerful than those in the arm, and are therefore more defined.

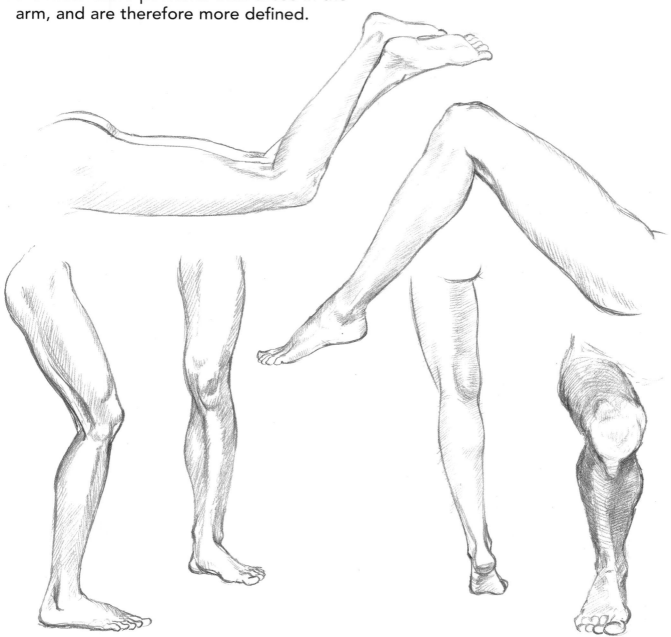

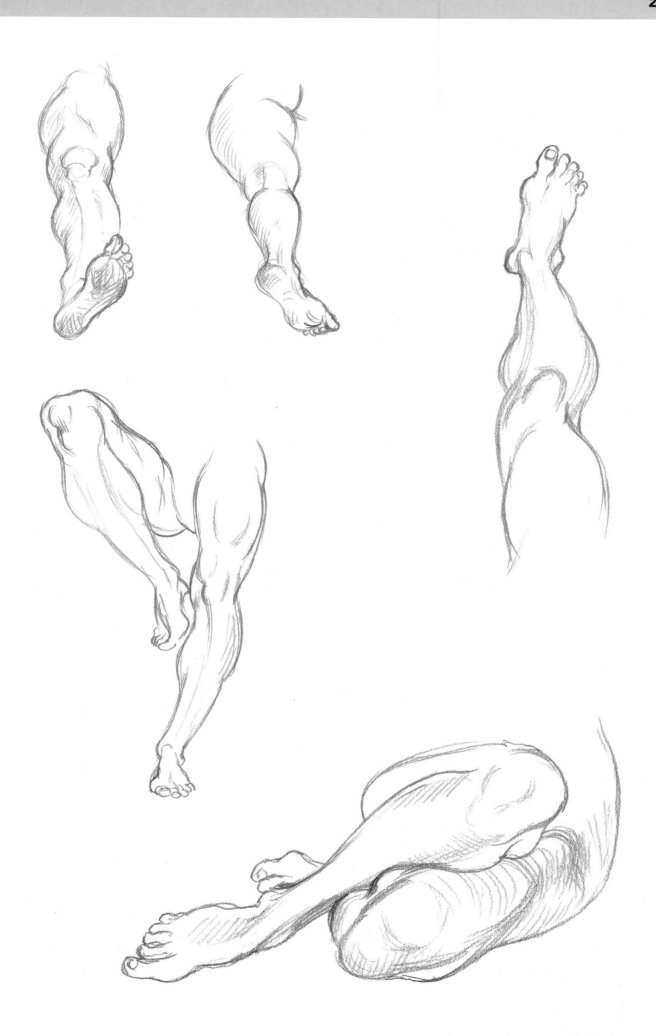

# The hands

Over the next few pages the hand is shown in various positions, but here it is in its most simple pose. To get a clear idea of the shape of the hand, it is a good idea to simply draw carefully around your own or someone else's hand. Do this for both the left and right hands, both sides, and fill in the details such as fingernails, creases and knuckles. This sort of simple investigation and observation is very useful, as you will find you remember quite a bit of it.

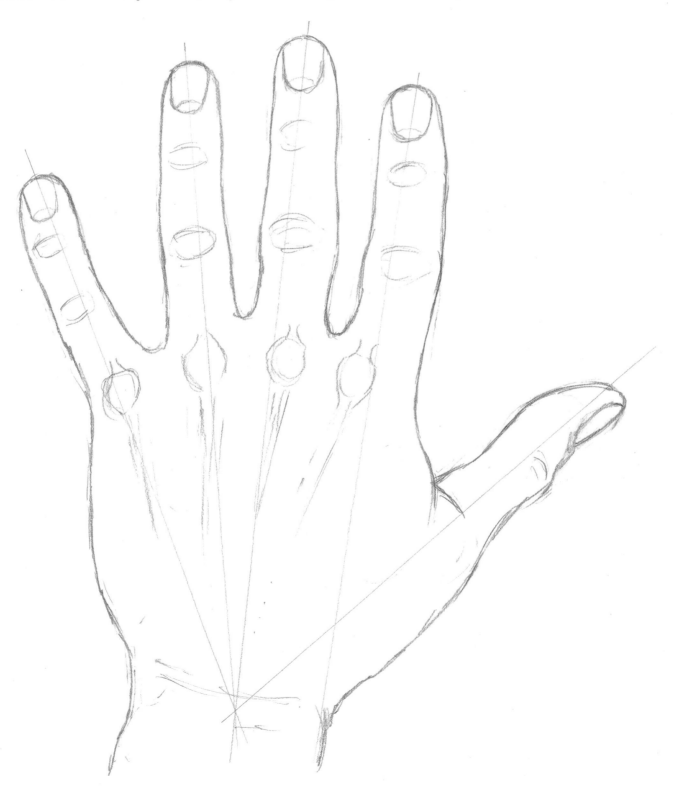

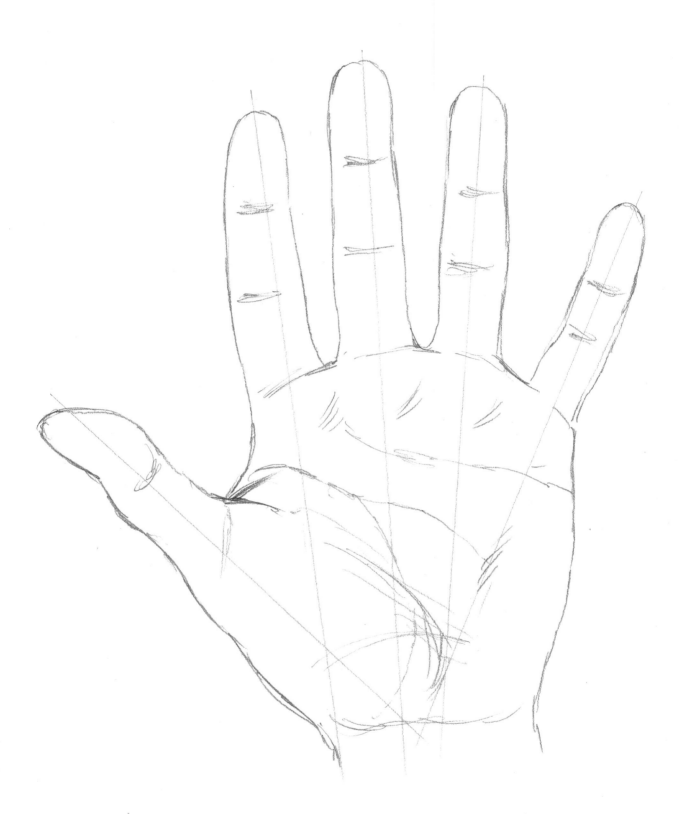

In these two outline drawings of the hand from the front and back, notice the relationship of fingers to palm. Note the fact that the fingers taper and the palm has fleshy pads on it, while the back of the hand has ridged tendons and knobbly knuckles. Some hands, of course, are longer and narrower, while others are thicker and broader.

Shown from many angles, these hands give some idea of the complex movements of which the hand is capable. Note especially the drawings of the hand in perspective, foreshortening the shape – it is a good practice to try drawing your own hands in the front of a mirror to see them extending away from you. Try side views with and without the mirror. Notice the relationship of each finger to the other, and their relationships with the thumb. When you are really confident about drawing hands, try two hands with fingers interlocked. Be careful you don't draw too many fingers!

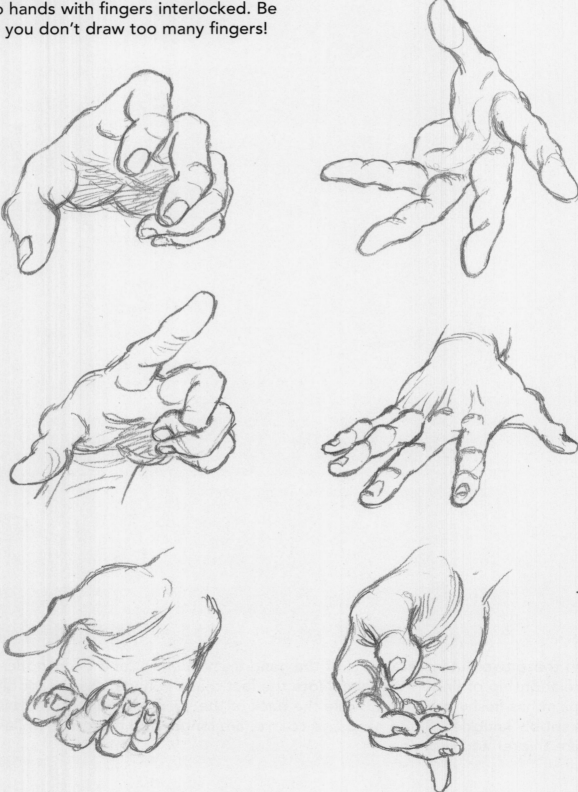

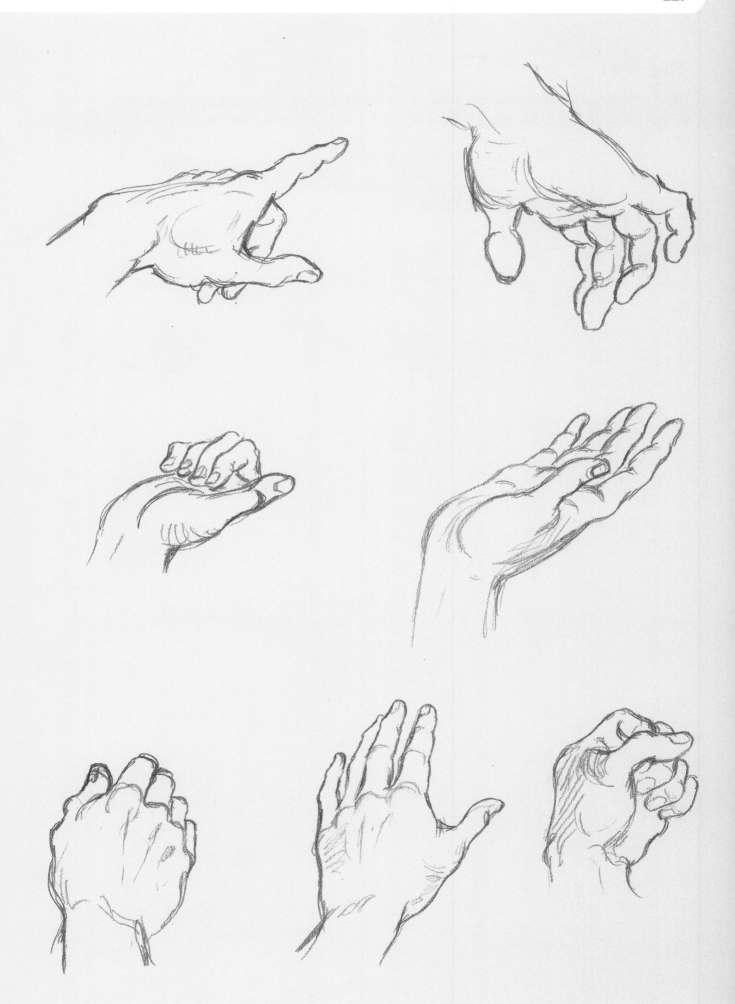

# The feet

Feet are simpler than hands and don't have the same flexibility, but they are still quite difficult to draw well, especially when seen from the front or back.

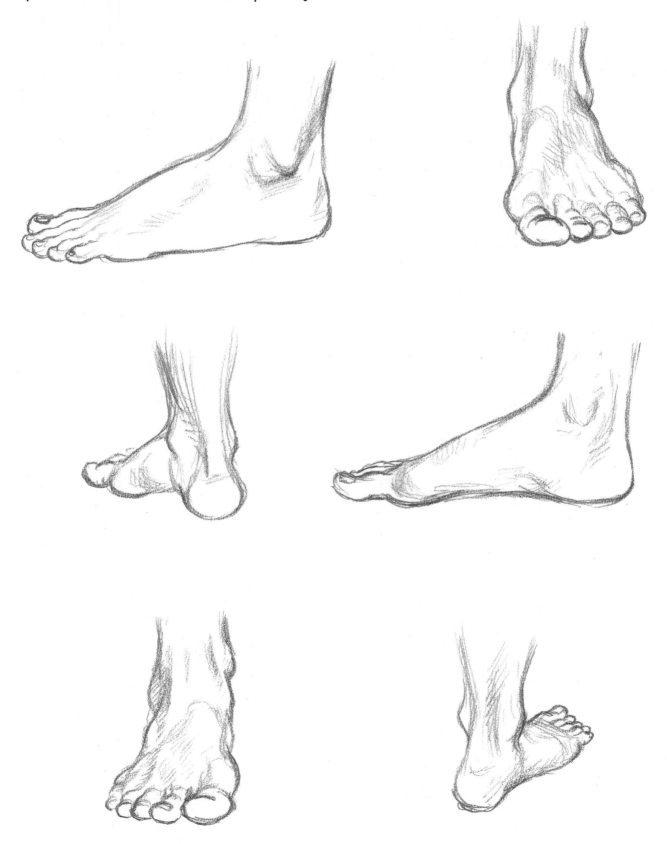

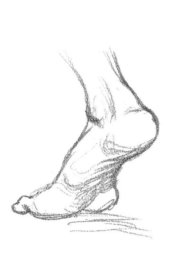

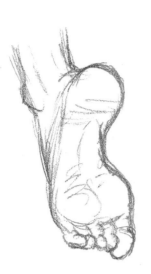

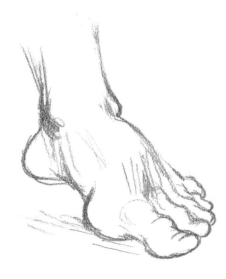

Notice the difference between the inner side of the foot and the outer side view. Notice which ankle bone is higher – is it the inner ankle or the outer ankle? The awkwardness of feet seen from the front has to be addressed, because you cannot always draw people in profile; so have a good try at showing how the toes project forward from the solid part of the foot. Don't forget to look at feet from below as well. When a model is not available, you can practise drawing your own feet reflected in a mirror.

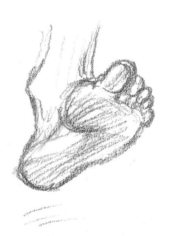

# The eyes

Basically a sphere, the eye is set into a socket in the skull and covered by the eyelids and muscles surrounding the socket. The parts that we see in the mirror or when talking to someone are just a small part of this sphere, and are composed of the white part (sclera), the coloured part (iris), the central focal lens (cornea), and the flexible hole that lets in the light (pupil). If you remember that the eye is an orb shape, it is easier to draw correctly from observation.

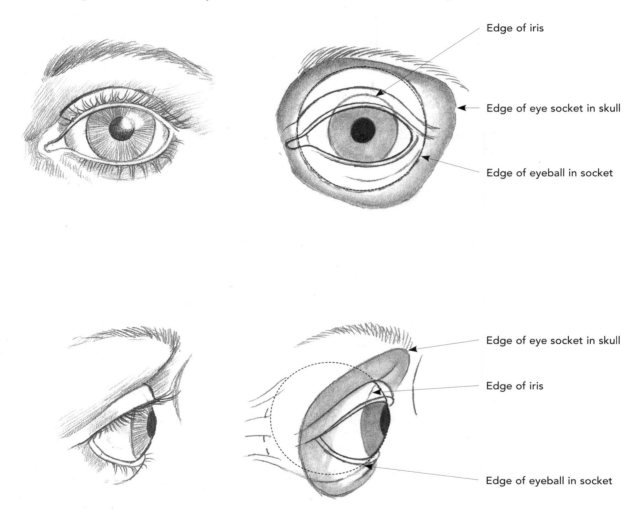

Edge of iris

Edge of eye socket in skull

Edge of eyeball in socket

Edge of eye socket in skull

Edge of iris

Edge of eyeball in socket

Because the eyeball is set in the eye socket of the skull, its rounded shape is only seen clearly in the part of the eyeball shown when the lids are open. We do tend to forget that it is only a segment of a ball that we are looking at, but this is especially noticeable from the side view; if you don't draw that curve, the eye looks unconvincing. Note that normally the upper lid covers a small section of the iris (the coloured part) of the eye, and the lower rim of the iris appears to just touch the lower lid. As soon as the eyelids are stretched a bit, perhaps in alarm, this changes of course, and the iris and even the white of the eye around it is exposed. Don't forget that the eyelids actually have a thickness where the base (the roots) of the eyelashes are located. The eyebrow shows the position of the bony upper edge of the eye socket.

Now look at the selection of eyes opposite, male and female, old, young, front view, side view, looking down and up. Detailed studies – or even just observation – like these are worth doing whenever you can.

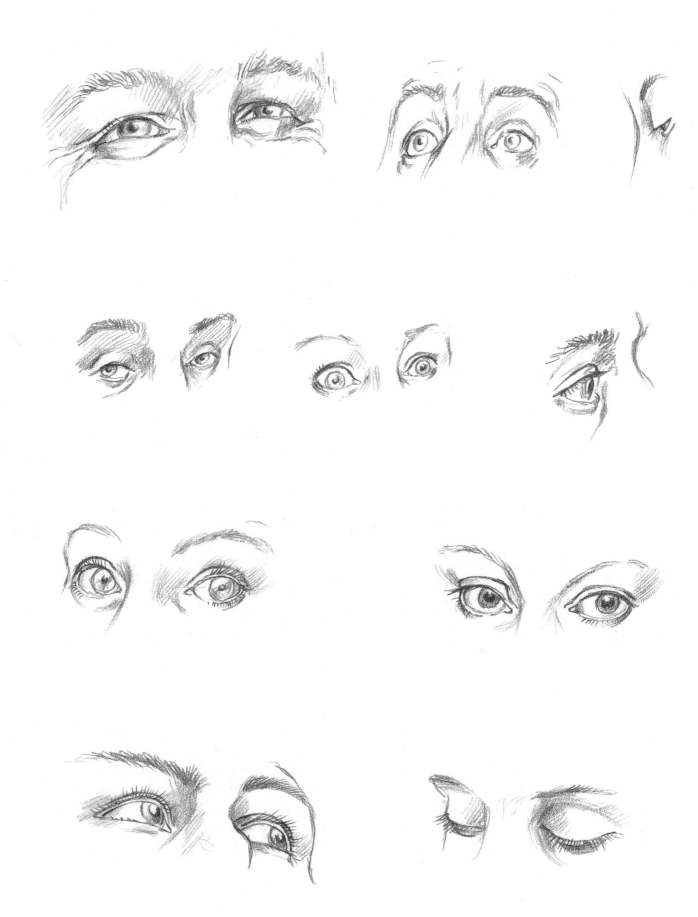

# The mouth

Drawing the mouth does not impose too many problems as long as you remember that the most significant and strongest line of the mouth is the part where the lips meet – not the outline of the lips, which is often incorrectly supposed to be more important.

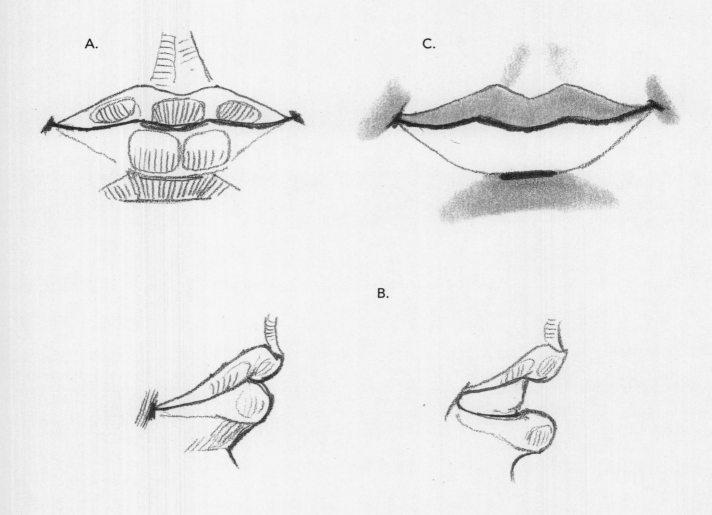

The upper lips of the mouth have three pads of thickness and the lower have two (diagram A). The side view of the lips (diagram B) shows how the shape alters when the mouth is open and shut. Under most lighting, the upper lip is in more shadow because its plane is angled downwards; there is shadow under the lower lip and the corners of the mouth often have a slight shadow due to the corner tucking into the flesh of the cheek (diagram C). These are merely general rules and you will still have to observe carefully the individual shape of your model's mouth.

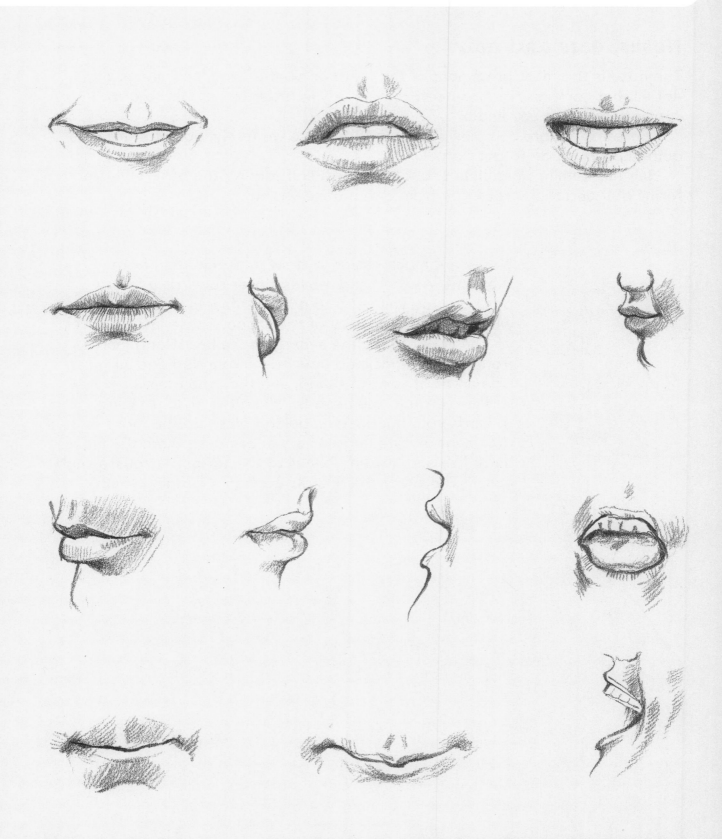

These illustrations show a range of mouths: open, closed, smiling and shouting, seen from above, below and the side. When the mouth is seen partly from one side, the further side will look much shorter and more curved than the side closest to you. In a smile, the lips become stretched and therefore appear slightly thinner. When the mouth is closed, it can be full and soft-looking or pressed together and thinner, depending partly on age and disposition. Very young children's mouths are extremely rounded and soft, and usually fuller in shape.

# Noses, ears and hair

The nose is the most prominent of the features on the head, and although not all that complex, it does need some study in order to be able to draw it convincingly from any angle.

The ear is a more complex shape, and because we rarely look at it, it takes quite a bit of study to get right.

Hair has infinite possibilities, but it is worth considering the basic styles or forms of it and then drawing it from direct observation.

Noses are much easier to draw in profile than from the front. As the head moves closer towards a facing position, you will need to note the facets of the surface which show the solidity of the shape. These images give you an idea of how the average nose has a long, narrow frontal surface inclined upwards, a rounded end surface, side areas of varying shape, and then the more complex surfaces around the nostrils. When the nose is facing towards you, the nostrils, being holes, are the most dominant feature. Noses vary enormously from the most hawk-like and aquiline beaks to the softest retroussé snub noses. The tilt of the nostrils is often a defining shape.

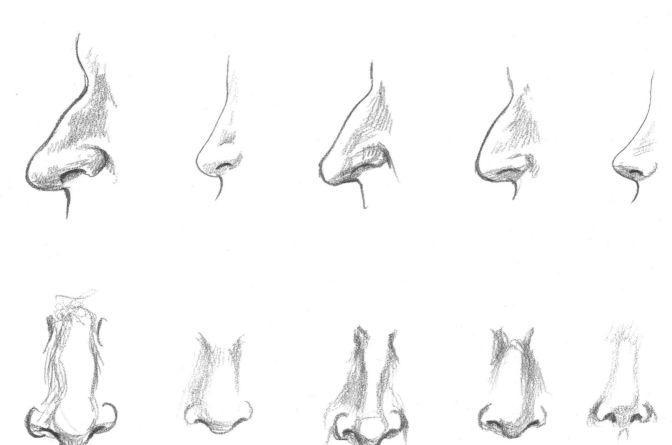

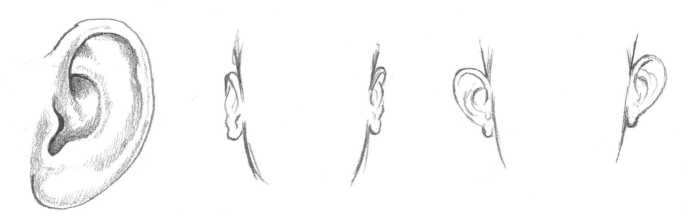

Ears are only difficult because we rarely look at them. The diagram here shows an ear of average shape, and although there are many variations, the basic structure remains the same. Some ears are much flatter against the side of the head and are not noticeable from the front; others stick out like jug handles and can be quite a strong feature on a head with short hair. Apart from their size and the amount they protrude, they are not an instantly recognizable feature in the human face.

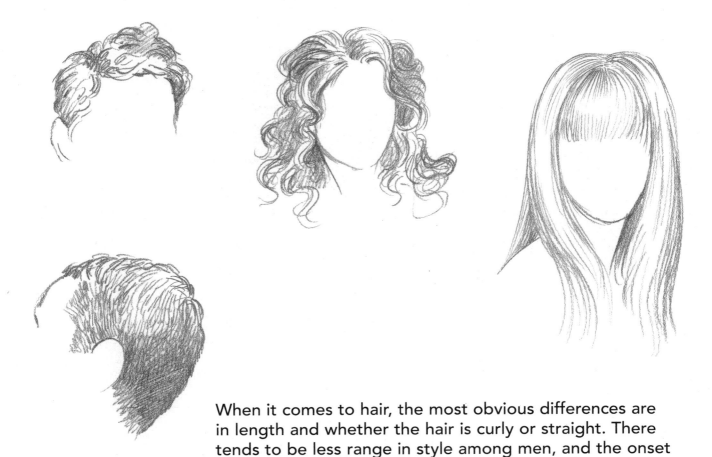

When it comes to hair, the most obvious differences are in length and whether the hair is curly or straight. There tends to be less range in style among men, and the onset of thinning hair with age does tend to change the look of someone's face. Shown here are just four examples of how to tackle short, straight, curly and long hair.

# Body language

The human figure will usually bring some emotional context to a picture. This is mostly shown by the way the figure is depicted moving in the scene, and quite often requires the juxtaposition of two figures – for example, a figure waving their fists in the air and confronting a cowering figure would obviously suggest some disagreement or aggression going on. However, the moods indicated are usually more subtle than this and, particularly when there is only one figure present, the artist has to understand and master the conventions of body language before the picture will tell the desired story. Here, you will find some examples of the moods that different poses evoke.

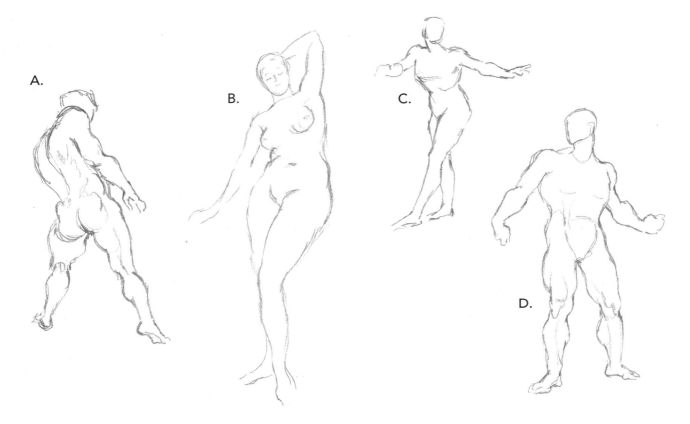

A. The pose of this masculine figure suggests some effort possibly related to pulling or pushing, shown by the braced legs, straight arm and twisted spine.

B. The female figure seems to stretch out in dreamy languor, emphasized by the sinuous quality of her arms and legs.

C. Another female figure, this time one who looks startled by something behind her, with a slightly theatrical gesture.

D. This male figure is obviously aggressive, with his pulled-back fist and fighting stance, reinforced by his heavily muscled form.

E. A female figure with arms aloft appears to be crowing with delight or jubilation, as though she has just won a prize.

F. Turning to look at something behind and at her feet, this figure shows her surprise in a rather dramatic gesture.

G. In a crouching position with head down, this man appears to be moving hastily away from something causing fear or a similar emotion.

H. The kneeling figure shows mental strain of some sort which, with his hand to his head, suggests the conventional pose for agonized thought.

I. This female figure seems to be protecting herself with a pose suggesting the foetal position.

J. A male character sitting back as though on the beach enjoying the sunshine evokes a feeling of simple relaxation.

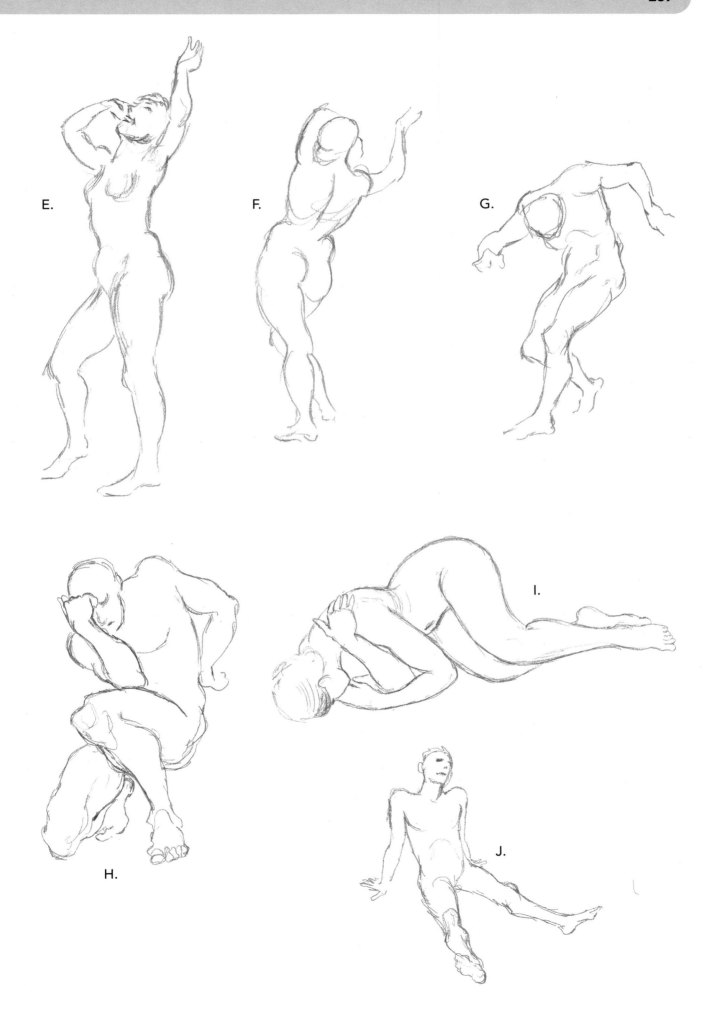

E.

F.

G.

H.

I.

J.

# Drawing Portraits

It is now time to look at the most important aspects of drawing portraits. Themes are presented in the order in which you will tackle them, so that even if you have never done a portrait before, you will know how to proceed. You will notice that much emphasis is placed on the structure of the head and the features. The main shape of the head is vital because if you ignore this, the resulting drawing will never really catch the qualities of the sitter. If you are very new to portrait drawing, you will find it beneficial to practise drawing just that shape accurately, if loosely and lightly.

There is an objective shape that a particular face will have, and this can be studied until correctly drawn. How each lump or bump in each feature is related to the whole shape and whether the curves are greater or smaller can make a lot of difference to the final result. There is no substitute for careful observation. If you practise looking at people's faces, it will enhance your ability to draw the shapes in front of you. Changing light conditions and expressions give subtle variations to the features. You have to decide exactly which of these variations to include in your drawing.

Finally, we look at a range of materials in order to give you a wide spectrum of options. What you discover for yourself through trial and error will stay with you and inform your work in the future.

## The angle of the head

The most distinctive part of any portrait is the face, which is where the likeness and characteristics of the sitter can be shown most easily. This is your starting point. The head should be dealt with as a whole so that the face has a solid basis. Only so many views of the head are possible for a portrait to be recognizable.

The position you choose for the head will make a lot of difference to the end result and whether people recognize your subject. We will start with the most common, and then assess the workable alternatives.

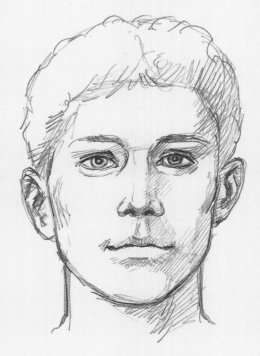

Full face, from the same eye level as the artist, is excellent for capturing the expression in the eyes, but the shape of the nose is less obvious.

The three-quarter view is probably the most popular position. It gives a clear view of the eyes and enough of the shape of the nose to give a good likeness.

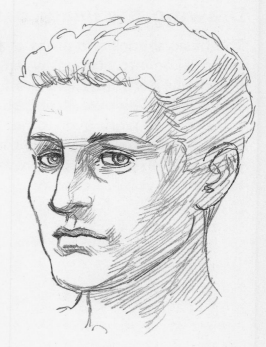

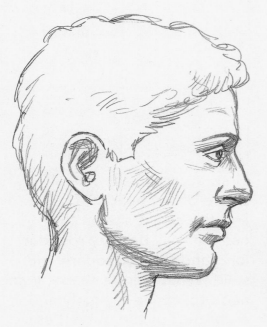

The head seen in profile allows clear definition of the features. Generally, though, portraits from this angle are less expressive, because the eyes are not clearly seen.

The head tilted back a little gives an air of coolness, even haughtiness, but it's worth considering.

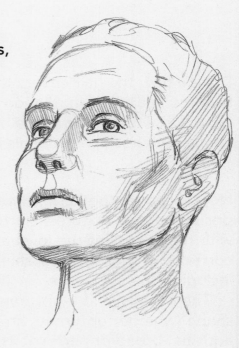

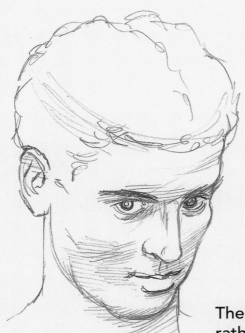

The head tilted forward can give a rather quizzical or defensive expression.

# Drawing the head: basic method

The basic shapes and areas of the head have to be taken into account when you start to draw your portrait. There are five basic steps. These will give you a strong shape which you can then work over to get the subtle individual shapes and marks that will make your drawing a realistic representation of the person you are drawing.

First, ascertain the overall shape of the head or skull and the way it sits on the neck. It may be very rounded, long and thin, or square and solid. Whatever its shape, you need to define it clearly and accurately at the outset, as this will make everything else easier later on.

Decide how the hair covers the head and how much there is in relation to the whole head. Draw the basic shape and don't concern yourself with details at this stage.

Now ascertain the basic shape and position of the features, starting with the eyes. Get the level and size correct and their general shape, including the eyebrows.

The nose is next – observe its shape (whether upturned, straight, aquiline, broad or narrow), its tilt and the amount it projects from the main surface of the face.

Then look at the mouth, gauging its width and thickness, and ensuring that you place it correctly in relation to the chin.

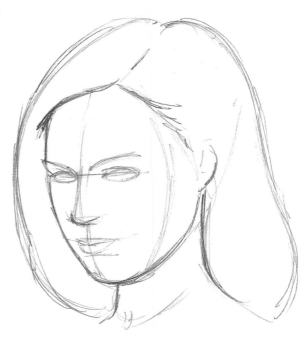

The form of the face is shown by the tonal qualities of the shadows on the head. Just outline the form and concentrate on capturing the general area correctly.

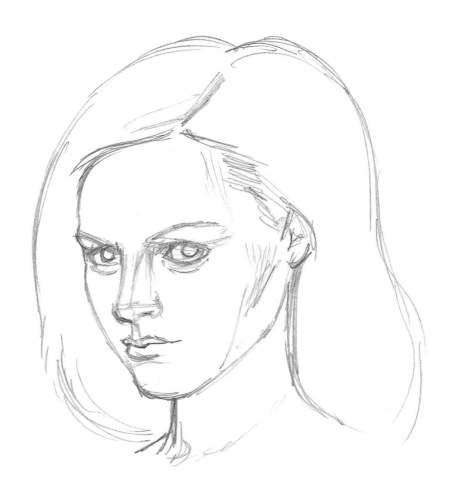

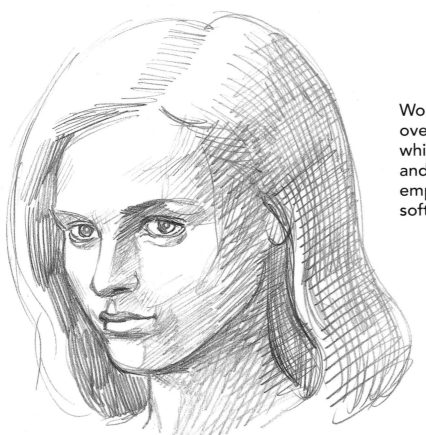

Work in the tonal values over the whole head, noting which areas are darker and which are not so dark, emphasizing the former and softening the latter.

# Drawing the head: alternative method

An alternative method for beginning a portrait is to work from the centre of the features and move outwards towards the edges. This approach is appropriate for both fairly confident draughtsmen and beginners, and is very helpful if you are not too sure about judging proportions and measuring distances. For this exercise we will assume that we are drawing a three-quarter view.

## Phase one: marking out the features

- Mark a horizontal line for the position of the eyes, halfway between the top and bottom marks. Roughly draw in the relative position and shapes of the eyes.
- Make a mark halfway between the top mark and the level of the eye for the position of the hairline.
- A mark halfway between the level of the eye and the bottom mark will give you the position of the end of the nose. Draw in a very simple shape to give you a clear idea of its form. The top mark denoting the top of the head will appear to one side of your vertical line.
- The bottom line marks the point of the chin, which will be on the vertical line.
- The position of the mouth has to be calculated next. The mouth is nearer to the nose than it is to the chin, so don't put it halfway between them.

## Phase two: defining the features

- Draw in the shapes of the eyes and eyebrows, ensuring they are correctly placed. Notice how the eye nearest to you is seen more full on than the eye further away. You can try to define the point where the further eyebrow meets the edge of the head as seen from your position.
- The nose now needs to be carefully drawn: its outside shape and also – in lightly drawn lines – how the form creates shadows on the unlit side.
- Positionally, the ear fits between the levels of the eye and the nose, but is off to the side. Gauge how the distance between the eye and the ear relates to the length of the nose, and put in the outline shape of the ear.
- The half of the mouth on the further side of the face will not look as long as the half of the mouth on the facing side. The centre of the mouth must be in line with the centre of the nostrils. Draw in the pointed part of the chin.

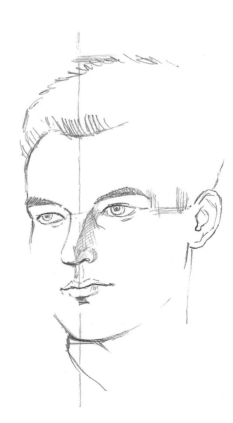

## Phase three: outlining shadows

- Trace out the shape of the shadows running down the side of the head facing you. Just outline the edge of the shadow faintly from the forehead down round the cheekbone, the outside of the mouth and onto the chin. Indicate the neck and its shadow outline.

- Put in the shadows around the eyes, nose and, where they are needed, the mouth. Softly shade in the whole area, including the hair area and the neck. Define the edges of the back of the head and neck, and on the opposite side where the brow stands out against the background. Complete the shape of the top of the head.

- Put in the whole of the shape down the edge of the face furthest away from you; be careful not to make the chin jut out too far. Check the accuracy by looking at the distance between the line of the nose and the outline of the cheekbone, and then the corner of the mouth on the further side and the edge of the face and chin related to it. Make any corrections. At this stage, your drawing should look like a simple version of your sitter.

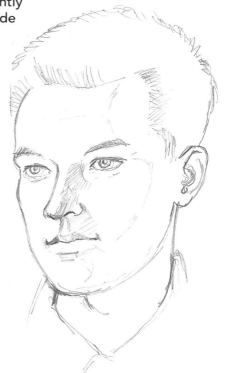

## Phase four: applying tonal values

- Begin by darkening the areas that stand out most clearly. Carefully model the tone around the form so that where there is a strong contrast you increase the darkness of the tone, and where there is less contrast you soften it, even rubbing it out if necessary. Build up the tonal values with care, ensuring that in the areas where there is a gradual shift from dark to light you reflect this in the way you apply tone.

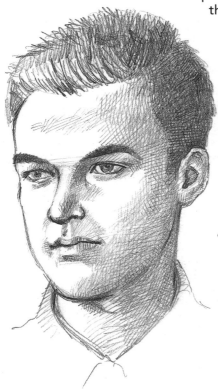

  - The most definition in the features should be in the shape of the eyes, sometimes on the eyebrows, and in the corner between the nose and eye and around the nostrils. The most definite part of the mouth is where it opens, and sometimes the area just below the lower lip. The edge of the chin is often quite well defined, depending on the sort of light you have.

  - Mark in the clearer strands in the hair, and the outer and inner shapes of the ear. Look at the setting of the head on the shoulders, noting how the shoulders slope away from the neck on both sides of the head.

  - You may find that the background behind the lighter side of the head looks dark, and the background behind the darker side of the head looks lighter. A darker background can help to project the face forward. Finish off by applying delicate touches – either with the pencil or a good eraser – to soften the edges of the tones.

# The male head: working out proportions

Especially for beginners, it can be very helpful to use a grid as a guide on which to map out the head, to ensure that the proportions are correct. Despite the amazing variety of faces found in the world, those shown here are broadly true of all adult humans from any race or culture, unless there is major deformation, and so can be applied to anyone you care to use as a model. Obviously there

## Horizontal reading: full face

For the full-face examples, a proportion of five units across and seven units down has been used. Before you begin to study the individual units, note the central line drawn vertically down the length of the face. This passes at equidistance between the eyes, and centrally through the nose, mouth and chin.

- The width of the eye is one-fifth of the width of the whole head, and is equal to 1 unit.
- The space between the eyes is 1 unit.
- The edge of the head to the outside corner of the eye is 1 unit.
- The outside corner of the eye to the inside corner of the eye is 1 unit.
- The inside corner of the left eye to the inside corner of the right eye is 1 unit.
- The inside corner of the right eye to its outside corner is 1 unit.
- The outside corner of the right eye to the edge of the head is 1 unit.
- The central unit contains the nose, and is also the width of the square base of the chin or jaw.

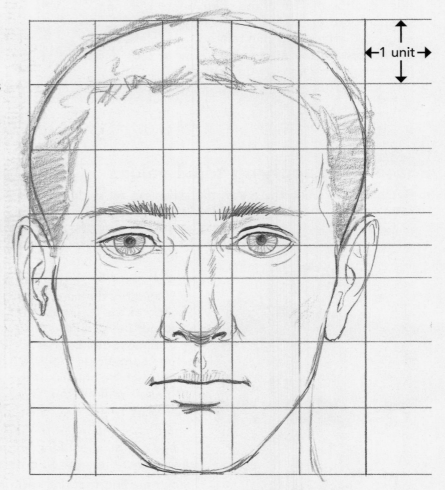

←1 unit→

## Vertical reading: full face

- Eyes: halfway down the length of the head.
- Hairline: 1 unit from the top of the head.
- Nose: 1 and a half units from the level of the eyes downwards.
- Bottom of the lower lip: 1 unit up from the edge of the jawbone.
- Ears: the length of the nose plus the distance from the eyeline to the eyebrows is 2 units.

will be slight differences, but these are so small as to be safely disregarded. The only proviso is that the head must be straight and upright, either full face or fully in profile. If the head is at an angle, the proportions will distort.

The number of units varies depending on whether you are drawing the head full on or in profile. Study each example with its accompanying notes before trying to use the system as a basis for your portraits.

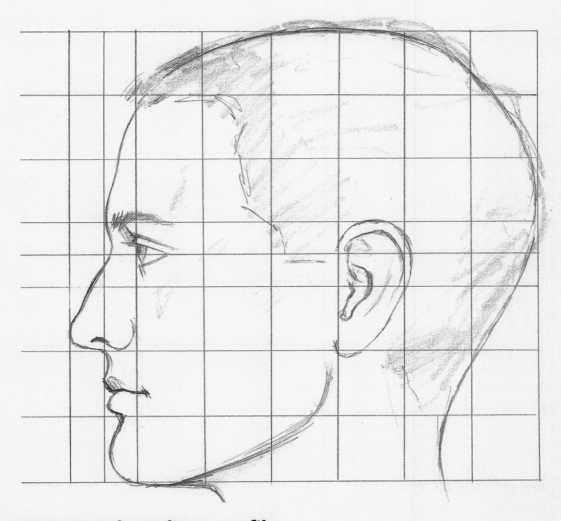

## Horizontal reading: profile

- The head in profile is 7 units wide and 7 units long, including the nose.
- The front edge of the eye is 1 unit back from the point of the nose.
- The ear is 1 unit in width. Its front edge is 4 units from the point of the nose and 2 units from the back edge of the head.
- The nose projects half a unit from the front of the main skull shape, which is about 6 and a half units wide in profile.

# The female head: working out proportions

Generally, the female head is smaller than the male, but the proportions are exactly the same. (Also see page 152 for information on the head proportions of children, which at certain ages are significantly different from those of adults.)

## Horizontal reading: full face

For the full-face examples, a proportion of five units across and seven units down has been used. Before you begin to study the individual units, note the central line drawn vertically down the length of the face. This passes at equidistance between the eyes, and centrally through the nose, mouth and chin.

- The width of the eye is one-fifth of the width of the whole head, and is equal to 1 unit.
- The space between the eyes is 1 unit.
- The edge of the head to the outside corner of the eye is 1 unit.
- The outside corner of the eye to the inside corner of the eye is 1 unit.
- The inside corner of the left eye to the inside corner of the right eye is 1 unit.
- The inside corner of the right eye to its outside corner is 1 unit.
- The outside corner of the right eye to the edge of the head is 1 unit.
- The central unit contains the nose, and is also the width of the square base of the chin or jaw.

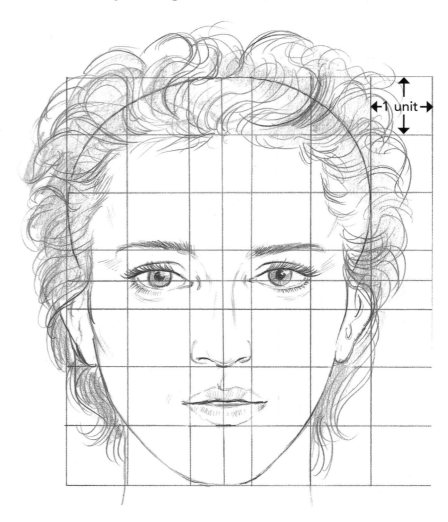

## Vertical reading: full face

- Eyes: halfway down the length of the head.
- Hairline: 1 unit from the top of the head.
- Nose: 1 and a half units from the level of the eyes downwards.
- Bottom of the lower lip: 1 unit up from the edge of the jawbone.
- Ears: the length of the nose plus the distance from the eyeline to the eyebrows is 2 units.

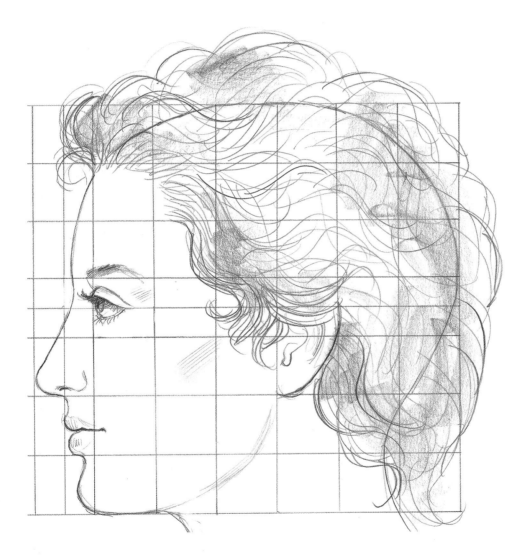

## Horizontal reading: profile

- The head in profile is 7 units wide and 7 units long, including the nose.
- The front edge of the eye is 1 unit back from the point of the nose.
- The ear is 1 unit in width. Its front edge is 4 units from the point of the nose and 2 units from the back edge of the head.
- The nose projects half a unit from the front of the main skull shape, which is about 6 and a half units wide in profile.

# Your first portrait step by step

When you are confident of your ability to draw features accurately, you are ready to try your hand at a full-scale portrait. You will need to agree on a number of sittings with your model, and how long each of these should last; two or three sittings of between 30 minutes and one hour should be sufficient. It is advisable not to let your subject get too bored with sitting, because dullness may creep into their expression and therefore into your portrait.

Once the schedule has been decided, it is time to start work. First, make several drawings of your subject's face and head, plus the rest of the body if that is required, from several different angles. Aim to capture the shape and form clearly and unambiguously. In addition to making these drawings, take photographs: front and three-quarter views are necessary, and possibly also a profile view.

All this information is to help you decide which is the best view of the sitter, and how much of their figure you want to show. The preliminary sketching will also help you to get the feel of how their features appear, and shape your ideas of what you want to bring out in the finished work. Changing light conditions and changing expressions will give subtle variations to each feature. You have to decide exactly which of these variations to include in your drawing.

Draw the face from left and right, and also in profile.

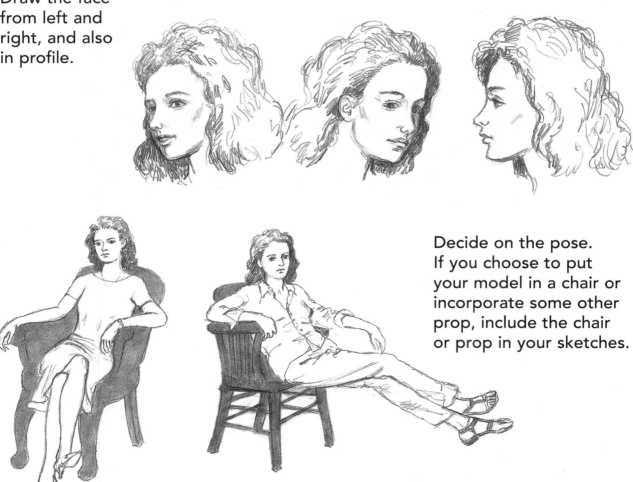

Decide on the pose. If you choose to put your model in a chair or incorporate some other prop, include the chair or prop in your sketches.

Decide what sort of clothing you would like your model to wear – casual, formal, textured, patterned or plain?

Plan the background. This can be merely a pleasant backdrop, or it can be part of the visual narrative and tell the viewer something about the sitter. It can be as simple or detailed as you decide to make it.

Decide on the lighting – gentle or dramatic? See the following pages for guidance on how to achieve different types of lighting and their effects.

# Lighting your subject

Portraits can be affected by the sort of lighting used, whether natural or artificial. Natural lighting is usually the softer of the two types, and is better if you want to see every detail of the face. However, this can have its downside if you want to draw a sympathetic portrait and not highlight the sitter's defects.

Leonardo said that the ideal set-up was in a sunlit courtyard with a muslin sheet suspended above the sitter to filter the daylight and give a diffused light. This may be beyond most of us, but we can aim to get a similar effect with a cool, diffused light through a large window.

The artist Ingres described the classical mode of lighting as, 'illuminating the model from an almost frontal direction, slightly to above and slightly to the side of the model's head'. This has great merit, especially for beginners, because it gives a clear view of the face and allows you to see the modelling along the side of the head and the nose, so that the features show up clearly.

Artificial lighting is, of course, extremely flexible, because you can control the direction and amount of light possible and you are not dependent on the vagaries of the weather. You don't have to invest in expensive equipment to achieve satisfactory results: several anglepoise lamps and large white sheets of paper to reflect light will do very nicely.

Lighting from behind the subject has to be handled very carefully, and while it can produce very subtle shadows, there is a danger of ending up with a silhouette if the light is too strong. Usually some sort of reflection from another direction creates more interesting definitions of the forms.

1. The light coming from precisely side-on produces a dramatic effect, with strong, well-marked shadows to the left giving a sharp-edged effect to the shadowed area.

2. The three-dimensional aspect of the girl's head is made very obvious by lighting coming from directly above, although the whole effect is softer than in the previous example. The shadows define the eyebrows and cheekbones, and gently soften the chin and lower areas of the head.

3.

3. Lighting the face from the front and to one side (as advocated by Ingres) gives a very even set of shadows – in this example on the right side – and clearly shows the bone structure.

4.

4. Lit frontally and from above, this example also owes a debt to Ingres. The slight tilt of the head allows the shadows to spread softly across the far side of the face.

5.

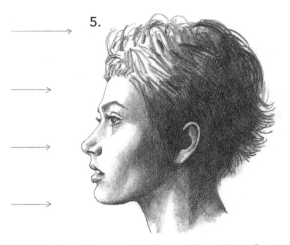

5. Lighting the model from directly in front shows the features strongly, subsuming the areas of the hair and the back of the head in deep shadow.

6.

6. Lighting from behind is not common in portraiture, although it can be done quite effectively. The trick is not to overdo it and end up with your subject in silhouette.

7.

7. Reflected light can be used to flatten out too many shadows cast over the face. If you want to try this, place a large white sheet of card or something similar opposite your light source.

# Self-portraits

Artists are their own easiest models, being always around and having no problem about sitting as long as they like. Some artists, such as Rembrandt, have recorded their own faces from youth right up until almost the point of death. Drawing yourself is one of the best ways of learning about single portraits, training your eye and extending your expertise, because you can be totally honest and experiment in ways that would not necesssarily be open to you with most other people. With your own portrait, you can proceed on a course of investigation to discover all the methods of producing a subtle portrait in some depth.

One of the most interesting aspects of exploring your own facial features is that each time you do it, you meet a new individual – still you, but different. You will be amazed by the depth of psychological insight that can be gained from continual study of a person you thought you knew.

Try portraying yourself in as many different mediums as possible and see how far you can take the likeness both physically and psychologically. What you learn by drawing your own face in various states and at various ages will expand your skills when drawing other people.

## Posing for yourself

The most difficult aspect of self-portraiture is being able to look at yourself in a mirror and still be able to draw and look at your drawing frequently. What usually happens is that your head gradually moves out of position, unless you have some way of making sure it always comes back to the same place. The easiest way to do this is to make a mark on the mirror – just a dot or a tiny cross with a felt-tip pen – with which you can align your head. You might ensure that the mark falls between the centre of your eyes, the corner of an eye or your mouth, whichever is easiest.

You can only show yourself in one mirror in a few positions, because of the need to keep looking at your reflection. Inevitably, the position of the head is limited to full face, three-quarters left, or three-quarters right of full face. In these positions you can still see yourself in the mirror without too much strain. Some artists have tried looking down at their mirrored face and others have tried looking upwards at it, but these approaches are fairly rare.

If you want to see yourself more objectively you will have to use two mirrors, one reflecting the image from the other. This way, you can get a complete profile view of yourself, although it does make repositioning the head after it has wandered out of position slightly more awkward. Despite the difficulties, this method is worth trying at some point, because it enables us to see ourselves the right way round instead of left to right, as in a single mirror. It will also give you a new and different view of yourself.

Drawing your own reflection in a mirror is not too difficult, but you have to learn to keep your head in the same position. It is very easy to move slightly out of position without noticing it, and then finding your features don't match up. Use a marker spot on the mirror and line up a feature on your face with it.

The angles of looking are restricted, and whichever way you turn your eyes will look straight at you. This means there will be a similar effect in your finished drawing, whatever the angle.

You can use two mirrors in order to draw your own profile image. Rarely do we see ourselves in this perspective, so it can be quite interesting visually.

# Index